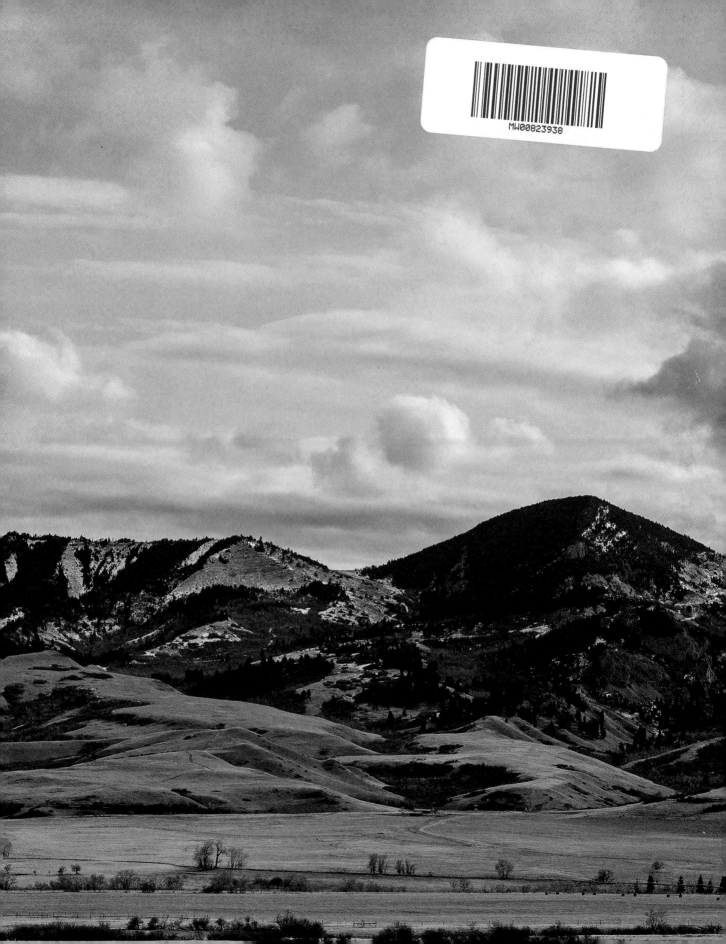

Apsáalooke
Women and Warriors

Neubauer Collegium
for Culture and Society

Contents

The Apsáalooke people come from a spiritual ecology. We believe that all things are connected and have kinship with each other. This means that power can be manifested from the world around us, anything can become a channel for the holy and sacred, including animals, birds, plants, rocks, insects, and human beings.

— Bishéessawaache/The One Who Sits Among the Buffalo, Grant Bulltail

foreword

Nina Sanders

Above all, and before we begin, it is my responsibility to thank the Apsáalooke people who came before us and acknowledge the work they did and continue to do. It is because of their hard work, prayers, and agency that *Apsáalooke Women and Warriors* exists. Aho.

This exhibition and publication have been in the making for many generations, as much of our knowledge and creativity is transmitted through art, objects, and oral history. With these gifts we created an exhibition and publication that properly articulate the culture and life force of the Apsáalooke people. In particular, I believe that this book will continue to transmit the ideas, words, and art of the Apsáalooke across oceans and into future generations.

All of the work presented was woven together to unite multiple views and beliefs—providing the reader with an inclusive collective of intellectual and aesthetic expressions of Apsáalooke culture. In curating *Apsáalooke Women and Warriors*, I've chosen to adhere to and emphasize foundational belief systems and practices that consider the Apsáalooke diaspora and the cultural differences that result from movement. There are many ways to identify as an Apsáalooke, but we all come from the same source.

I begin this journey by telling of the Apsáalooke people's emergence. Knowing where we come from will give the reader a better understanding of who we are. There are many iterations of the Apsáalooke creation story; this version follows the one Chief Medicine Crow would recite at Tobacco Society ceremonies. (In an effort to emphasize the unifying concepts and lessons that resonate throughout Apsáalooke culture, I've left out certain details.)

Long ago, before there were people, water covered all things, only Iichiikbaaliia/First Maker was present.

Deep down under the water Iichiikbaaliia sensed something extraordinary that wanted to come up to the surface.

Iichiikbaaliia called four ducks and asked them to go to the bottom and bring up the thing that wished to become.

One by one the ducks went down. The first, a red-headed mallard, did not return. The second duck, a pinto, failed to rise to the top as well. Sadly, the third, a blue-feathered duck, did not succeed at his task. Iichiikbaaliia was saddened, but did not give up. Finally, the last and smallest duck, the Hell Diver, went down. First Maker waited for a very long time until the little duck finally surfaced, breathless and weakened but with earth in her webbed feet.

First Maker picked up the duck and thanked her, then took the clay from her webbed feet and began to spread it in every direction, starting from the east. From this same earth Iichiikbaaliia created man and woman equally and at the same time. The First People were Awaagaabiilixpaaka.

After the First People were complete, Iichiikbaaliia gave them the gift of language and song. They were told that words are sacred and can be used to make wishes both good and bad, and to always be wise about what one says.

Iichiikbaaliia showed the First People all of creation and told them many things about the beings of the earth, and how they'd come to be. Among these beings were the rocks, Old Man Coyote, and Red Woman. Iichiikbaaliia told the First People that these sacred beings were powerful and sacred and should be respected.

As Iichiikbaaliia prepared the First People for their life on earth, a new presence arrived—the Star People. The First People witnessed two stars blaze across the sky, rest upon the land, then transform into two small tobacco plants blossoming with dazzling bright white flowers. This sacred plant is Ihchihchia.

First Maker told the people that the star beings came to earth to help and protect them, and said they would live in the form of the extraordinary flowering tobacco plant Ihchihchia. The First People were told to care for Ihchihchia: if they planted it and safeguarded it forever, it would always protect them and ensure they would be happy and successful.

Iichiikbaaliia instructed the people to live in a way that is considerate of all living things, and told them it was their responsibility to care for earth and her creatures, and to honor the many gifts they were given. This way of being is Immachiikittuua.

The people vowed they would honor Ihchihchia, practice Immachiikittuua, and respect all of the gifts Iichiikbaaliia provided them. With this they set out on their journey.

Multiple generations of the First People journeyed before they found their home in and around the Bighorn Mountains in Montana and Wyoming, where Ihchihchia, the Sacred Tobacco plant, grows. It's here that the people became Apsáalooke, flourished as human beings, and produced a brave and vibrant culture—part of which you will explore in this book.

This publication was created in the spirit of Immachiikittuua. Clan members gathered, sweat lodges were erected, and people were fed and given prayer so that *Apsáalooke Women and Warriors* would be a positive experience for everyone involved. Our shared investment brought more than twenty Apsáalooke people to the Field Museum and the University of Chicago, and Apsáalooke hosts welcomed thirteen partners from the Field Museum and the University of Chicago at the annual Crow Fair celebration. Together we worked to honor the cultural legacy of the Apsáalooke people, and reimagine the work—*and future*—of cultural institutions with a colonial heritage. I am proud to say that we labored together creatively—over shared meals, through the exchange of gifts, and, most importantly, with mutual respect. I believe we must be unified in our pursuit of equity and equality for all indigenous people previously refused a voice in Western institutions of culture and thought. The work of representing all communities is strengthened by forward-thinking people, and by good people who use their privilege and space to support those who are marginalized. Our ultimate goal is to deliver our own narratives, write our own scholarship, and educate the world about our cultures, worldviews, and experiences.

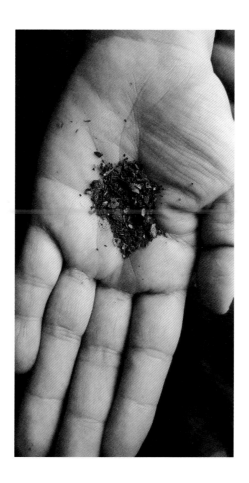

It is with permission from Apsáalooke Tobacco Society members that we are allowed to show you the Sacred Tobacco Society bundles and share our narratives. It is believed by our people that these items should be seen and remembered. They are at the core of Apsáalooke existence and well-being. We do not look inside other people's tobacco bundles without permission. These items are highly sensitive and powerful and must be approached and treated with deep reverence.
— Nina Sanders

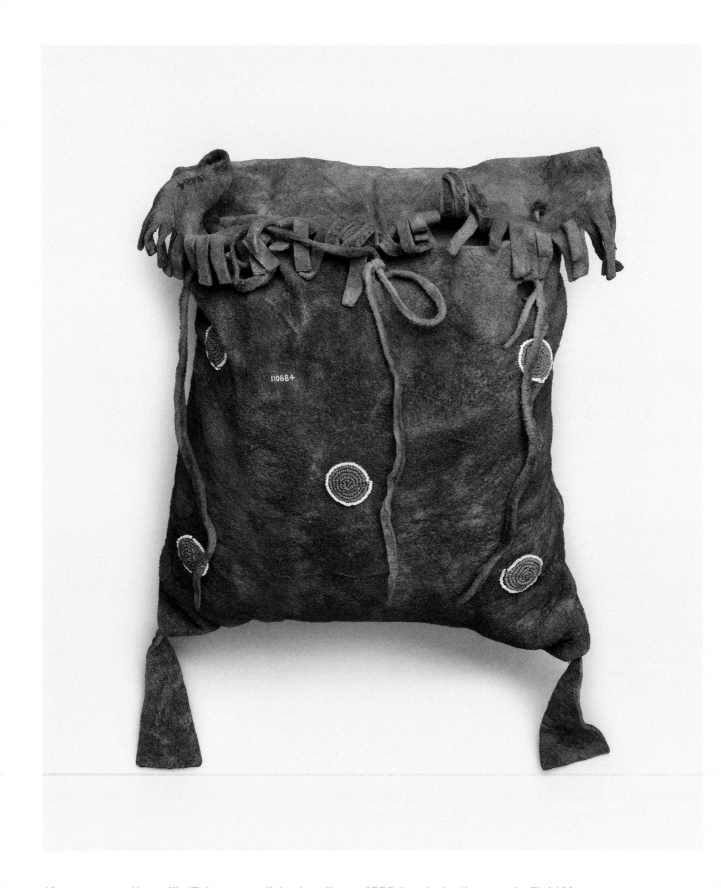

Xapaaliia/Tobacco medicine bundle, ca. 1880, beads, leather, seeds, Field Museum

marty lopez

Shiipdeetdeesh is the name of a man tied to the ethnogenesis of a whole tribal nation. Sometimes translated as No Vitals, No Intestines was the chief of what he and his followers simply called Biiluuke/Our Side. His brother, Red Scout, could be considered a Hidatsa chief. When these two brothers received visions at Devil's Lake, the two groups of people parted ways. Red Scout would lead his people to live a life of agriculture, planting their crops on the flood plains of a river. No Intestines was instructed to find the Sacred Tobacco plant. The people who followed him to this plant would come to be known as the Apsáalooke.

Many people chose to follow him because he was an honorable man. To the Apsáalooke, the word for "chief" is simply *bacheeiitche*, or "good man." They followed him across much of the Great Plains, from present-day Canada, past Great Salt Lake, to the Arrowhead River, in present-day Oklahoma. When No Intestines saw the plant for the first time, he saw shimmering lights. This happened at Extended Mountain, in the Bighorn Mountains. From that day forward, the Bighorn Mountains have always been the center of Apsáalooke country. The Sacred Tobacco plant was sparkling like stars. In fact, the Apsáalooke view the seeds of the plant as actual stars.

Many Apsáalooke stories are about the stars, and many cultural practices and beliefs are connected to the stars as well. The Tobacco Society stems from No Intestines' vision and his journey to fulfill that vision; it has been what marks the Apsáalooke people as a distinct and unified tribe. A major tenet of the Tobacco Society's functions is that the success of a garden of this specific short tobacco variety determines and guarantees the very prosperity of the tribe.

Without No Intestines, would this paramount Apsáalooke ceremony exist? What we do know is that No Intestines' example, of following and fulfilling instructions from a dream or vision, has continued to ensure the survival of the Apsáalooke. We lived a beautiful life in the best place for us, under the stars and with the stars. We lived with the Sacred Tobacco that No Intestines found. We call ourselves Biiluuke. We call ourselves Apsáalooke. We are still here today because our ancestors, our grandmothers and grandfathers, followed a good man called No Intestines.

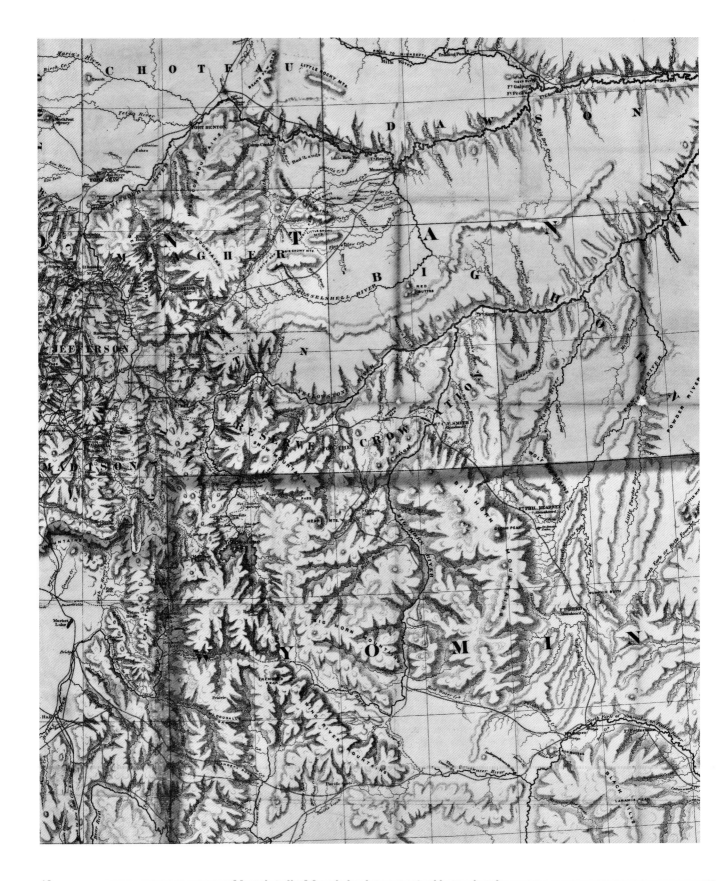

Map detail of Apsáalooke ancestral homelands

phenocia bauerle

The Crow are taught that everything you see has a purpose in this world and contributes something to life. There is a purpose behind everything; there is a force out there and that same force is responsible for all that surrounds you.
— Henry Old Coyote[1]

Relationality is at the center of the Apsáalooke worldview. Our cultural structure and stories tell us how to be in relation to all other elements that make up our world. The unique and specific history of the Apsáalooke people has created a resilience that is woven from these different modes of being in relation. As a people, we are a tribe born out of a tribe, our traditional cultural practices are both old and new, our homeland is the literal beginning of our people. The layers of relationships, kinship, clans, and societies, as well as place-based and spatial relationships, are our maps for being in this world, and they have allowed us to persevere throughout our existence.

The multilayered aspect of Apsáalooke identity is part of our deep resilience. In our becoming, we migrated, shifting our way of life to find our place, and we maintain traditions from our Hidatsa relatives. Our sense of tribal identity is deeply influenced by the culture of adoption, the growth of relations that permeates our societies and clans, and the strong belief that visitors are a blessing.

We are made from earth, filled with air from First Maker, and we hold respect for all elements in the world, as we are all created from the same force with purpose and power in the world. Even our lodges demonstrate our relationship to our environment through the symbolism of each piece that creates the tipi, reminding us of our Helpers and protectors. Clans are entwined with our blood kinship system, and together they give us a map of how to be in relation to other Apsáalooke and ourselves. Our relationality with the world ties together clan, other Apsáalooke society

relationships, and our surrounding world. Each layer presents specific community and familial roles and responsibilities for us to enact.

Scholarship, stories, and knowledge often frame Native peoples in relation to the past, stemming from accepted notions of linear time and existence. Indigenous scholars continue to make visible this problematic colonial narrative: Natives are of the past, a piece of American history that ceased existing *authentically* when the Reservation Era began; Manifest Destiny subsumed what remained of those ways of life, and they live on today only through the efforts of anthropologists, historians, and museums. Erasure of Native peoples in America has been, and continues to be, enacted through willful selective amnesia of history and by simultaneously claiming Native histories as part of the American identity.[2] By engaging in narratives that center on loss, Native people also engage in this dispossession of authentic Native traditions, and focus only on what has been lost in the American colonial project. Unangax scholar Eve Tuck urges communities to issue a moratorium on research centered on community damage and loss, because communities *are more than the trauma of the past.*[3] The selective national historical amnesia and damage-centered approach to our cultures and traditions obscure the role of our stories and knowledge: maps.[4]

You can't understand the world without a story. There isn't any center to the world but a story.
— Gerald Vizenor[5]

The beginning for the Apsáalooke people happened in different times and in different places: We were molded from mud by First Maker and became people; as followers of No Vitals we left the Hidatsa and became Biiluuke/Our Side; when we arrived at the center of *our* world, Awaxaawakuussawishe/Extended Mountain,

our identity and way of life as Apsáalooke was born with the Tobacco Society.[6] In a linear progression of time these are separate identities of evolving peoples, conflicting stories that need to be interrogated and researched to find the authentic beginning. Linear notions of time silence the reality that each beginning can happen without disrupting another. They are all part of Apsáalooke ways of being, stories that tell us about our place in this world. I say *place* intentionally, as a human-constructed notion of *space*: it is possible for multiple *places* to exist within the same *space*, overlapping without being at odds. The Apsáalooke people can have multiple beginnings at different points in time. We are Apsáalooke because Awaxaawakuussawishe exists in space.[7] But we also have always been. Our stories map a specific reality: Apsáalooke existence and temporalities.

We were a happy people when I came into this world, Signtalker. There was plenty to eat and we could laugh. — Pretty Shield[8]

In the popular writings of Frank B. Linderman we see Apsáalooke people in a time of transition. He imparts the writings with a sadness and senti-mentality for the past. In the foreword to his biography of Plenty Coups, he clearly lays out a sense of death of the "Indian" way of life at the hands of conquest:

Napoleon said after reading *The Iliad*: "I am specifically struck by the rude manners of the heroes, as compared with their lofty thoughts." The Indian has startled us by that same contrast, and so confounds us in our final estimate of a race we have conquered—from whom we might have learned needed lessons, if we had tried.[9]

The Apsáalooke way of life at this time was changing, but Linderman did not understand that Apsáalooke relationality allows our people to shift and survive against uncertain odds. Although his representation of Pretty Shield's and Plenty Coups' stories is imbued with sadness in a time of dramatic change, it misses the depth of the faith in the Apsáalooke way that motivated the sharing of those stories. Referring to the Reservation Era as the end of a way of life that the Apsáalooke had known,

Plenty Coups said, "After this, nothing happened." Reflecting on the meaning of these words, Jonathan Lear muses:

But this can be done in the hope of clearing the ground for new forms of Crow subjectivity. There is a reason to think that Plenty Coups told his story to preserve it; and he did so in the hope of a future in which things—Crow things—might start to happen again.[10]

This is an insightful understanding of Apsáalooke cosmovision. While a transitioning generation recognized that the world was changing and that it was uncertain how Apsáalooke life would transform, there remained a faith in our resilience as Apsáalooke people. This is underscored in Lear's interpretation of Plenty Coups placing his war bonnet and coup stick on the Tomb of the Unknown Soldier.[11] We do not acquiesce to sadness; it is something to be moved through toward a future that we may not discern. We are a people of adaptation and change, with a unique resilience centered in a culture that is at once markedly limber and sturdy—like the willow branches that frame our sweat lodges.

This project, *Apsáalooke Women and Warriors*, centered wholly in Apsáalooke understandings, is a new step for our people and in the much-discussed process of decolonizing museums. The act of planning this exhibition demonstrates a process of mapping our world in the present. Plenty Coups and Pretty Shield shared their stories to be preserved, to be looked to when the Apsáalooke had found their place in a changing world. These stories do not mark the end of Apsáalooke traditions and culture; they mark the transition to the next era. This exhibition engages their stories and others, our history and traditions, with the current reality of our people, who are thriving in the present, living the Apsáalooke way, and creating uniquely Apsáalooke art and knowledge.

The intentionally strong representation of women and our cultural contributions brings us back to our matrilineal roots and elevates the tradition of women warriors, who went to battle alongside men but have not been the subject of much discussion. True to our warrior culture, the exhibition highlights deeply important stories of the fight for survival while expanding notions of Apsáalooke warriors. We are warriors in a traditional sense, but we are

also warriors who are defending and reifying our way of life, reclaiming and redirecting how we define what is authentically Apsáalooke. This exhibition exemplifies a way to look beyond a damage-based approach toward Native culture, redirecting us to embrace what we have and the possibilities for the future: *Apsáalooke are resilient.*

Notes

1

Sylvester Morey and Olivia Gilliam, *Respect for Life: The Traditional Upbringing of American Indian Children* (New York: The Myrin Institute, 1974), 138.

2

This refers to Shari Huhndorf's discussion of "going native," and the historical efforts of non-Natives to possess Native America as a way of obscuring conquest as a piece of American history. Shari Huhndorf, *Going Native: Indians and the Cultural Imagination* (Ithaca, NY: Cornell University Press, 2001).

3

Eve Tuck, "Suspending Damage: A Letter to Communities," *Harvard Educational Review* 79, no. 3 (September 2009): 409–28.

4

I use "maps" here as a reclamation of ways of understanding being, or decolonizing notions of mapping and geography similar to Seneca scholar Mishuana Goeman's work exploring notions of mapping as spatial discourse, (re)mapping the Americas as indigenous land, and as a mechanism by which to be accountable to the ways in which we have become "a self-disciplining colonial subject." Mishuana Goeman, *Mark My Words: Native Women Mapping Our Nations* (Minneapolis, MN: University of Minnesota Press, 2013), 12.

5

Laura Coitelli, *Winged Words: American Indian Writers Speak* (Lincoln, NE: University of Nebraska Press, 1990), 156.

6

The word "Biiluuke/Our Side" stems from an older dialect of the Apsáalooke language, which was "*miikuuka.*" This means "the one close to the Creator or unique among the rest." Lanny Real Bird, "Ashaammaliaxxia, the Apsáalooke Clan System: A Foundation for Learning" (PhD diss., Montana State University, 1997), 24. See also Timothy McCleary, *Crow Indian Astronomy and Lifeways* (Prospect Heights: Waveland Press, 1997), 19.

7

Ojibwe scholar Megan Bang and colleagues explore notions of indigenous epistemologies and ontologies surrounding land and environmental education, which has informed my understanding of this. Megan Bang et al., "Muskrat Theories, Tobacco in the Streets and Living Chicago as Indigenous Land," *Environmental Education Research* 20, no. 1 (2014): 37–55.

8

Frank B. Linderman, *Pretty-shield: Medicine Woman of the Crows* (New York: The John Day Company, 1932), 20.

9

Frank B. Linderman, *Plenty-coups: Chief of the Crows* (New York: The John Day Company, 1930), xvii.

10

Jonathan Lear, *Radical Hope: Ethics in the Face of Cultural Devastation* (Cambridge, MA: Harvard University Press, 2006), 52.

11

Ibid., 33.

allen knows his gun

Allen Knows His Gun, *Crow Buffalo Lodge*, 2013

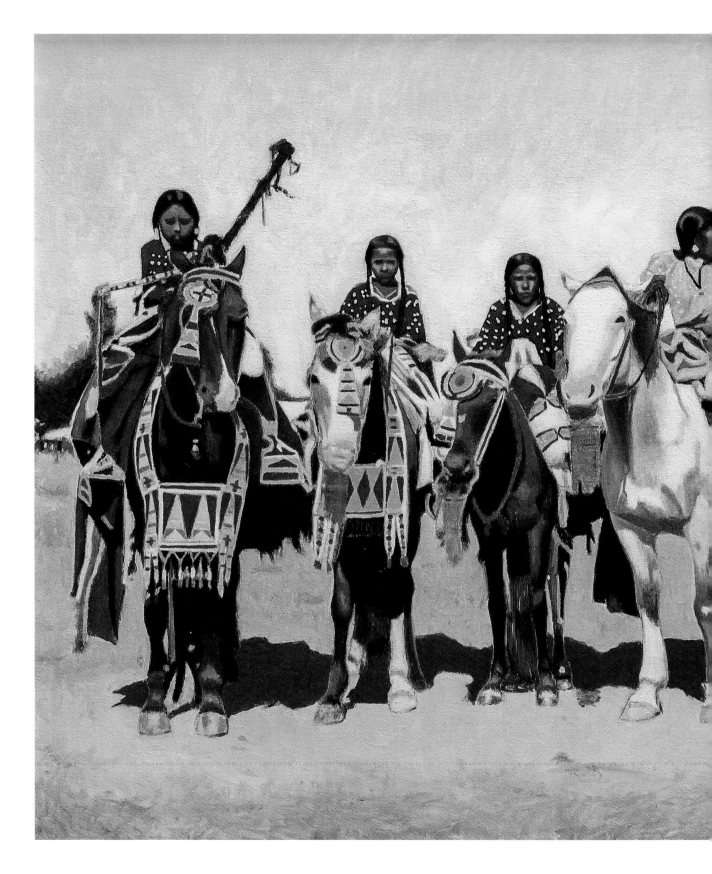

Allen Knows His Gun, *Apsáalooke Biakalishta (Crow Girls) Early 1900s, 2019*

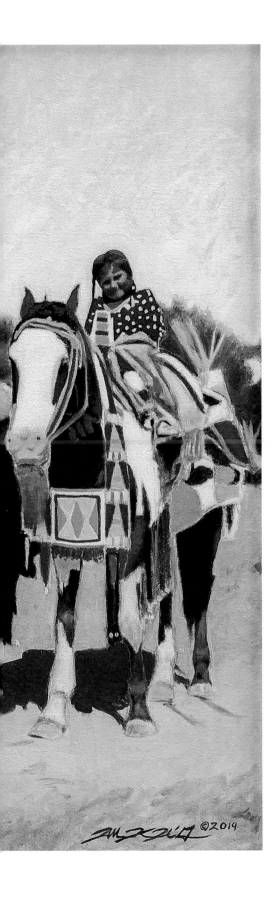

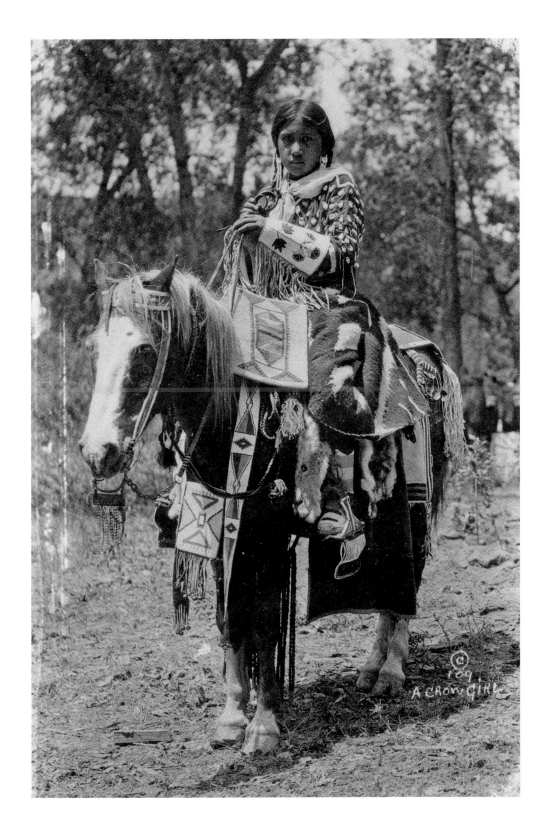

Susie Morrison on a Horse Prepared to Parade, 1917–1928, William Wildschut

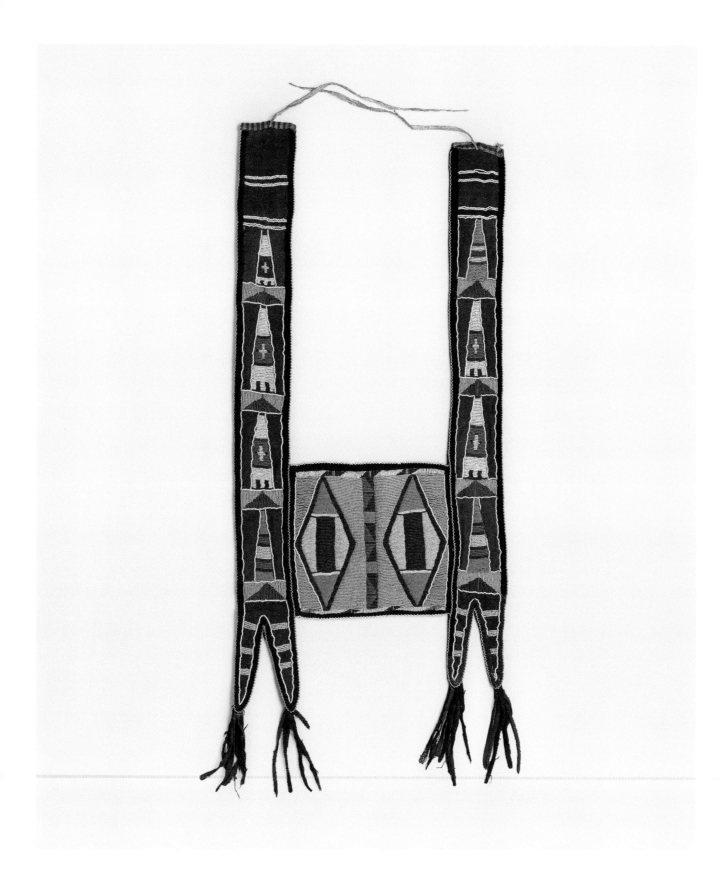

Daatchipeetaaliche/Martingale, ca. 1880, beads, deer hide, trade cloth, sinew, Field Museum

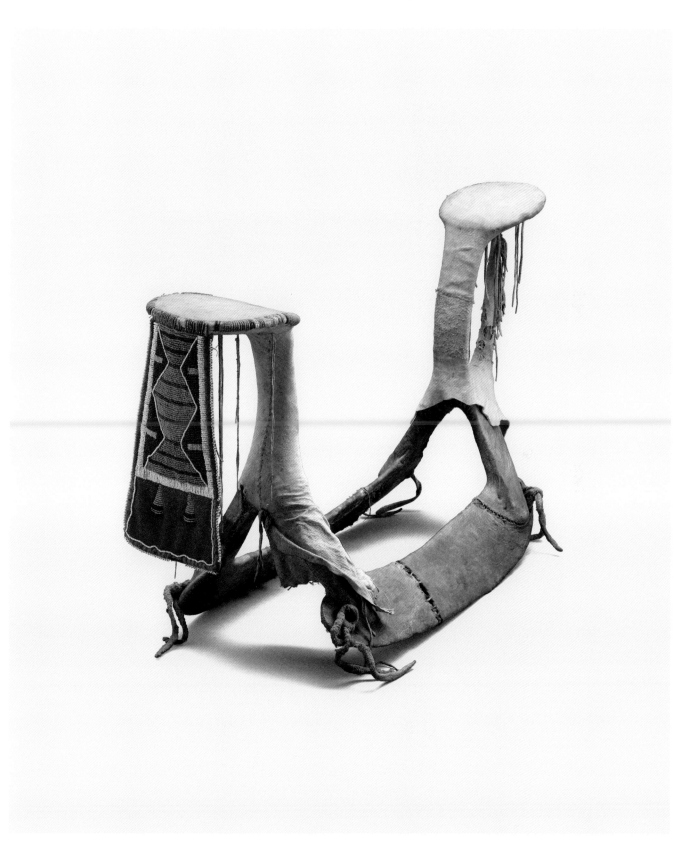

Annaahko/Saddle, year unknown, hide (leather, rawhide, buckskin), wood, glass, textile, sinew, thread, Field Museum

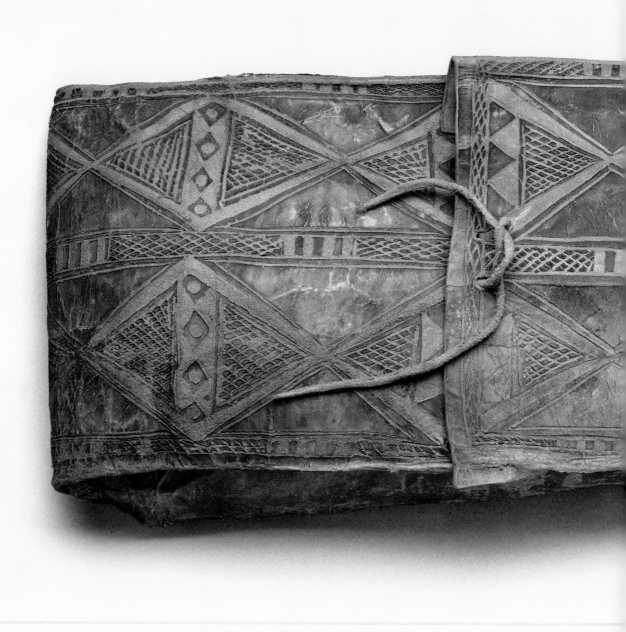

Bishkiischaiisshe/"Bags carried by dogs," year unknown (possibly early nineteenth century),
parfleche, buffalo hide, Field Museum

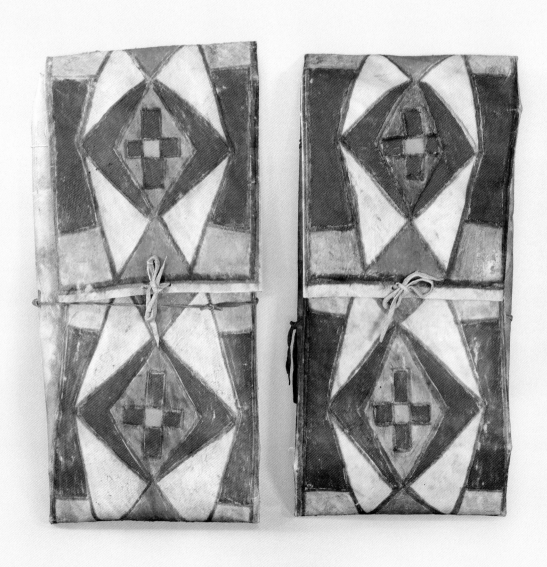

Bishkiischaiisshe/Parfleche envelopes for storage, 1890, hide, trade paints, Collection of Don and
Liza Siegel

letter to my people

joree lafrance

I want Crow children to know they have a place under the sun. That place is that they are a Crow tribe of Indians. The material in their roots is as good or better than what's happening today. I think we are beginning to blossom from our roots. A blossom is growing, and I am glad.
— Alma Hogan Snell[1]

We are the people made of mud who highly respect the stars. We are the people of the tallest peaks of the Bighorn Mountains. We are the people of the banks of the mighty ferocious waters that flow through our home. We are the product of our mothers and the answers to our grandparents' prayers. We are exactly who we were meant to be. We are few but we are mighty. We may be small like the duck that brought mud to the surface, the Chickadee who helped Plenty Coups, the shield that changed the weather, or the Little People who care for all the land, but we are powerful and mighty just like them. We are small in numbers but we have survived. We need to take the lessons from the small but mighty powers that have guided and assisted us. We have a way of understanding the world around us that sets us apart from any other people. We are fortunate enough to call where we live home. We are blessed to have a place like Crow Country and we must do all that we can to protect it.

We need to take better care of our mothers: Mother Earth, our homes, and our birth mothers. We need to care, protect, and uplift our women. We need to listen, show our love and appreciation for them. We must listen to our teachers, our mothers, fathers, the Big Horn Rams, stars, Little People, buffalo, rocks, and the water. We must intentionally listen so we can learn how to do and be better. We need to remember that this land is not ours to keep and we are simply borrowing it. We need to remember that the blood of our ancestors has infiltrated the land, demonstrating their gruesome fight to protect their way of life for future generations, including us. We must not forget that we are also made of the same roots of the teachings of our mothers and Helpers, the strength and sacrifices of our ancestors, and the prayers that have been heard and prayed since time immemorial. We must remember that we are them in a different time and we have the same obligations to protect. Power was given from the land and prayers were said for our leaders to guide us to where we are today. Remember that the same fight and strength that was in them is also in us. I pray that we can continue living as Apsáalooke people for another millennium on the land where good is found, that our rivers will always flow and be named after the sacred Big Horn Rams, and that our mountains will continue to belong to our grandchildren's grandchildren. Everything in this life was created for a purpose and you are part of that purpose. Taking care of the earth is taking care of our people.

Notes

1

Alma Hogan Snell, Becky Matthews, ed., *Grandmother's Grandchild* (Lincoln, NE: University of Nebraska Press, 2001).

the land that raised us

joree lafrance

The Crow Country is a good country. The Great Spirit has put it exactly in the right place; while you are in it you fare well; whenever you go out of it, whichever way you travel, you will fare worse.... The Crow Country is exactly in the right place. Everything good is to be found there. There is no country like the Crow Country.
— Sore Belly, Apsáalooke Chief[1]

The land is reflected in every aspect of Apsáalooke thought, design, and way of being. Understanding how Apsáalooke people see and interact with their landscape is rooted in their language, knowledge, and stories, which have been given to them by Iichiikbaaliia/First Maker and his Helpers. Our way of being is passed on from generation to generation through the social fabrics of Ashammalíaxxiia, our clan system. This exploration of the Apsáalooke landscape can only be understood with a fundamental understanding of how this world came to be, and how we came to be, where our strength comes from, and how we must draw on that fortitude to perpetually protect this way of being.

Creation Story, Our Mothers, Water, and Layers of the Universe

Red Woman appeared and pulled out her root digger and started scratching the earth and made the springs, creeks, and rivers. As the water flowed from the riparian areas, plants started to grow. Red Woman said... "If you are sick take the roots of the plants and eat and you will be healed."
— George Reed[2]

We are told of the time when the earth was covered with water. It was then that the creation of the land and Biiluuke—Crow people—began. Iichiikbaaliia, First Maker, instructed four ducks to dive into the deep waters in search of mud. The first three ducks failed, but the last duck—a mud duck, which was the smallest of the ducks—succeeded and brought a small amount of mud to the surface. Iichiikbaaliia took the mud, sang his creation song, then breathed into the mud, spreading it onto the water, and created the land on which we stand.[3] There are varying sizes of land masses—continents and islands—because the small duck was only able to bring up what he could, but Iichiikbaaliia used what he was given. Hisshiishduwiia—Red Woman, wife of Old Man Coyote—was responsible for carving out streambeds for our waters to flow.[4]

Iichiikbaaliia molded Biiluuke from the mud and breathed life into them, thus teaching us that the breath we use to speak our words is sacred and that we must always be mindful of what we speak into this world.[5] Our people were originally called Awakiiwiluupaapke, which translates to "People on Top of the Ground" and references the creation of the Apsáalooke people, who come from the materials of the ground itself.[6] When Biiluuke were created, they were created equal; "neither man nor woman was made first, it is simply said that [Biiluuke] were created."[7] We are made from the elements of the earth. We are taught that the earth is our first mother, the tipi (lodge or home) is our second mother, and the third is our birth mother. We are instructed to treat our mothers with high regard and reverence, for they are the ones who unapologetically provide, shelter, teach, and care for us even at our lowest. An Apsáalooke elder stated, "Treat your mother well, for our mothers are only on loan to us by Iichiikbaaliia. They are only on earth for a while, then they return. Take care of them while they are here."[8] Everything in this life that sustains us is not ours to possess or keep. Just like our birth mothers, we are borrowing the earth and our homes from Iichiikbaaliia, and we must do our part to protect them. It must be remembered that Apsáalookbia, Crow women, have always had agency and a significant purpose in sustaining the Apsáalooke way of life. Just as we must protect our

women, we must protect our land and all that comes with it.

Our universe is made up of three layers. The highest layer, known as Baakuukutaawaa Alakoole/Where People Live Up Above, is the place where the old ones, Isaahkaxaaliia/Sun and Kaalexaaliia/Moon, ihké/stars, and weather make their home. Baakkaawiile/Water Up Above also reside in the first layer and are known to be the five sacred waters—rain, mist, sleet, snow, and hail.[9] The middle layer is Awé—the land on which we stand and from which we are made. This is where Apsáalooke and all of our relatives live as well as Awakkulé, Earth Holders—the Little People and other spiritual beings. The third layer is the home of the Bimmuummaalakoole/Water Beings and Awewuutaalakoole/People Who Live Underground/ Under the Earth.[10]

It is important to highlight that there is communication and transcendence between these interconnected layers of the Apsáalooke universe. The four sacred medicines given to Apsáalooke people—the tobacco planting ceremony, rock medicine, sweat lodge, and Sun Dance—are the gateways for communication between the layers of the universe.[11] These medicines are not only ways of expressing deep gratitude through sacrifice, intention, and prayer; they are also gifts given to us that should always be respected.

Power from the Apsáalooke Landscape

The ground itself is respected and held "sacred" not only because of past events that happened on the landscape, but for the simple fact that the Apsáalooke come from the ground and are made from it. Apsáalooke are part of the ground, made from the same elements, and given the same powers. Therefore, in this traditional society, land is held in the highest regard.
— Aaron Brien [12]

No Vitals respected his fasting vision, split from the Hidatsa, and led the Mountain Crows on a strenuous yet incomprehensibly rewarding multigenerational journey to their promised land.[13] It is because of the great reverence and respect for Iichiikbaaliia and his Helpers that we are able to thrive and continue our way of life. Within the Apsáalooke landscape, there is a dynamic and constant synergy between

Apsáalooke people and all those that make up the different layers of the universe. As Lanny Real Bird stated, "Apsáalooke elders will often refer to the uniqueness of this land as the heart of the reason of who they are...visions were attracted to this country and it is blessed with many sacred, mystical, and holy places."[14] For it was the might of Ihchihchia, the Sacred Tobacco plant, that brought Apsáalooke to their promised land through visions. Alaxcheeahuush Ishbahee/Chief Plenty Coups told author Frank B. Linderman, "Look at our country. It was chosen by my people out of the heart of the most beautiful land on all the world, because we were wise. And it was my dream that taught us the way."[15] There is authority and reason in the way things have been done by Apsáalooke people, and we are fortunate to come from their wisdom and power.

In order for people to attain power from their Helper, they must show that they are worthy through sacrifice, such as fasting by means of the four medicines. When the vision seeker is given a Helper, it is necessary to carry out the Helper's obligations and serve the Helper's needs. At times when there is abuse of responsibility or ignorance of a Helper's request, the weather might change in an instant or bad luck might occur. Power is given to chosen people who are deemed worthy enough to receive it, and this can come in many forms of natural elements, such as the rock-medicine bundle that saved Apsáalooke people from complete annihilation or the Chickadee that helped one of our greatest warriors protect the land from which his strength derived.

One of our most notable leaders, Chief Plenty Coups was driven by the power of the land and love for his people. Plenty Coups put his life on the line to protect all the mothers (earth, lodge, and birth) that raised him. From a young age, he yearned for the day when he was deemed worthy enough to go fasting in hopes of obtaining medicine. Even the smallest of things in this world contained so much power that could help and heal nations. Take the Chickadee, a small bird with an average adult height of about five inches, which carried strong medicine that provided guidance for a whole nation. The Chickadee was a Helper for Plenty Coups. "The Chickadee is small, so are we against our many enemies, white and red," Plenty Coups said. "But he was wise in his selection of a place to pitch his lodge," just as the Apsáalooke have been chosen

to live in the promised land and wise enough to protect it.[16] On one of Plenty Coups' earliest fasting journeys, he was taken to the lodge of the Awakkulé chief. Plenty Coups was told that he already possessed all that he needed and that it was up to him to make the right decisions to live a prosperous, long life. The Awakkulé chief told Plenty Coups, "We, the Dwarfs, the Little People, have adopted you and will be your Helpers throughout your life on this world. We have no medicine bundle to give you.... You have a will. Learn to use it. Make it work for you. Sharpen your senses as you sharpen your knife."[17] When Plenty Coups was in combat, his Helpers, Awakkulé, were always standing next to him on the front lines of the battleground.[18]

We are taught that the keepers of the land, who ensure that it is cared for and that the waters stay flowing, are Awakkulé, who reside in the second and third layers of the universe. The "Little People live under the earth and take care of the earth, make sure that the rivers flow and the grass grows and the trees...and they will take care of the Crows and they will be their Helpers so leave gifts at the Pryor Gap so that they know that you are thinking about them and in return they will help you."[19] This was told by Grant Bulltail, an Apsáalooke elder, who has been recognized with a National Endowment for the Arts Heritage Fellowship for his immense knowledge and ability to share stories. He tells a story of Little People warning those who fasted in Awaxaawissee, the Pryor Mountains, that because the earth was being mistreated, they were going to move to the north because "people were polluting the land and it was not fit for them to live [t]here anymore and they were not mindful of the energy that was flowing here."[20] There are those who are silently suffering as a result of our decisions, and this is a stark reminder that one must act upon the responsibility to care for and protect the land. Gratefully, Awakkulé have always taken care of and assisted their Apsáalooke relatives while receiving honor and gifts in exchange. To this day, we hear of Awakkulé visiting those on their fasting journeys or of the casual comical encounters that remind us of our humor, humility, and, most importantly, our responsibilities. We are appreciative of our relatives who helped us during the triumphant times of Chief Plenty Coups' warfare and negotiating days and the demanding yet sunlit days we are blessed to live.

To receive help from the weather or the four elements or to have the ability to control them is an unparalleled power gifted to some people. Iisaatxaaluuash/Chief Two Leggings was given medicine that could change the directions of the wind and, more extremely, cause it to hail as he approached his enemies.[21] Apsáalooke warriors' shields also hold the unique ability to change weather. Apsáalooke warriors painted depictions of night and day, the landscapes, sky, and their Helpers on their shields. One such shield contained so much power that ethnographer Stephen Chapman Simms, the former director of the Field Museum of Natural History, wrote in his 1900–1903 field notes, "On occasions when asking to see shields, the old man declared if they exposed the shields it would rain and hail and on both occasions it did—the sky was clear and [then] was thundering."[22] The natural world has always assisted Apsáalooke people, especially in their time of need, and for that we are eternally grateful.

As a result of these powerful experiences, place names are the backbone of Apsáalooke land knowledge and our sense of place. The descriptive names create images of the experiences that once occurred at specific places or tell how the names were given by a spiritual being. The true names of places known to Apsáalooke represent the immense connection they have to the natural world. These names and the locations can be seen on the interactive maps in the *Apsáalooke Women and Warriors* exhibition: places like Ammilisshíissaannuua/Where They Fast, formally known as the Castle Rocks; Daxpitcheeaasáau/Bear's Lodge, known as Devil's Tower; Bishiáxpe Alíkuua/Where They Saw the Rope, known as Dry Head Overlook; Iishbíaassaao/Mountain Lion's Home, known as Pompey's Pillar; and Ashísshípuoo/Where the Sun Dance Lodge was Run Over, known as the confluence of the Clark's Fork and Iichíilikaashaashe/Yellowstone River.[23] Each descriptive name represents a common understanding of the significance of the place and is implicitly shared through the transferable knowledge of language. Our identities are embedded in the land that has raised us, and we are fortunate to call Apsáalooke country home.

Notes

1

Rick Graetz and Susie Graetz, *Crow Country: Montana's Crow Tribe of Indians* (Billings, MT: Northern Rockies Publishing Company, 2000).

2

Emerson Bull Chief, "Belief Ways of the Apsáalooke: Development of a Culture Through Time and Space" (PhD diss., Montana State University, 2016).

3

Grant Bulltail and Gary Wortman, "Crow Stories: The Little People," YouTube video, accessed September 12, 2019, https://youtu.be/3SJbQ1-IfcE.

4

Lanny Real Bird, "Ashammalíaxxiia, the Apsáalooke Clan System: A Foundation of Learning" (master's thesis, Montana State University, 1997).

5

Daniel Old Horn and Timothy McCleary, "Apsáalooke Social and Family Structure," 1995, cited in Little Big Horn College Library reference guide, at http://lib.lbhc.edu/about-the-crow-people/history-and-culture/creation-story.php.

6

Aaron Brien and Kelly Dixon, "From the Land: An Indigenous Perspective of Landscape and Place on the Northern Plains" (in progress).

7

Old Horn and McCleary, "Apsáalooke Social and Family Structure."

8

Real Bird, "Ashammalíaxxiia."

9

Old Horn and McCleary, "Apsáalooke Social and Family Structure."

10

Timothy McCleary, *Crow Indian Rock Art: Indigenous Perspectives and Interpretations* (London: Routledge, 2016).

11

Peter Nabokov, *Two Leggings: The Making of a Crow Warrior* (New York: Crowell, 1967).

12

Brien and Dixon, "From the Land."

13

Joseph Medicine Crow, *From the Heart of the Crow Country: The Crow Indians' Own Stories* (Lincoln, NE: University of Nebraska Press, 2000).

14

Real Bird, "Ashammalíaxxiia."

15

Frank Linderman, *Plenty-Coups: Chief of the Crows*, 2nd ed. (Lincoln, NE: University of Nebraska Press, 1998).

16

Ibid.

17

Ibid.

18

Bulltail and Wortman, "Crow Stories."

19

Ibid.

20

Ibid.

21

Nabokov, *Two Leggings*.

22

Stephen Chapman Simms, *Crow Indian Culture Field Notes* (Chicago: Field Museum of Natural History Archives, 1900–1903).

23

Linderman, *Plenty-Coups*.

adam sings in the timber & joree lafrance

Akchiwakiideeiishiitchaash/One Who Loves to Pray, Janine Bernadette Pease, D. Ed.

Baahkuukawiia/Early Morning Woman, Margo Real Bird

Ammaakushdeeiitcheesh/Goes Towards Good Places, Sharon Stewart-Peregoy

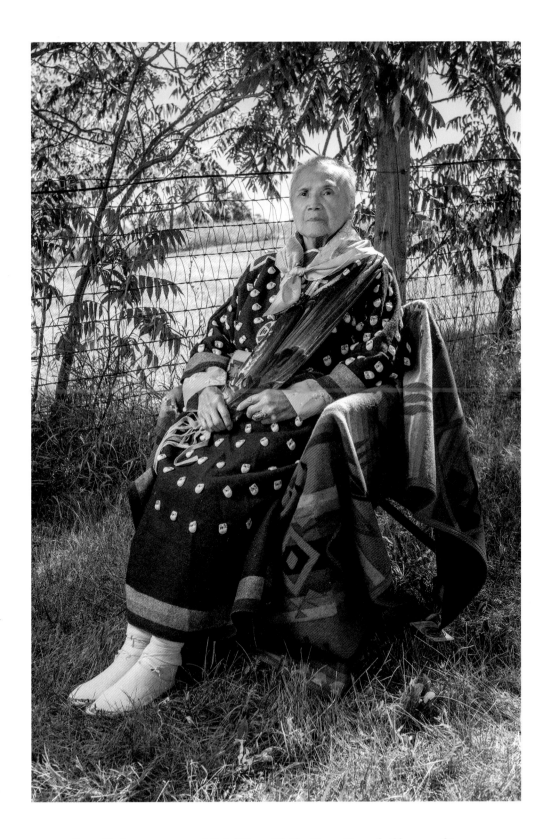

Daxpiitcheeaxpaawachiish/Sits with the Bear, Beverly Charges Strong

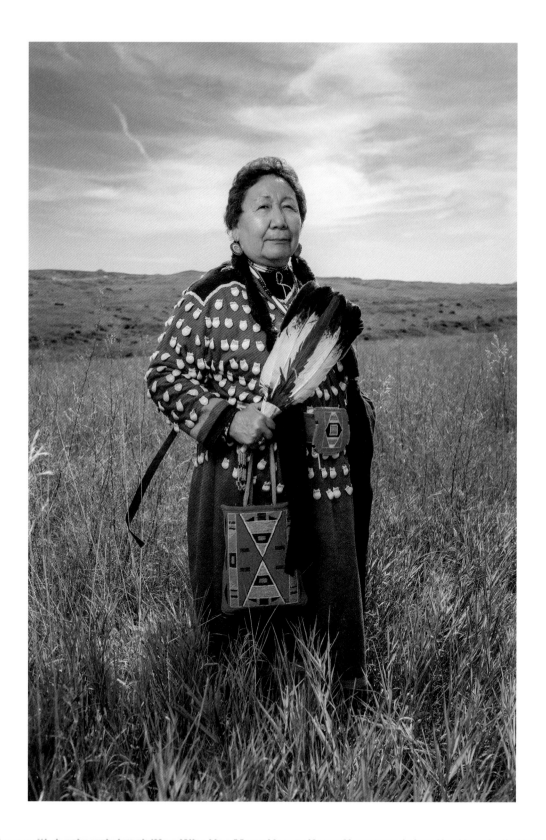

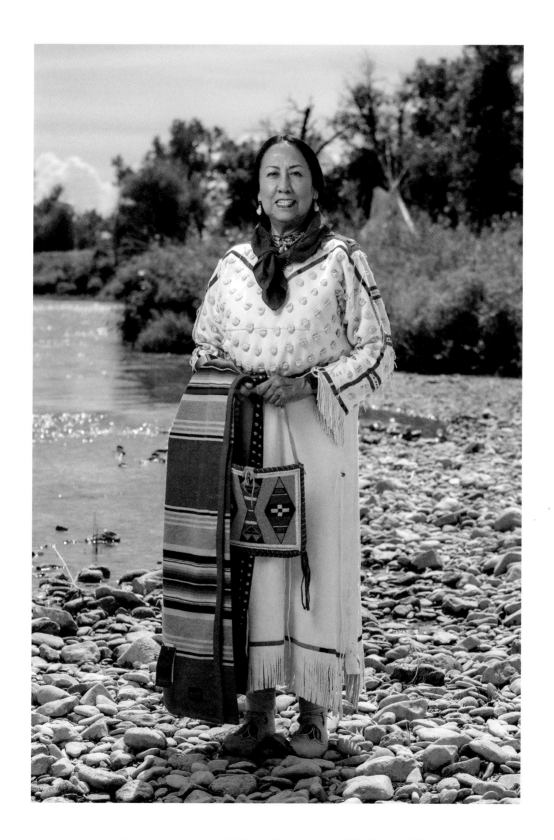

Bassaanneeahoosh/First Many Times, Birdie Real Bird

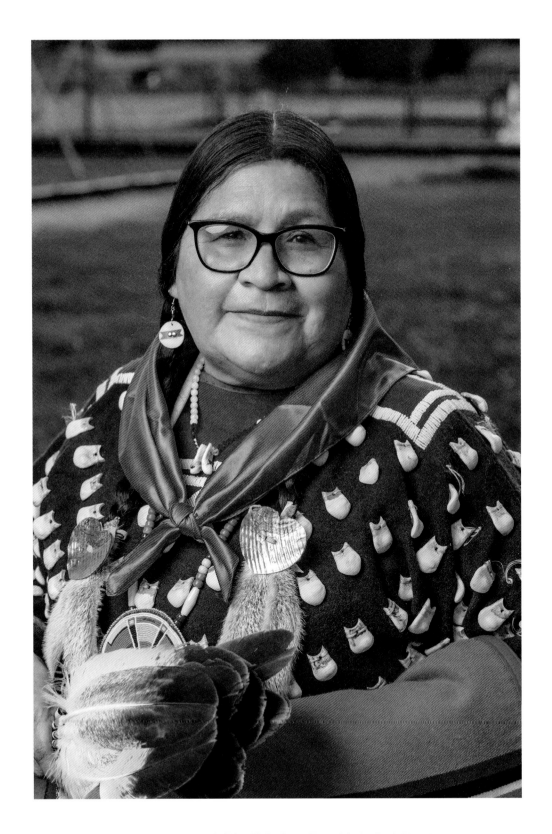

Baainneeiiwaaxpaash/The Holy One, Reva Little Owl-Not Afraid

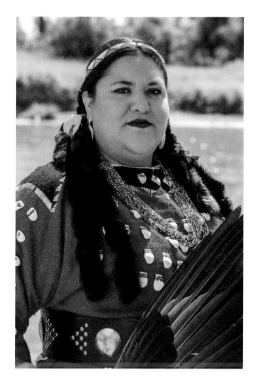
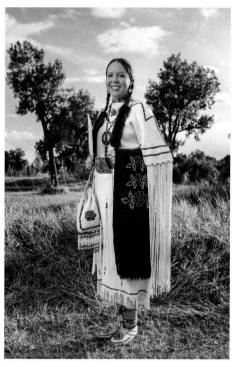
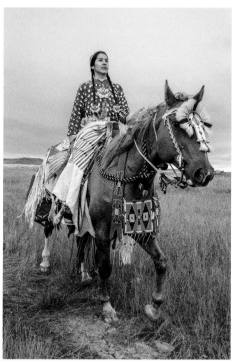
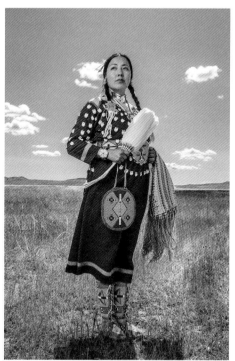

Clockwise from top left: Akbaaiitcheesh/One Who Keeps Things Good, Luella N. Brien; Biilaahsaalakuuahisseesh/Well Known Winner, Mary Hudetz; Angela Bear Claw; Iichiinmaatchiilaash/Fortunate with Horses, JoRee LaFrance.

43

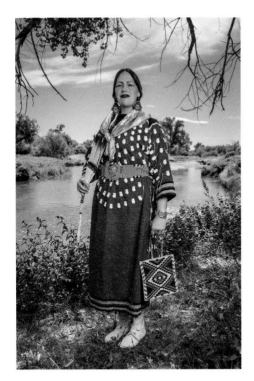
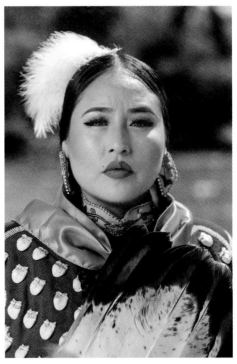
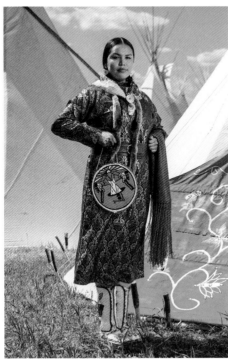
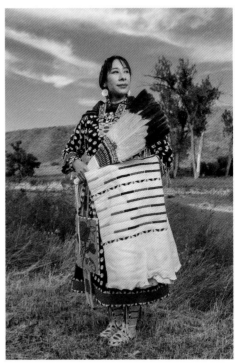

Clockwise from top left: Akbileoosh/Brings the Water, Nina Sanders; Biilaakshe Heeleen Diileesh/ One Who Walks in the Light, Teri Lea McCormick; Baawalaatchxiiaseesh/Well Known Writer, Brocade Stops-Black Eagle; Biiabaashilebaaxpaash/Sacred Dream Woman, Cordelia Falls Down.

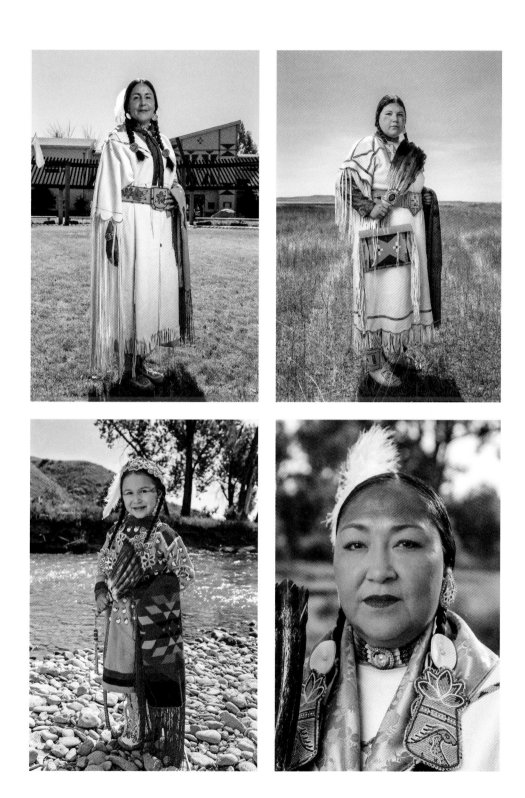

Clockwise from top left: Bilitaahisshewiiash/Butterfly Woman, Dr. Gerlinda Morrison; Biiawassaaneesh/Woman in the Front, Hunter Old Elk; Ammaakoonahkoo, Amber Old Horn; Baaiitchiilappeesh/Kills Pretty, Aiyana Skunk Cap.

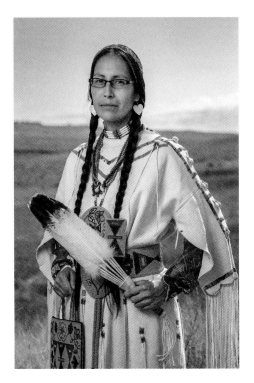
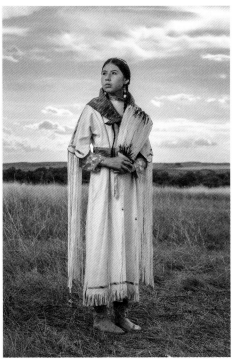
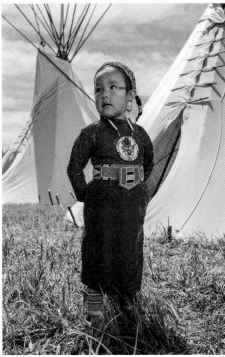
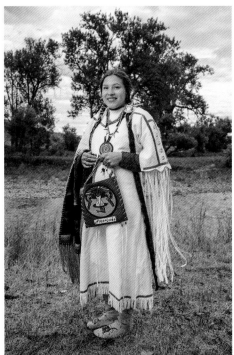

Clockwise from top left: Uutebalooxxiiasaash/Weasel with Outstanding Beads, Amber White; Biiakaatbaatchiileesh/Lucky Girl, Angela Stump; Balaaxiitcheesh/Sings Pretty, Autumn Charges Strong; Bassaaniilaaxpaakeesh/First People, Arya Old Bull.

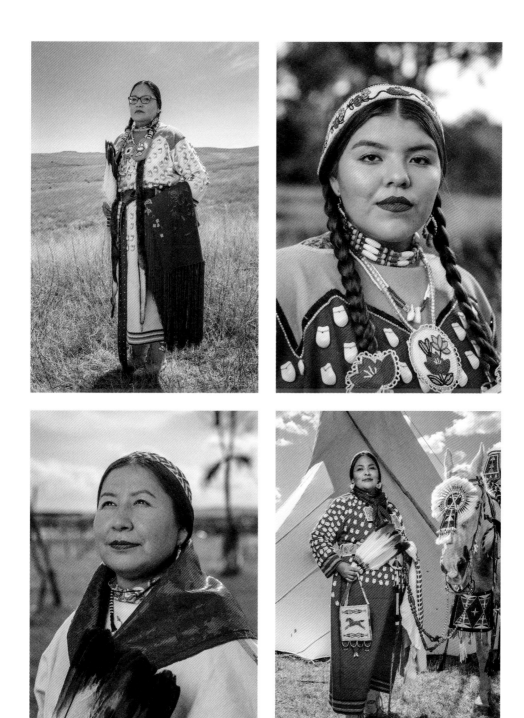

Clockwise from top left: Ishpooshebaatchiliish/Has Good Fortunes with Her Eagle Feather, Melissa Holds the Enemy; Alamiiaahoosh/Many Ambitions, Deidra Beads Don't Mix; Biialiipiitcheesh/Woman Sharpshooter, Destiny White Clay-Bear Claw; Ahaakawaatchaacheesh/ Last of the Greatest, Della Big Hair-Stump.

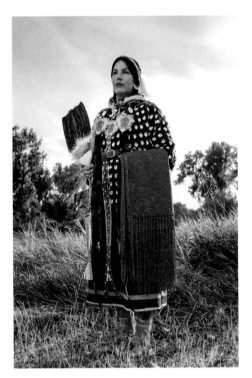
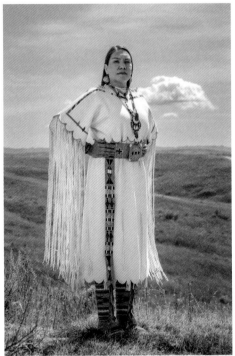
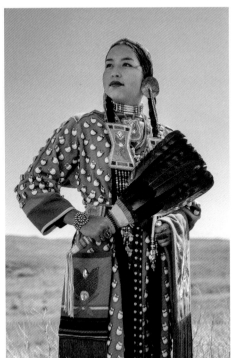
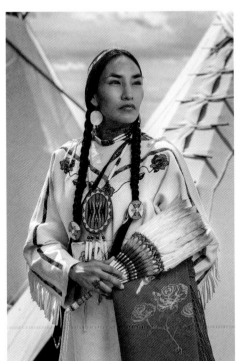

Clockwise from top left: Ishkooshiitbalaaxiitcheesh/Strawberry Sings Pretty, Eleanor Breath Kindness; Atkuuxshiileedaak/No One Helps Her, Dr. Grace Bulltail; Alawasuuabiiash/Sweat Lodge Woman, Lakisha Flores; Iikuualasaash/Thinks of Others before Herself, Jordynn Paz.

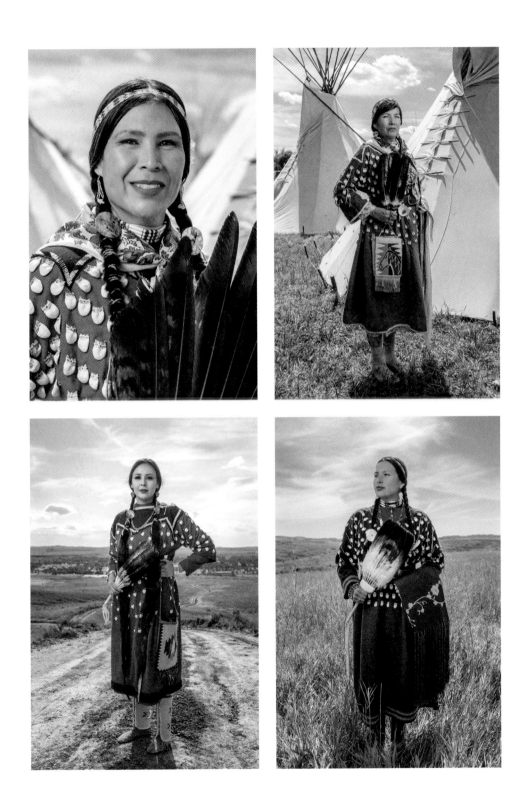

Clockwise from top left: Awaanbaakooshdaaluukkoo/Fasts in the Mountains, Laurie Dawn Kindness; Aashesiiteesh/Well Known Camp, Lissa White Clay; Baachuuakaateapaale/Chokecherry Blossom, Madisan Chavez; Baaiitcheeahoosh/Has Good Things, Lorna Little Owl.

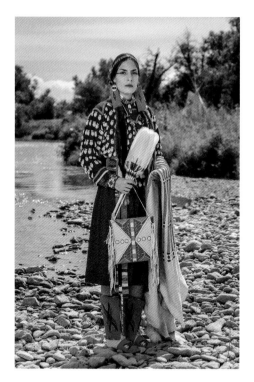
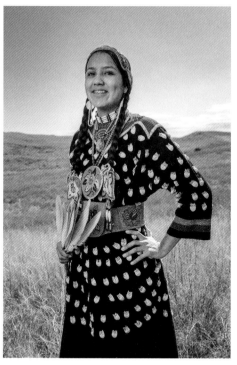
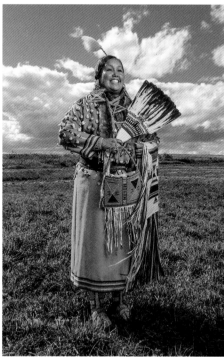
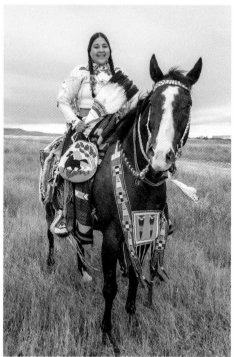

Clockwise from top left: Dakaakebiiaiitcheesh/Pretty Bird Woman, Amanda Not Afraid; Ihkeiiwaaxiiasaash/Shining Star, Marion Hugs; Axxaasheiikaash/Looks at the Sun, Nicole Real Bird, Aapcheexiiasaash/Can Hear Her Voice above Others, Myra Ann Crooked Arm.

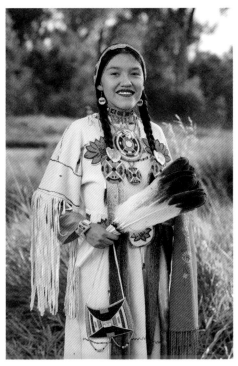
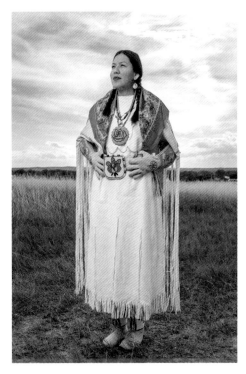
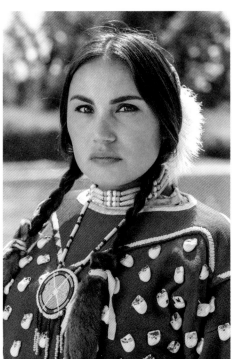
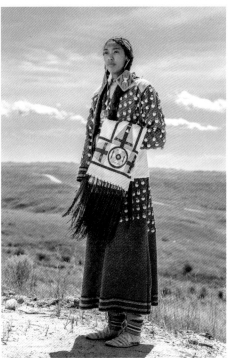

Clockwise from top left: Baaiihkammaache Isiitcheesh/Likes to Be Happy, Revonna Alamo;
Baa Aahiiwasaaneeahoosh/Always Takes First with Her Parade Regalia, Sharmaine Hill;
Bahaaiishdeesh/Brings Spring Water, Terae Briggs; Aasheeiitchiish/Makes Good Lodges,
Tana Stewart.

apsáalookebia

kami jo white clay

After all
Past
Struggles
Á woman warrior
Arises
Leading
Other women
Onward
Knowing
Every Apsáalooke
Bia
Is following, unapologetically
Apsáalooké

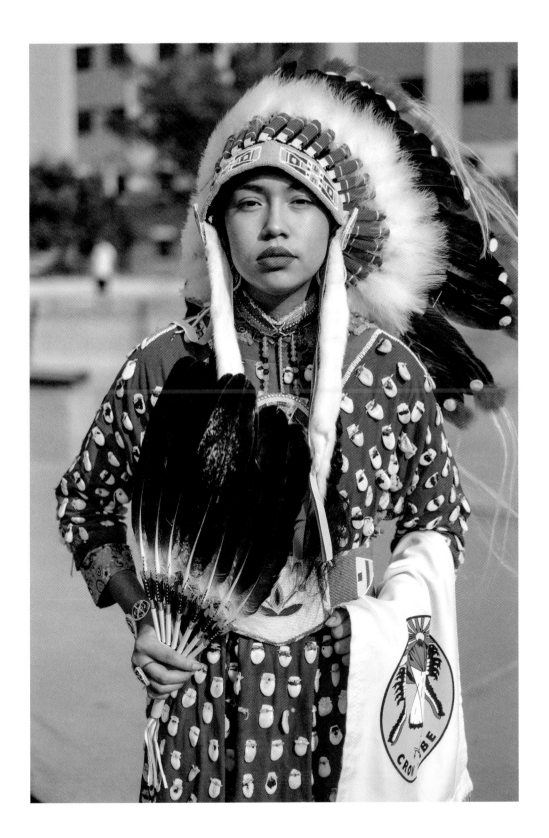

Daxpiitcheeaxapaliiash/Bear Medicine, Kami Jo White Clay 53

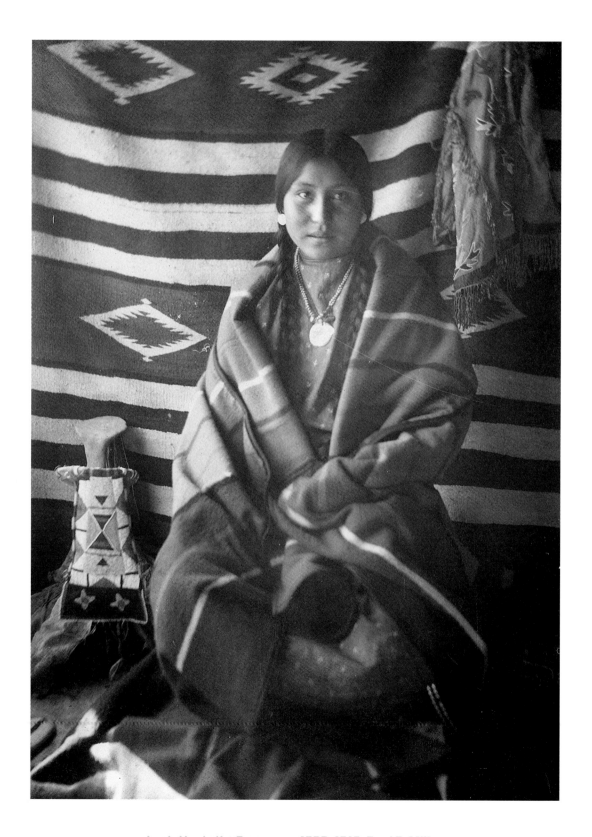

Louis Hunts the Enemy, ca. 1898–1910, Fred E. Miller

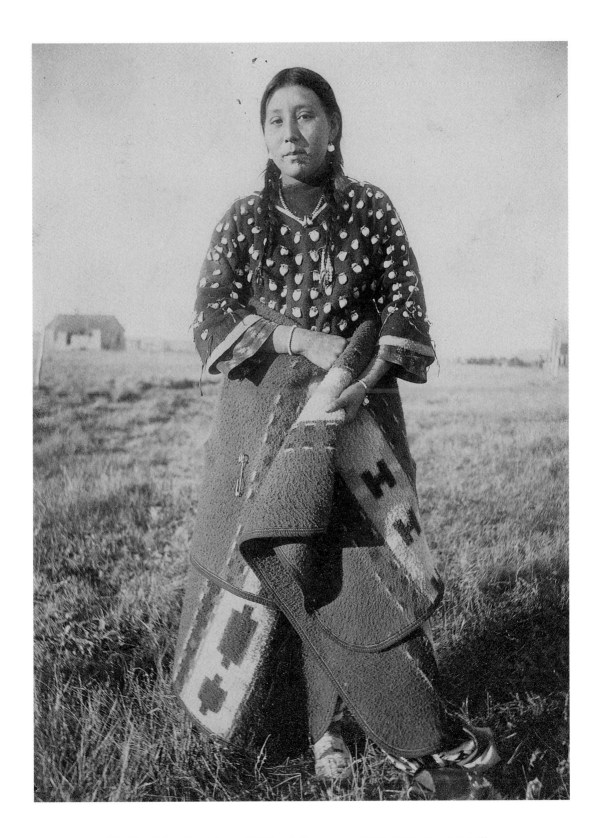

Big Medicine Rock in an Elk Tooth Dress, ca. 1898–1910, Fred E. Miller

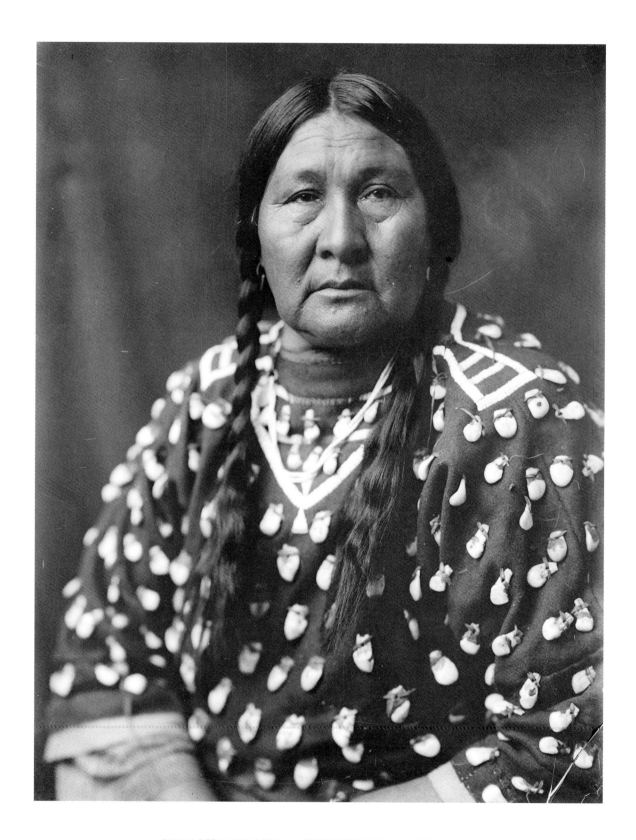

Sacred Mountain Sheep, 1902–1933, Richard Throssel

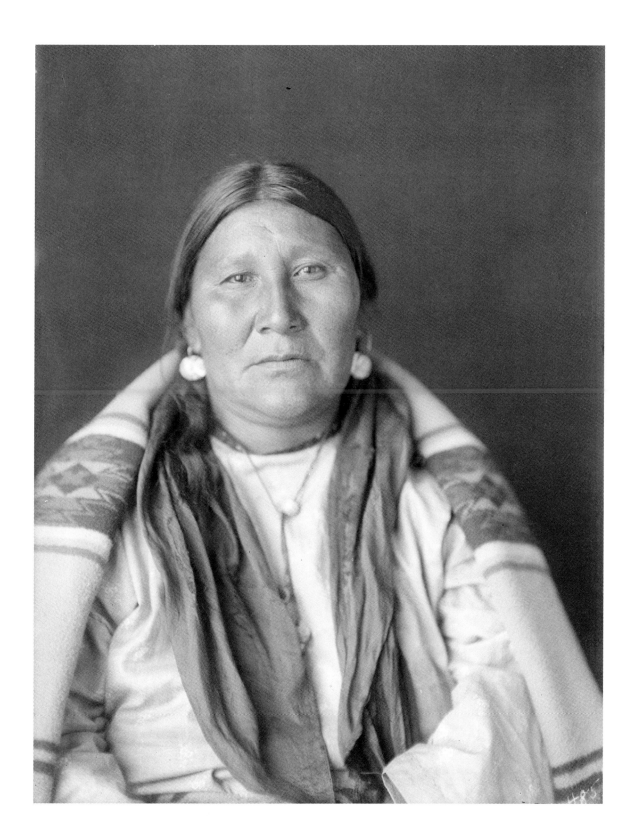

Pretty Shield, 1902–1933, Richard Throssel

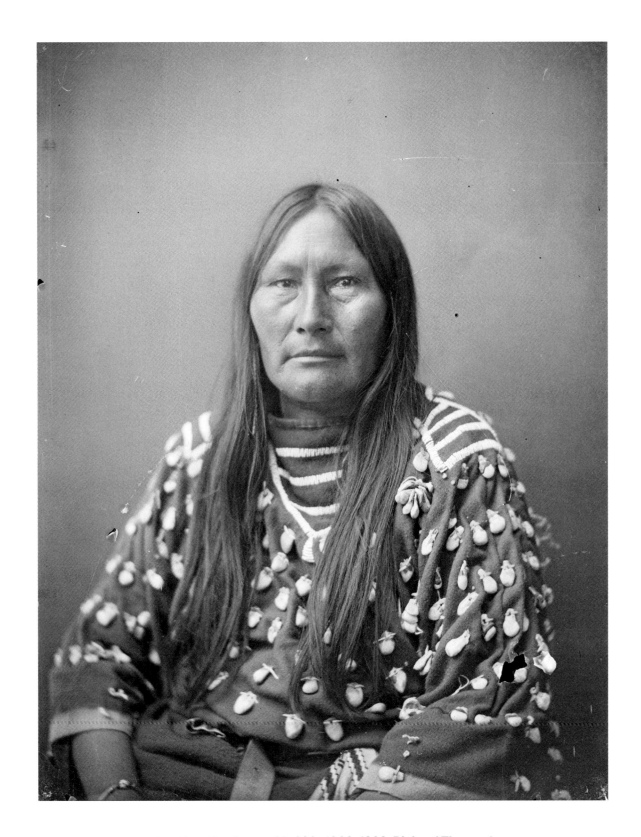

The First Mrs. Spotted Rabbit, 1902–1933, Richard Throssel

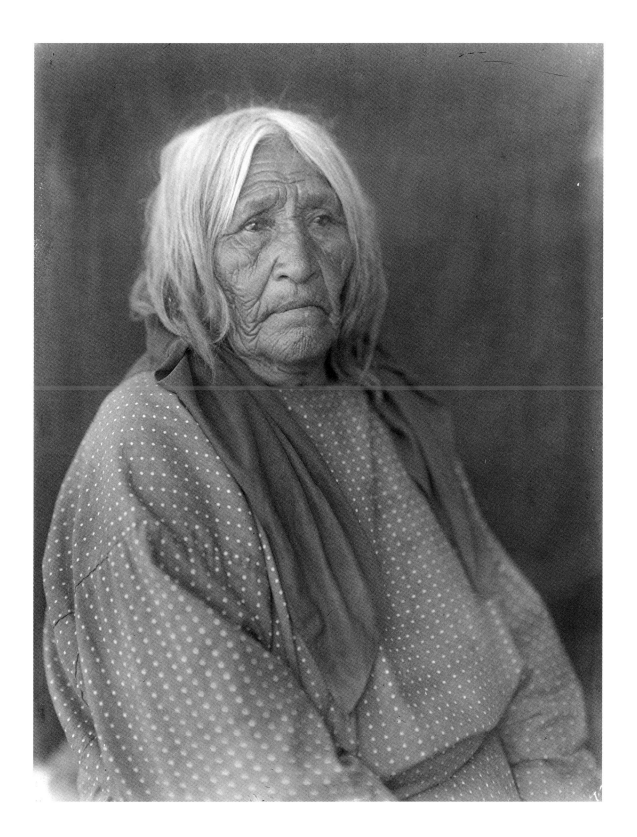

An Unknown Kaala (Woman), 1902–1933, Richard Throssel

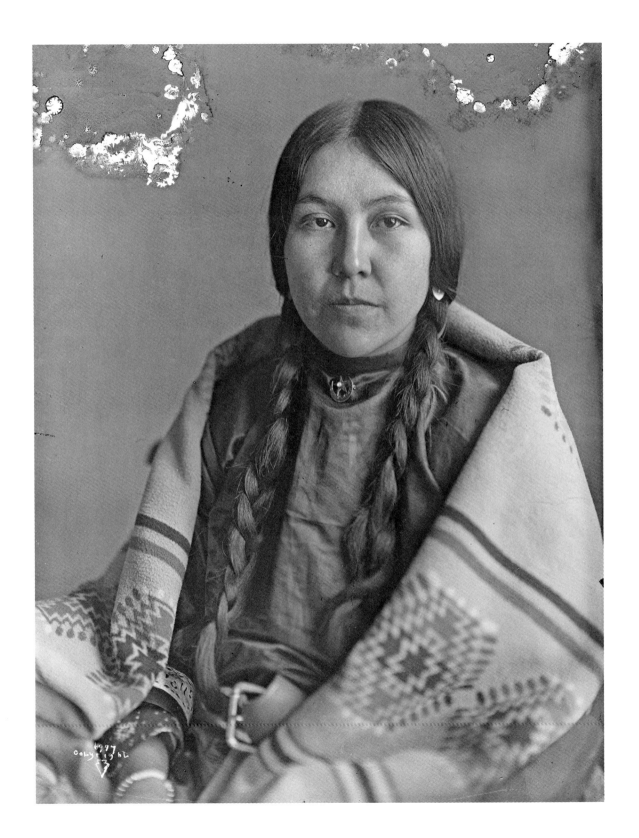

Carries the War Staff, 1902–1933, Richard Throssel

midwifery and women's health

janine pease

Crow midwives attended the birth of their tribal children in respective districts of the reservation. The knowledge of treating women's illnesses and conditions was a well-developed specialty with sacred elements within the tradition. Robert Lowie's research at the beginning of the twentieth century found that midwives gave the birthing mother tea infused with baneberry root and ground-up horned toad. These were in imitation of the expectant cow buffalo. Crows placed a beaded fish in the bed of the expectant mother and sometimes placed a small live fish in the palm of the mother's hand. Midwives' medicine bags contained nodding onion, red baneberry, porcelain dolls, and chewing tobacco. The nodding onion was beaded on an aphrodisiac bag. Mothers were instructed to eat chokecherries while pregnant to promote black shiny eyes in their babies, and to avoid facing the fire.

Midwives were trained by their mothers and grandmothers, and the process started through observations, listening, and assisting with deliveries. A special lodge was prepared for the birth, and the floor was lined with the grass that buffalo do not eat. The expectant mother refrained from eating as her time approached, and she walked in all four directions.

In 1912, Commissioner of Indian Affairs Cato Sells issued an order that focused on infant health. He saw the Indian health service chief's duty was to protect the Indian's health and "save him from premature death": "We must save his life...we must care for the children." The statistics from Indian country showed a startling three-fifths of Indian infants died before the age of five. He introduced the "Save the Babies" campaign, which expanded the field matron program, to promote prenatal and infant health care, and generated pamphlets to convince Indian women to seek medical assistance and practice good home hygiene.

In *They Call Me Agnes: A Crow Narrative on the Life of Agnes Yellowtail Deernose*, Agnes described her dilemma as her delivery came near. The Bureau of Indian Affairs field matron advised that she go to the Agency hospital to have her baby. On the other hand, she could seek assistance from the Crow traditional midwife, an elder woman she had known all her life. When the time came, she feared having a non-Indian male doctor deliver her baby. Agnes called upon midwives Horse and Bird in the Cloud, sisters who lived in the Lodge Grass District, where she lived. They tended to her successful birth, the delivery of her son Robert. The midwives had her kneel down to give birth and not to cry out; no males were present.

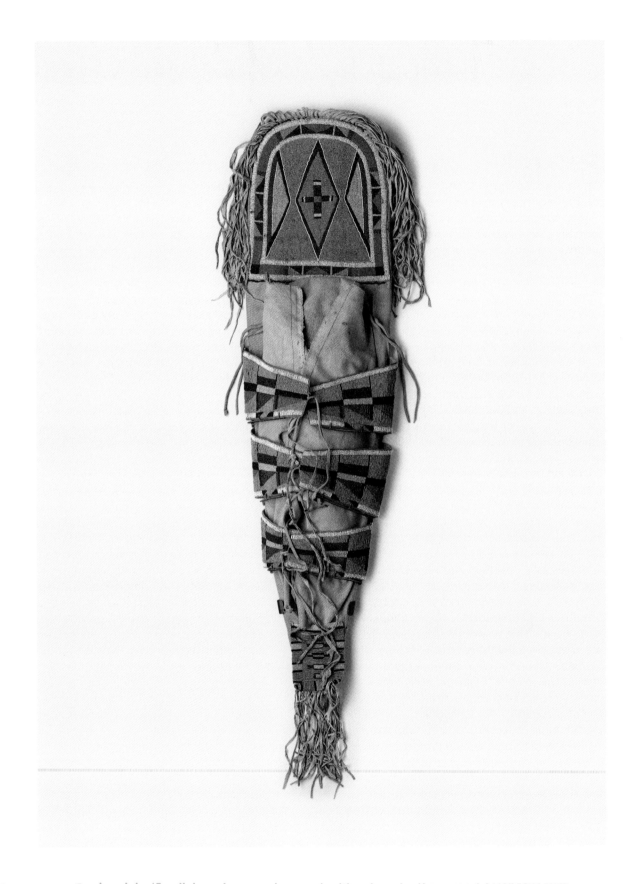

Baakaatiche/Cradleboard, year unknown, textile, glass, leather, wood, Field Museum

the crow federated women's club

janine pease

Minnie Reed Williams, Katie Stewart, Cordelia Big Man, and several other Crow women organized the Crow Federated Women's Club in 1931. The General Federation of Women's Clubs (GFW) was a national women's organization, part of the nation's Progressive Movement. During the 1930s the GFW had 850,000 members. The club received a national charter from Congress in 1901 with the motto "unity in diversity" and a mission to be municipal housekeepers, to clean up politics and cities, and to improve the health and well-being of their neighbors. The club emphasized "maternal expertise" to lobby and investigate community needs. The GFW had a Division of Indian Welfare and an alliance with the American Indian Defense Association.

The Crow Federated Women's Club was registered with the GFW in 1932. The club's preamble stated its focus: "To enlighten the public toward a better understanding of the Crow Indians; to preserve our cultural values; to endeavor fair adjustment of our tribal affairs; to obtain and preserve our rights under the Crow Indian treaties with the United States; to also promote our common welfare."

The Crow Federated Women's Club went to the tribal council for recognition and approval. Tribal council leader Deernose supported the club's formation. Right away, the club sought justice for two Crow Indian boys who had been beaten by Crow Agency public school teachers, following a two-week absence. (The boys' family had taken them to their grandmother's burial in the Bighorn Mountains, which took two weeks.) Club president Minnie Reed Williams wired the Montana education office and the Bureau of Indian Affairs (BIA) superintendent about the school's harsh and unwarranted discipline of the boys. The club invited all school parents to a meeting. A Billings radio station reported that the Yellowstone County Federated Women's Club came to Hardin to ally on this school discipline issue. Because of the crisis, the teachers were fired, and

the first Crow Agency Parent Teacher Association was formed.

Health conditions among the Crow people worsened with the rising incidence of tuberculosis. The BIA field matrons in the Crow districts routinely visited rural Indian families to administer treatments to Crow who suffered ailments. Club members accompanied the field matrons on these home visits. The club took up other issues related to disease and health, including maternal and children's health, childbirth, whooping cough, measles, and infections. They recognized poor water quality as a contributing factor to poor health; many land allotments were without water, and filthy conditions led to sores. Club members and the BIA field matron held weekly meetings to teach personal hygiene. They requested sessions on nutrition, home economics skills, women's health, farming, and husbandry, and they documented the need for Indian nurses.

The BIA jail became a focus of the club's efforts, prompted by several murder cases. When Indian alcoholics were arrested, they were held in a jail without an outhouse. Crow women met to discuss the unsanitary jail conditions, and advocated for improved communication and justice for the Crow people. As a result, the BIA added a Crow deputy to address the jailed addicts and the jail conditions. In a related effort, the club took up a concern for rising juvenile delinquency. Big Man and Reed Williams requested that efficient police women patrol the alleys.

The conditions of drought brought attention to the need to build dams for irrigation. When the Bighorn River came under consideration for a dam project, Reed Williams viewed proponents of the dam project as seducing the people with promises of fish and game resources and access, expanded hunting, electricity, and water for crops and livestock. The Crow Federated Women's Club raised funds and sent Big Man and Reed Williams to Washington, DC, as delegates to express the views

of the women pertaining to the proposed dam.

In 1951, the first statewide Conference on Indians convened, and Reed Williams attended the meeting. The club also wrote to the Office of Indian Affairs, the National Congress of American Indians, and the American Association of Indian Affairs, and petitioned the commissioner of Indian Affairs to remove a physician who was the subject of many Crow women's health complaints. The club's correspondence shows its members' active participation in many tribal political discussions as well, the majority of which addressed the need for improved health conditions on the Crow Reservation.

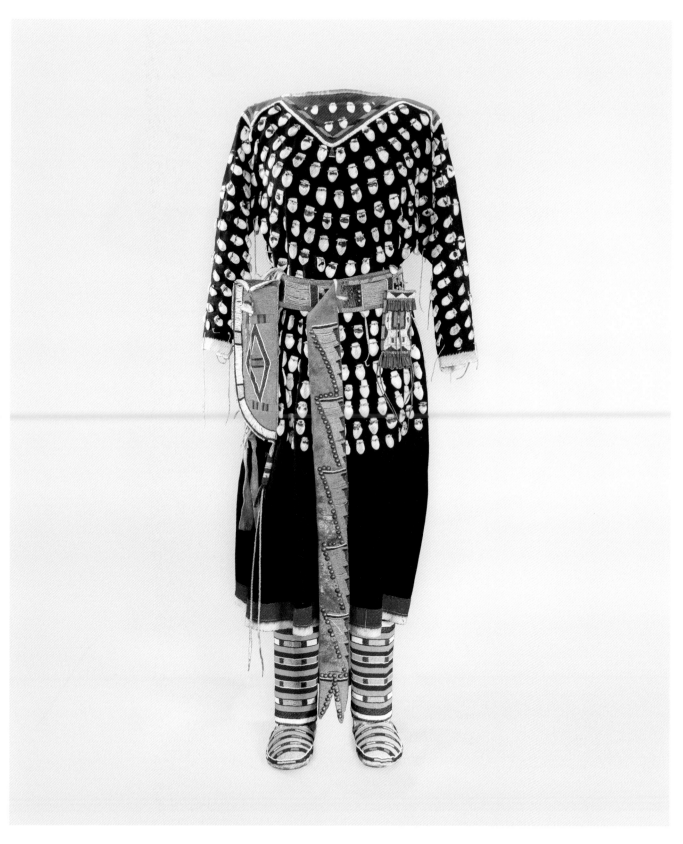

Iichiilihtawaleiitaashtee/Elk tooth dress, 1880s–90s, elk teeth, carved bone, wool trade cloth, glass beads, Collection of Don and Liza Siegel

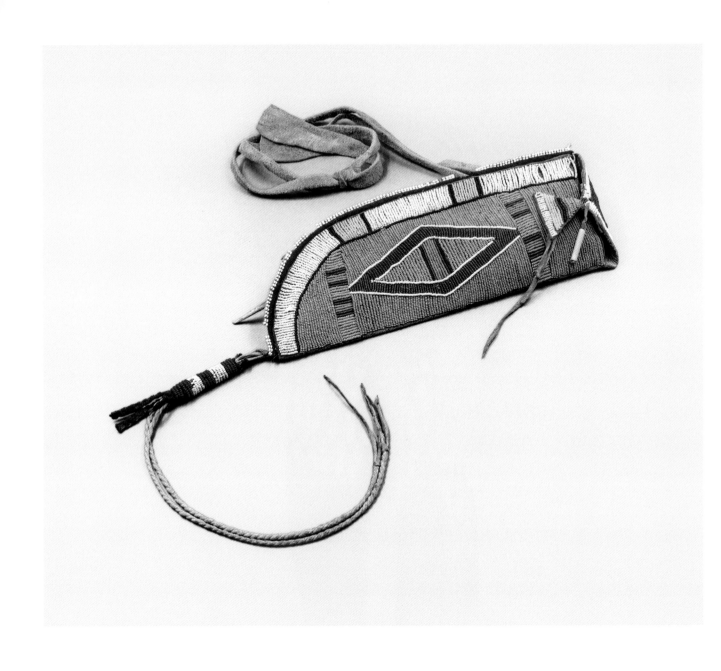

Biitchiiaisshe/Knife case, ca. 1870, buffalo hide, trade cloth, beads, sinew, Collection of Don and Liza Siegel

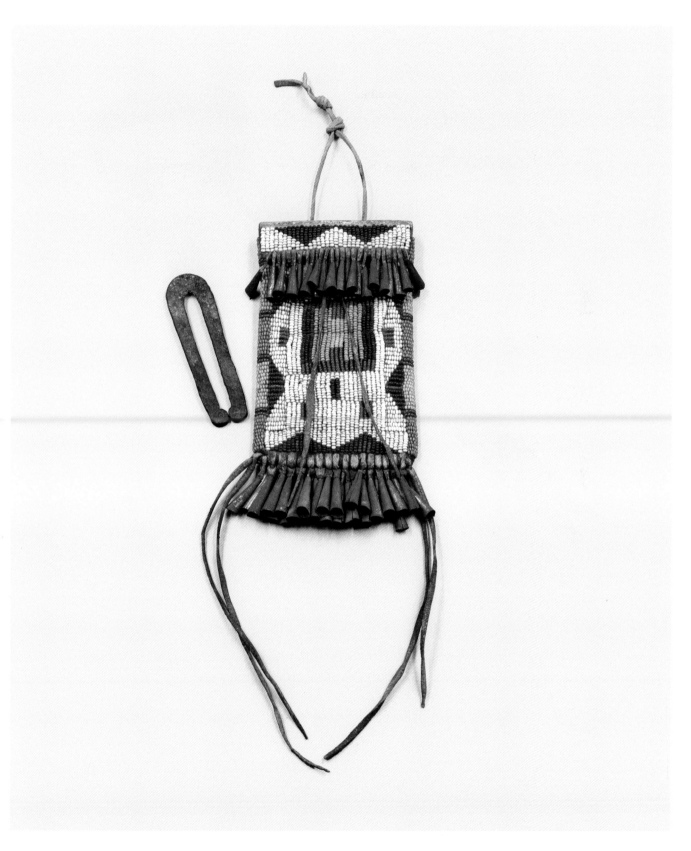

Bilaakshe alaxxiia/Strike-a-light bag and striker, ca. 1885, hide, beads, tin cones, sinew, fringe, metal striker, Collection of Don and Liza Siegel

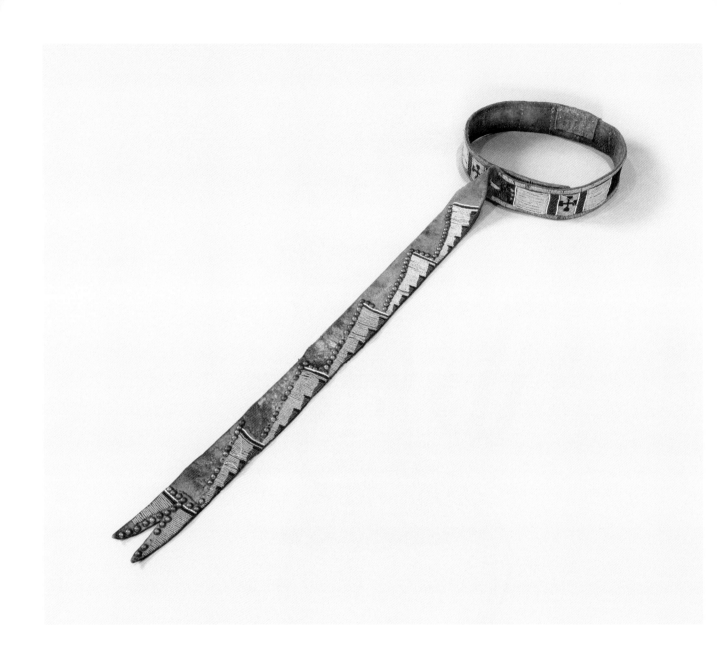

Baleiipahpaatbaaloo/Beaded belt, 1860s–70s, buffalo hide, beads, sinew, brass tacks, Collection of Don and Liza Siegel

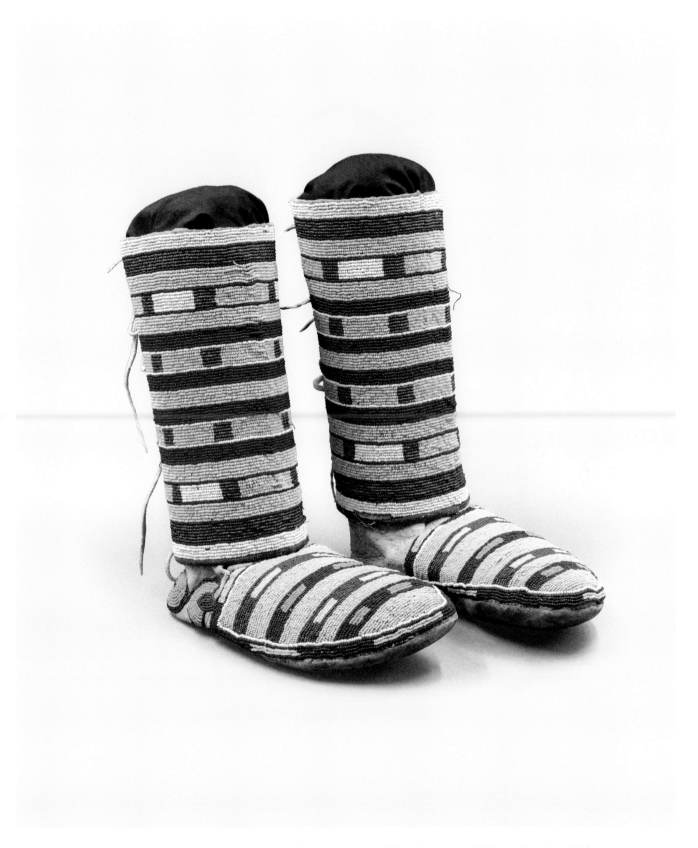

Huupkootaawaaluu o baleichkisshbaloo/Moccasins and leggings, ca. 1885, trade cloth, hide, beads, Collection of Don and Liza Siegel

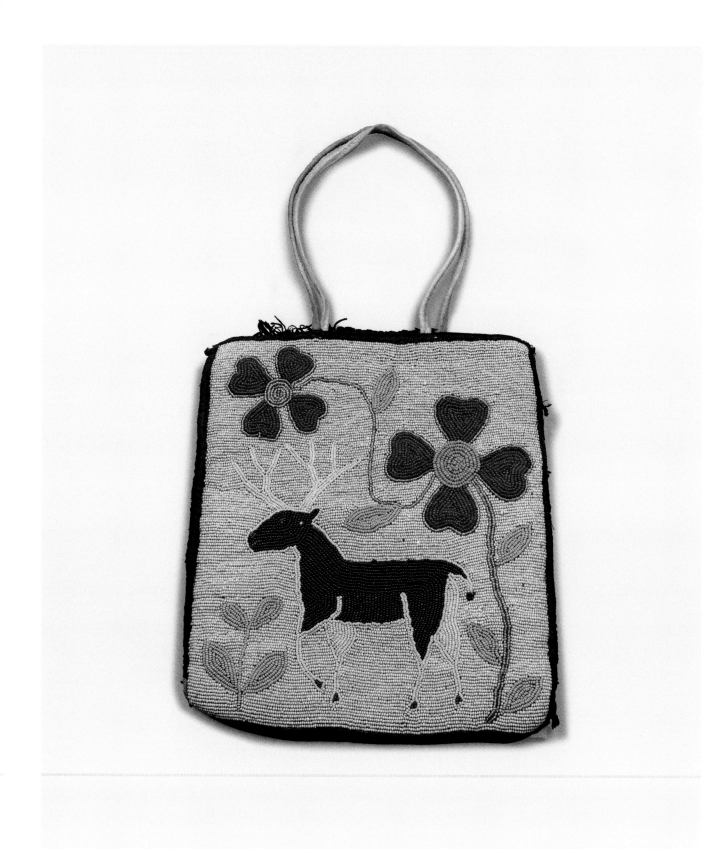

Baaísshe/Plateau bag, ca. 1885, beads, hide, sinew, Collection of Don and Liza Siegel

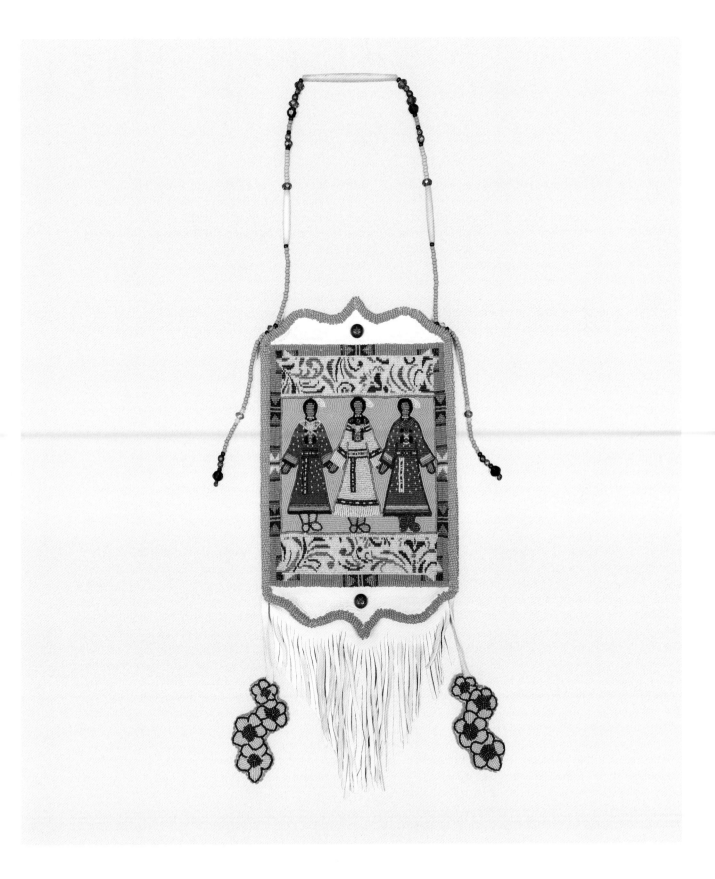

Karis Jackson, *Let's Round Dance,* **2016**

ishbinnaacheiitchiish

jamine pease

Ishbinnaacheiitchiish/Pretty Shield was a member of the Sore Lip Clan of the Crow. She lived in the time of greatest transition for the Crow, the period of 1850 to 1930. Montana historian Frank Linderman interviewed Pretty Shield in 1910 through a translator and using the Plains Indian sign language. Her narrative tells of her girlhood and experience as a young adult.

Pretty Shield had received the medicine guidance of the red ants. During her young adulthood she was informed by the ants of an enemy war party approaching her band. She relayed this message to the band chief, who sent scouts out in the direction the ants had foretold, and they discovered a Lakota war party in the vicinity. As an elder and grandmother, *kaale*, raising grandchildren in Crow Agency, Pretty Shield saved dried bread (or pilot bread), ground it up, and had the children spread it on the ground outside their house for the ants, her Helpers. She named her grandniece "Stands with the Ants."

Her granddaughter remembered that on Mondays in the summer, Pretty Shield's household would head out to wash clothes at the river. Pretty Shield carried the laundry in a big bundle on her back. She waded into the Little Bighorn River, sat there with a washboard while the grandchildren took the pants and shirts in the laundry, and weighted them down with river rocks to soak in the river's flow. One by one, they brought the items to her to scrub and clean; then they took the clean shirts or pants to hang on the bank willows to dry. Meanwhile, the children would swim and play in the river. At day's end, they would gather all the clean, dry clothes and head home.

The Crow Agency gathered lease payments from Pretty Shield's land and land she inherited, then issued her a monthly purchase order, which she used at the trading post. She would buy flour, oats for the horses, and Heart of Makawa Cereal (made at the flour mill in Crow Agency). Once a year each family member got a pair of leather shoes (but wore moccasins, too). Sometimes Pretty Shield treated her grandchildren to an apple or an orange to eat on the way home. They also got rations at the Agency office, as this was a time of no game to hunt. They raised squash in the garden and then had squash for nearly every meal. Sometimes her brothers shot pheasants to feed the family.

The house was full of grandchildren, without parents, because many had contracted tuberculosis and passed away. Pretty Shield raised twelve grandchildren. Three beds covered the entire floor of their small board house. On the floor, Pretty Shield had her bed of buffalo robes. Six of the grandkids slept with her. The other two beds accommodated the rest of the family.

In season, they picked berries, one crop at a time, as they ripened. She pounded the berries into a pulp (seeds and skins), pressed the pulp into patties, and dried them in the hot sun. Once they were dry, she stored them away for the winter in a parfleche (rawhide trunk). She removed the pits from wild plums, then prepared and dried the cakes. Pretty Shield sliced meat into thin slices and dried it over lodge poles in the yard. The grandchildren turned the meat over during the day, and guarded it from thieving magpies, dogs, and young boys. They brought the dry meat in at night. Once the meat was dried, Pretty Shield stored it away in a parfleche trunk.

Pretty Shield had her grandchildren "feed the water." She dressed in her best and wore earrings. Together they went to the river, and took meat and potatoes to the water beings. She put the food into the water and told the water not to bother her children. This was due to the huge turtles that lived in the river. She made a red clay bracelet painted on each of her grandchildren as they completed this ceremony.

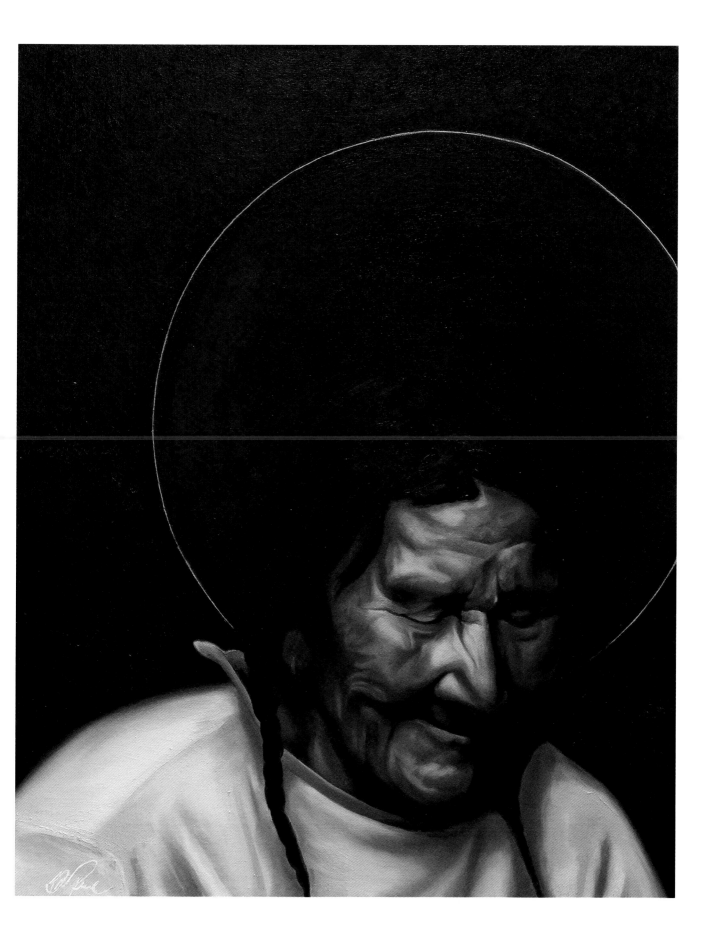

ben pease

Ben Pease, *The Prayer: Grandma Amy Yellowtail-White Man Runs Him*, 2019

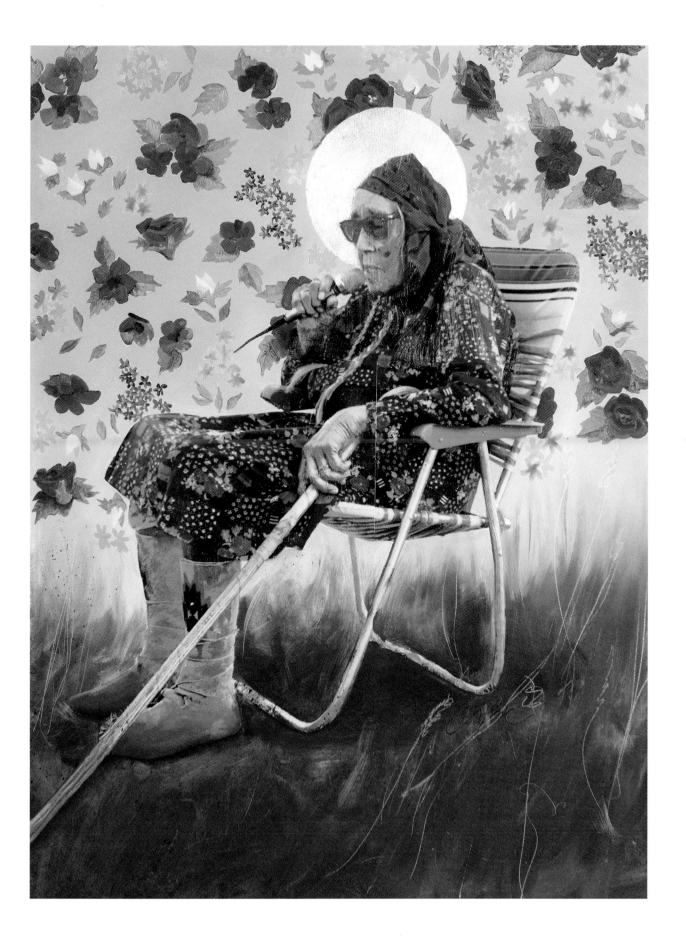

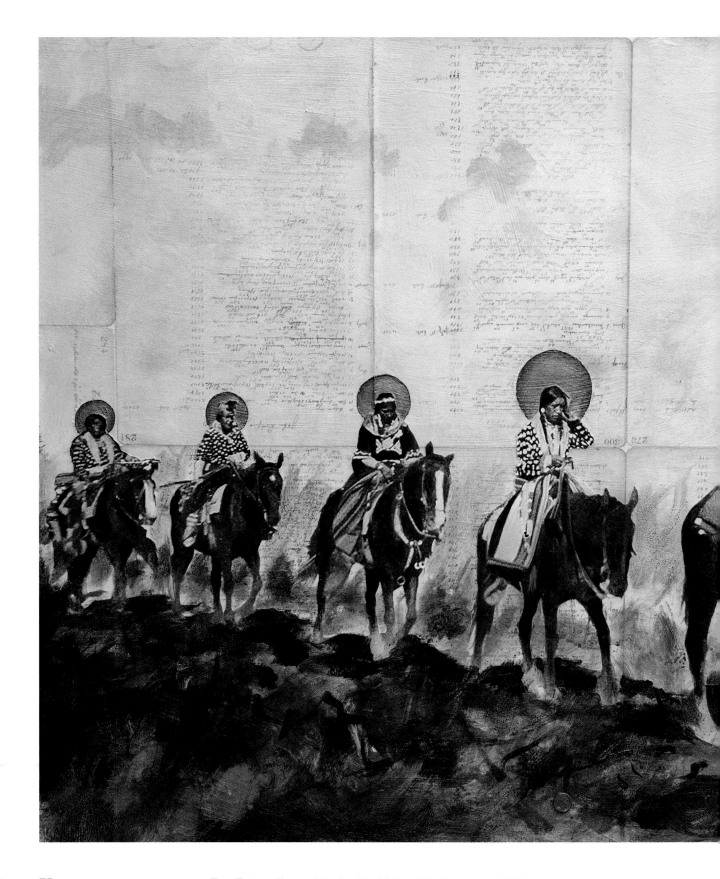

Ben Pease, *Sacred Under the Cliffs of Yellowstone*, 2017

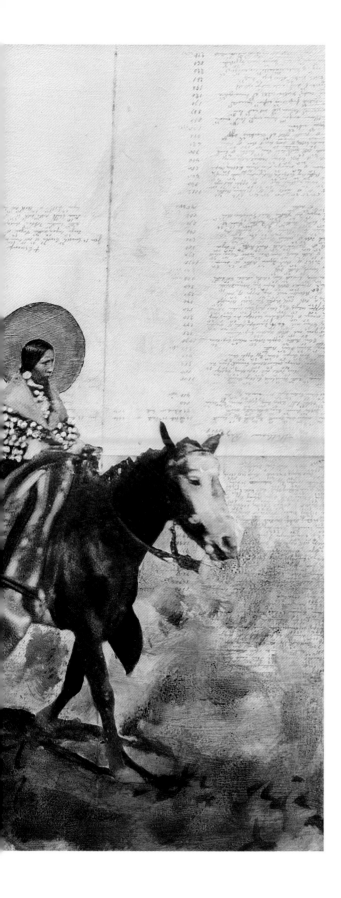

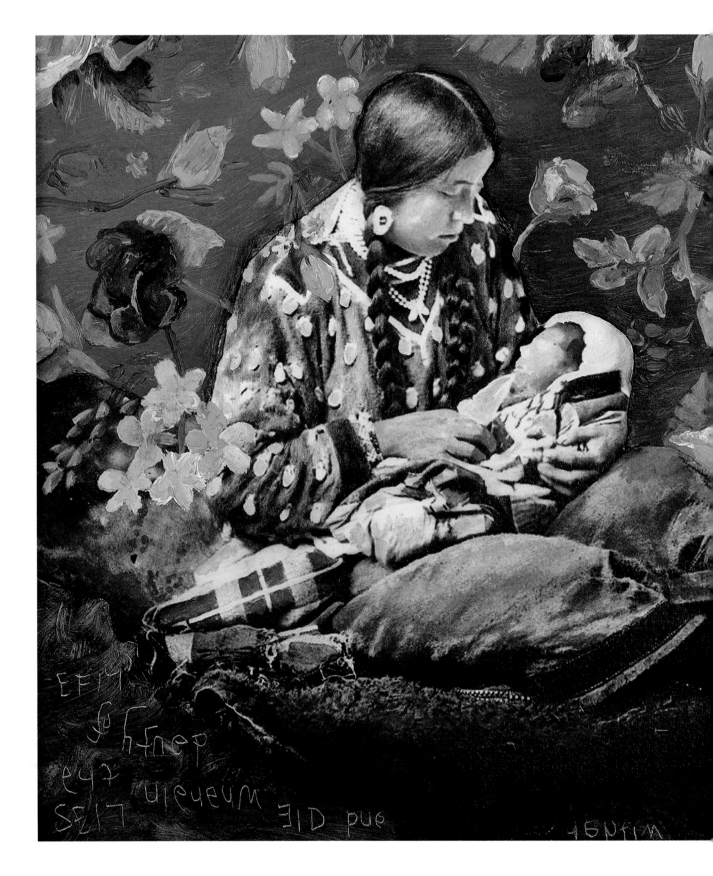

Ben Pease, *Wherein Lies the Beauty of Life*, 2019

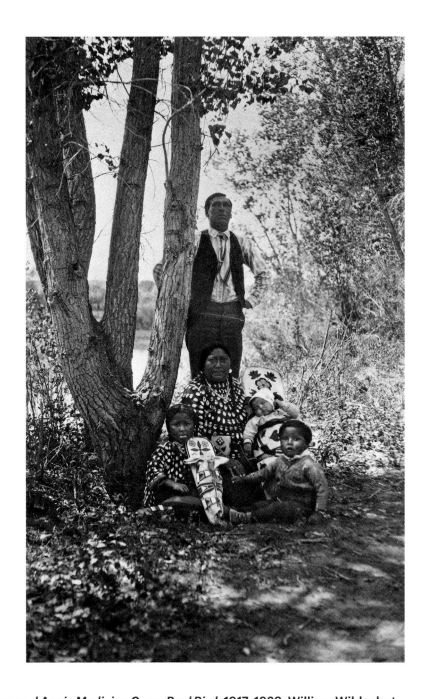

Frank Bethune and Annie Medicine Crow-Real Bird, 1917–1928, William Wildschut

My great-great grandmother Annie Medicine Crow-Real Bird was said to be an extremely kind and loving woman. Annie was the only daughter of Chief Medicine Crow and was said to be always at her father's side. In our family it has been said that Medicine Crow was a very kind man and was always surrounded by children because of his kind and cheerful nature, and that Annie was just like her father. Annie raised many of her grandchildren; she adored them and made all of them beaded floral cradleboards, clothes, and toys. We no longer have these cradleboards in our family, so I continue to search.

— Nina Sanders

mary hudetz

My mother began beading an Apsáalooke parade set, the kind that fully adorns a woman's horse, in the fall of 2005. For months, I watched her work, starting with the martingale—the bright, bold collar that drapes over the front of the horse.

Sometimes I sat with her while home from graduate school, following her directions and pattern to stitch yellow, iris, and blue cut beads to red cloth. But mostly I watched because, despite my lineage, I'm not a skilled beadwork artist. She created saddlebags, a lance case, trim for the saddle, and, among the most intricate of ornaments, a keyhole-shaped headpiece that ties to the horse's bridle.

It is moving to watch hundreds of Apsáalooke parade at Crow Fair and consider the hours the artists, who so very often are mothers, have spent on the beadwork. The year my mother completed her pieces, I told her I wanted to ride to show the work I hardly helped create. She smiled, saying all along it had been for me. "You for me and me for you," she said. Her words came in a moment so fleeting she says she has forgotten it. Yet I still think of them, a reminder of our bond and values.

Our mothers' art often represents an expression of their love. It's also emblematic of our culture, which is rooted, in large part, in a matrilineal kinship system. The bonds of grandmothers, mothers, and daughters are seeds.

Lineage is handed down through the mother, which means I was born into my mother's clan, the Whistling Water, and my heritage is traced through her to her mother and her grandmother's grandmother too. So many relationships flourish from this matrilineal line, including those I share with my mother's sisters and their children.

Whereas in English they would be my aunts and cousins, in Apsáalooke they are defined as mothers, sisters, and brothers. And because my grandparents had seven daughters, there are many of us. This is significant for me—half-white and Apsáalooke, and an only child of my parents. In a world where I might otherwise feel alone, I have many sisters and brothers who are there for me as I am for them.

"We have a lot of love," an older sister recently said to me. We had taken seats next to her tipi on an August evening during Crow Fair when she reflected for a moment. Nearby, our mothers visited after finishing dinner, and our youngest sister tended to her small children.

In my family's bonds, I find language's impact. I share a closeness with the women in my family that falls closer to what's expressed in the words "mother," as opposed to "aunt," and "sister," versus "cousin." My mothers' brothers, meanwhile, are my brothers, and my mothers' sons are my brothers too, showing me often what it means to be decent and good.

These relationships all are reflected in how our broader clan system is structured, with exponentially more Crows, in addition to those who are our close relatives, becoming our kin.

The clans today include Whistling Water, Big Lodge, Ties the Bundle, Greasy Mouth, and Piegan. Each has clan mothers, fathers, and children who give, pray, and rely on one another.

*

In college, I began to truly appreciate the value of our tribe's matrilineal culture, and how it guides the way we relate to one another. At my school, Fordham University in New York, I heard of East Coast friends' great aunts, second cousins, and first cousins once removed. I was both confused and amused. The terms suggest a system in which relations are inherently kept at a distance— "removed." Crows seek to pull all kin close.

A century ago, US agents enforced policies that sought to corrode Native cultures, pushing to end long-held practices and sending children, taken from their families, to boarding schools. But the Apsáalooke clan system appeared

unbreakable, along with its vast matrilineal family bonds. Culture carries an inherent staying power when the relationships of mothers, daughters, and sisters hold a central place.

In *Parading Through History*, Frederick E. Hoxie wrote of how our ancestors sustained the clans—and perhaps, in my view, were also sustained by them—as they adjusted to life in newly established communities across our reservation. "What government agents saw as settled farming communities were actually re-creations of Crow Band settlements," Hoxie wrote. "Nothing in the otherwise alien reservation environment disrupted the clan system."

When he was in school, Joseph Medicine Crow wrote in his master's thesis that our kinship system—"so affectionate, so real and embracing"—restored tribal values in children after they returned home from boarding schools. It was 1939, and he was a student at the University of Southern California, the first in our tribe to attain a master's degree.

He lived for nearly eight more decades, reaching the age of 102. In his final years, he explained to me why he believed he had been able to live so long, saying in an interview that he had adopted what good existed in the white people's world and rejected the bad. He had done the same with our own ways, clearly embracing Apsáalooke clans and kinship.

For Mardell Plainfeather, a Big Lodge woman who has worked in historical preservation, the clan system today offers a supportive framework for seeking guidance and prayers, just as it does for others. Her clan is also a source of identity, with its very name inspired by strong, hard workers, she said. The women kept large, beautiful lodges. No easy feat. As a Big Lodge woman, Mardell, now a widow, said she felt dedicated to being a good wife in her marriage, a part of which meant keeping a good home. "There's no rhyme or reason," she said. "I'm just a part of it, so I try to live up to it."

*

In our ancestors' stories—which are our stories too, though we don't always hear them or we forget—the clans came to be at a divisive time. There was gossip among women and disrespect within the tribe, leaving Old Man Coyote, who is at the heart of our moral stories, troubled.

At the river, he wondered how to restore civility, until he saw the currents carrying driftwood. Some pieces clung together, perhaps like tipis or lodges, as more floated along to join.

I had asked Mardell to retell me this story as I began the work of trying to express what our matrilineal kinship system means to me. She recalled how Joseph Medicine Crow—a Whistling Water man, World War II veteran, and longtime tribal historian—had told it.

In the driftwood's downstream journey, he said, Old Man Coyote found his answer. Apsáalooke would be like the Driftwood Lodges. At birth, we would join our mother's clan, where there would be women to confide in and take care of one another as sisters. In our father's clan, we would have more fathers and mothers—or uncles and aunts—who would pray and boast for us, and offer advice.

It's possible the river carrying the driftwood is life, Mardell offered.

*

In my life, I have learned to cling to my mother, her sisters, and my sisters when struggles mount. My parents, following a common Crow practice, have invited my clan aunts and uncles for dinner to offer advice and prayers at different turning points—when I went to college, prepared for a new school year, or started a new job. My work and schooling have kept me from living at home in Crow Country for more than half a year at a time since I was a teenager. Yet I know the matrilineal system remains strong enough to support me from afar.

Some worry that too few youth know their clan. It's a valid concern, but there are also signs that the matrilineal system that has carried us this far remains far from fading. Grade schools on the reservation and Little Big Horn College hold "clan days" that underscore these relationships, and children—even if they do not know their clan—know they are part of extensive yet tight-knit family networks. I witnessed this several years ago when a young relative disclosed that she did not know her clan. Yet she knew from her day-to-day life that the granddaughters of her grandmother's sisters were her sisters too. These relationships are upheld by our deep and broad kinship system, and knowing this now means she knows her clan.

When I think of all my mother has given me, I think of her art and her time, as well as the moments with our clan aunts and uncles that she facilitated and that have strengthened me.

It's heartwarming to realize I have always known this truth, and to see mothers in my generation bestow the same moments and gifts on their children. Our kinship ties and clans can still carry us.

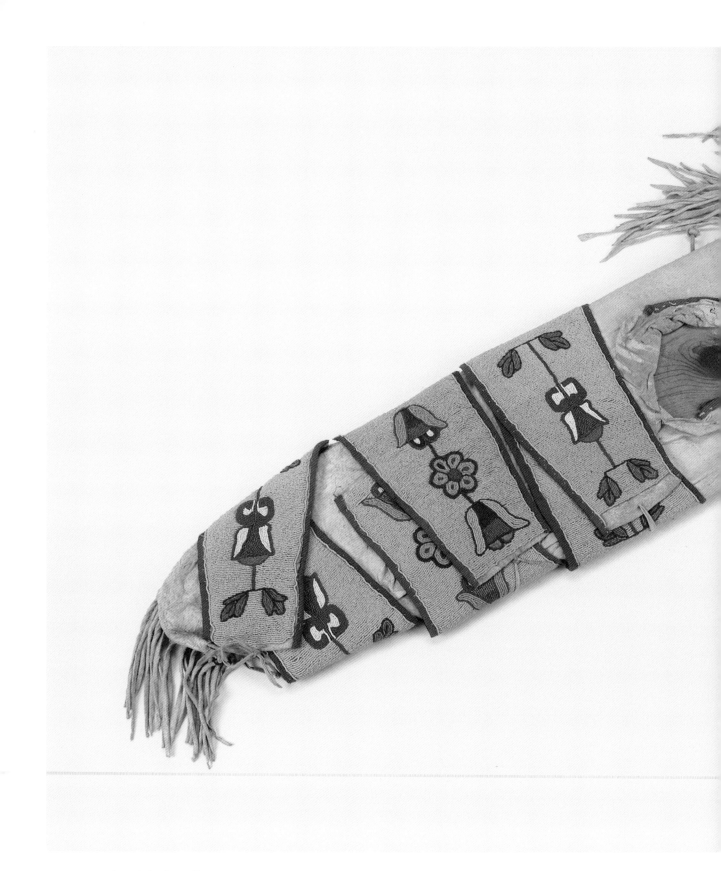

Baakaatiche/Cradleboard with floral designs, ca. 1880, deer hide, canvas, glass beads, cotton thread, National Museum of the American Indian

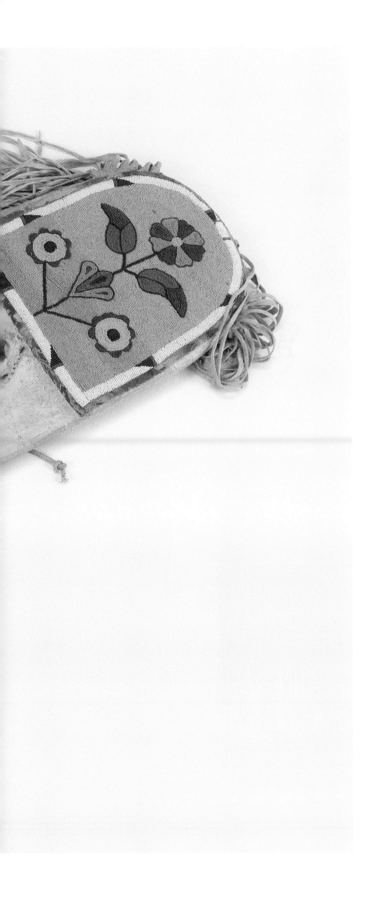

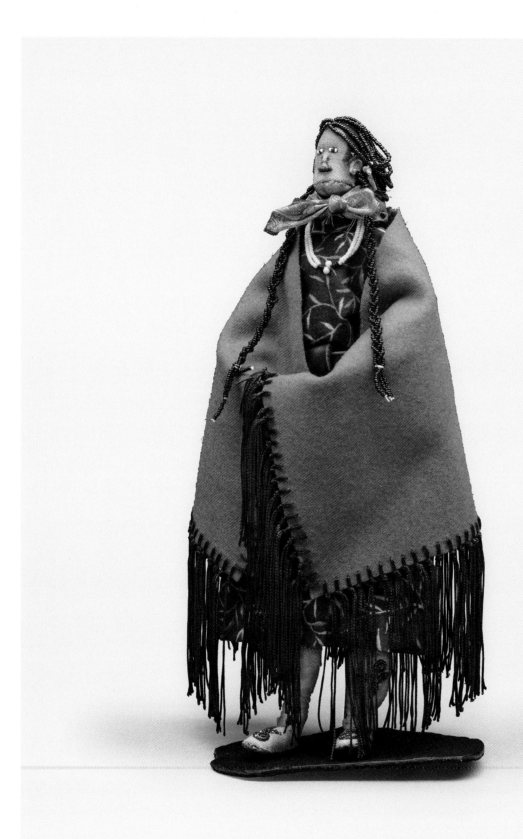

Birdie Real Bird, doll, 2019, buckskin, buffalo hair and cotton stuffing, beads, cotton, elk hide,

Field Museum

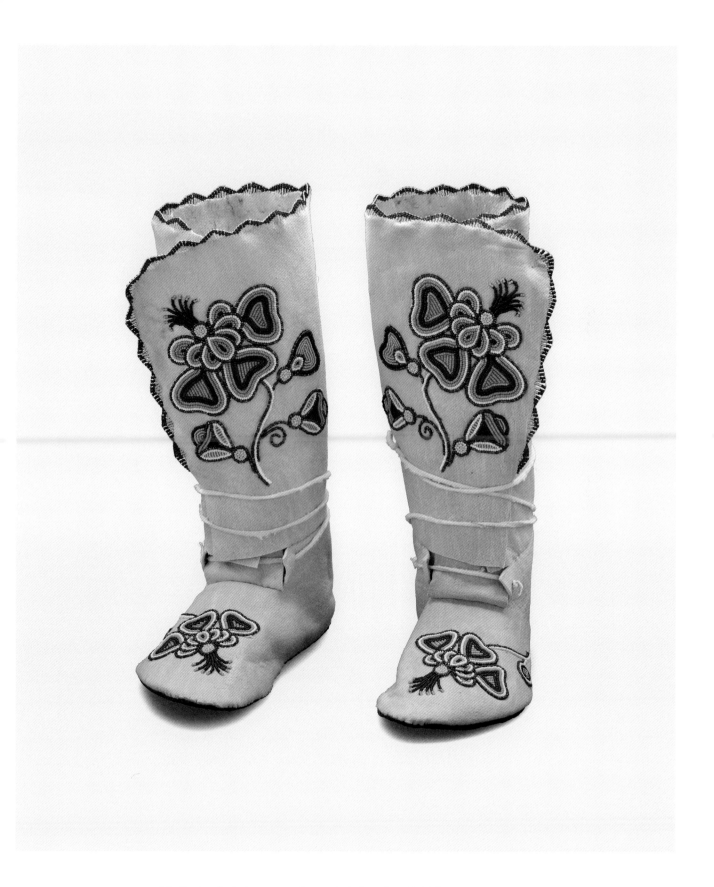

Birdie Real Bird, moccasins, 2019, beads, elk hide, Field Museum

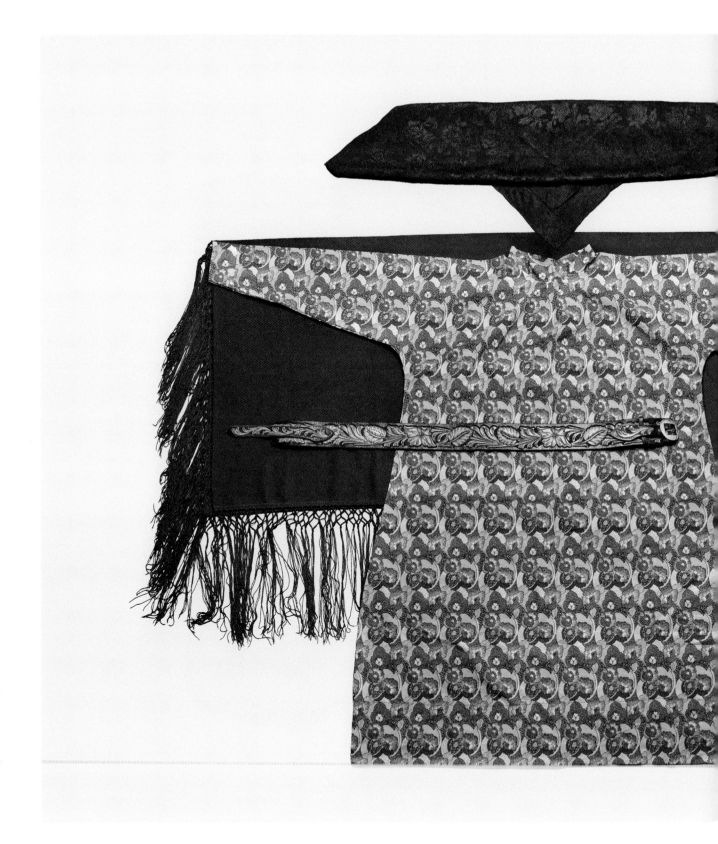

Birdie Real Bird, dress and accessories, 2019, Field Museum. Dress: calico cotton made out of replicated fabric from the 1930s. Scarf: silk. Earrings: shell. Necklace: Elk tooth with braided buckskin chain. Belt: leather with floral pattern.

the women who carry this wisdom

Luella N. Brien

The things that I've learned from the world are valuable in that they have given me professional skills to perform in a modern workplace. I have a working knowledge of computers and networks. I can write news stories and course-learning outcomes. I can produce reports for donors that have so much heart and human connection you would give your right arm to help.

But from the world I didn't learn compassion. I didn't learn faith. I didn't learn who I truly am. I learned all of those things from the women in my family. This transmission of vital information did not take place through emotional but pleasant heart-to-heart conversations like they did on the television sitcoms I loved so much growing up.

No, we lived in the Wild West of the Crow Reservation in the 1980s and '90s, where our lessons were learned by the example set forth by our matriarchs. We learned those lessons the same way Apsáalooke girls over the generations have learned to navigate the world.

Our matriarchs grew up in a time of great transformation. For the better part of the nineteenth and early twentieth centuries the Indian Wars and the forced removal of Native peoples were in full effect, but those experiments failed to solve this country's "Indian problem." New practices were put in place.

The late nineteenth century was a time when the identities of indigenous peoples across this country were being stripped away. American policy and practice boiled down to the removal of culture. The removal of the very thing that gave purpose in this world nearly broke us as a people. The boarding school era worked to tear down the psyche of our people through forced assimilation by any means necessary, up to and including physical and sexual abuse.

My great-great-great grandmother Pretty Shield was an old woman raising her grandchildren during this time period. She kept them with her as long as possible, going so far as to have them pretend to be ill if government agents came snooping around asking questions about why the kids weren't in school. My grandmother was one of those kids.

The relocation era of the 1950s and '60s was designed to separate extended families. Large family structures are one of the hallmarks of indigenous societies. These relocation policies cut families' ties to their reservation by moving thousands of people to larger metropolitan areas; many never returned.

My own grandparents lived in Los Angeles and in Denver, where they chased the promise of education and job training. In the 1970s, my grandmother Beverly returned to school at what was then known as Eastern Montana College, in Billings, Montana. She graduated with high honors in three years while caring for her husband, my grandfather, who was recovering from a heart attack. She also had adopted a young granddaughter who was finishing preschool and had a daughter, my mother, who was completing her senior year of high school.

The indomitable spirit she possessed was something she saw in her own grandmother. It was something she passed down to my mother, Lorrie.

When I was growing up, my mother worked hard at several jobs around the Crow Reservation, and she took us along for the ride many times. There was no nanny for us. We were going to learn to do the job and do it right.

I remember we marched down to the post office with her and I mopped that damn floor as she filled the mailboxes. When she opened a home-based bakery I was right there color-mixing icing to match bridesmaids' shoes.

It was not uncommon for young girls to emulate their mothers' behaviors and values. The values and lessons I've acquired from my mother and grandmother are so special to me because they helped define my moral fiber, my values, and my priorities.

But with that valuable information and connection there comes loss. My grandmother freely shares stories about her girlhood with her grandmother, Pretty Shield, even though it makes her remember all the people she has lost since then. I can see the sadness wash over her face when she tells these stories. It's another lesson for me. Sometimes sharing our knowledge hurts, but we must do it.

When I was eighteen years old, my mother shared her most painful experience and the lessons she learned about the world through the lens of our culture. Her best friend was murdered. Her name was Beverly Diane, and she was sixteen years old. Today we call it the Missing and Murdered Indigenous Women's Crisis. In 1977, there was no name for it. There were no marches or rallies for justice.

The murder of Beverly Diane was never solved. In fact, it wasn't even classified as a murder. It was just another case of a dead Indian. We were and are still considered disposable, if we are ever considered at all. Beverly Diane and my mother were always together. She was called Deedee by everyone who knew her, and she was also my father's younger sister. With her death there came outrage, shame, and a long silence. It took twenty-two years for my mother to share her story, but she had to do it.

These lessons are hard. It hurts. The wisdom of an indigenous woman is not something to share freely with just anyone, but it must be passed down to our daughters. Regardless of the pain we feel sharing some of the hard lessons and sad histories, the future of the Apsáalooke people is in the hands of the women who carry this wisdom. This wisdom women carry is sacred. As Apsáalooke women, it is our responsibility to carry that knowledge and protect it. We are charged with the duty and the right to keep it safe. This is how we preserve and protect our culture and identity as a society. The burden may be heavy to bear, but the rewards will be felt far in the future.

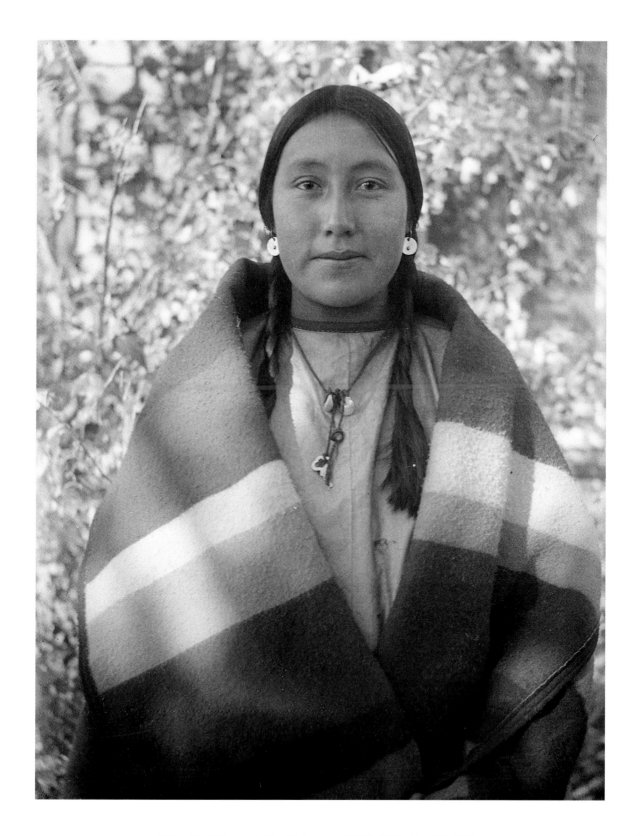

Otter that Stays at the Water, ca. 1898–1910, Fred E. Miller

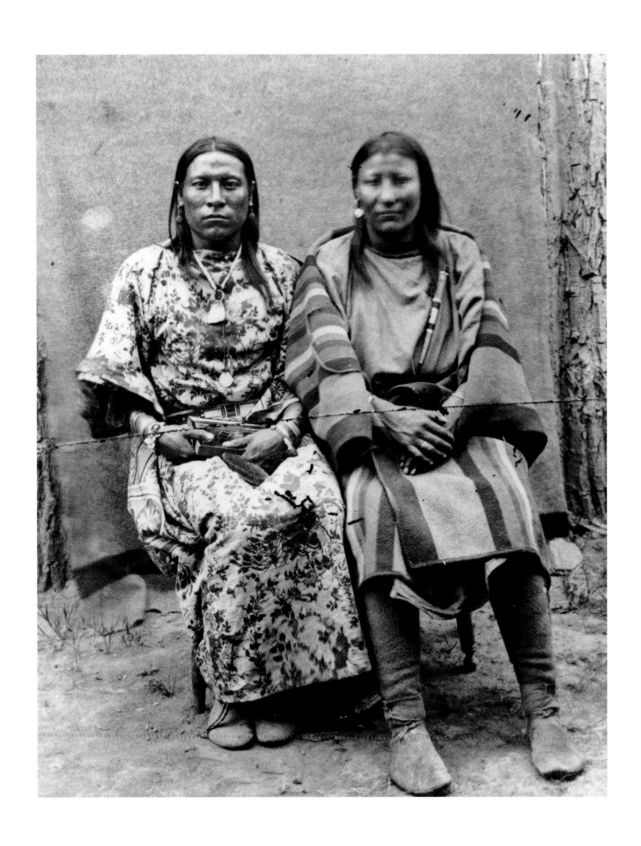

Finds Them and Kills Them [left] *with The Other Magpie, ca. 1877*

recognizing and reclaiming batée

rusty lafrance &
katherine nova mccleary

In the 1920s, Ohchiish/Finds Them and Kills Them described a lodge of outstanding size, made of at least twenty-five buffalo hides, that they had tanned and constructed for Apsáalooke leader Iron Bull. Iron Bull had seen this lodge in a vision and entrusted Ohchiish to bring it to life. Ohchiish made at least one other lodge of this size during their lifetime and many beautiful garments.[1] In addition to being a renowned artist and warrior, Ohchiish also identified as batée.[2]

Within Apsáalooke society, there are three understandings of gender: biia, batée, and bachee. In the Apsáalooke language there are no third-person pronouns; rather, the absence of a pronoun signifies the third person. In specific instances "iis" is used as a nongendered third-person pronoun. Within a US settler context, "biia" is understood to be and translated as "woman," and "bachee" as "man."

Batée, most often understood as an individual who embodies aspects of biia and bachee, serves unique roles in Apsáalooke life. Ohchiish described being batée by saying they always knew that was their path.[3] Today, batée are sometimes referred to as two-spirit or transgender or gender nonconforming individuals in English.

Oral histories show the respected position batée have within Apsáalooke society and culture. Historically, batée would be called upon to secure and cut down a tree for the center pole of the Sun Dance lodge. In addition to unique ceremonial roles, batée also often filled both biia and bachee societal roles. During the summer of 1876, ten days before the Battle of the Little Bighorn, Apsáalooke warriors fought alongside the US Cavalry in the Battle of the Rosebud. According to Apsáalooke healer and midwife Pretty Shield, this battle was "won by two women, yet one was not a woman, but she was not yet a man."[4] The individual Pretty Shield speaks of is Ohchiish. The battle took place in the present-day Kirby, Montana, area, with Ohchiish and an Apsáalooke woman named The Other Magpie riding alongside male warriors. Pretty Shield feared for the well-being of Ohchiish and The Other Magpie but expressed immense pride at their bravery, as both of them came home with several war honors.[5]

Beginning in the late nineteenth century, the US government and settlers began to alienate and inflict violence on Apsáalooke for not adhering to settler gender norms. As part of the Fort Laramie Treaty of 1868, the Apsáalooke agreed to remain within specified boundaries of their territory, which later became the Crow Reservation. The US government relied on a Bureau of Indian Affairs (BIA) agent to supervise Apsáalooke containment on the reservation and assimilation to settler society.[6] With a stifled economy and little access to natural resources, Apsáalooke were forced to rely on the agent for food, supplies, and passes to leave the reservation.

During this time of great surveillance, settler medical professionals, teachers, scholars, religious leaders, and BIA agents targeted Apsáalooke for expressing their gender and sexuality in ways that transgressed Christian settler norms. In 1889, the BIA-employed doctor A. B. Holder examined Ohchiish, saying, "Of all the many varieties of sexual perversion this, it seems to me, is the most debased that could be conceived of."[7] Anthropologist Robert H. Lowie used similar language, describing batée as "pathological," "psychiatric cases," "abnormal," and "anomalies."[8] Throughout the late nineteenth and early twentieth centuries, Apsáalooke grappled with these newly imposed gender norms and often resisted them. Between 1888 and 1889, BIA agent E. P. Briskow imprisoned batée, including Ohchiish, and forced them to change their clothes and cut their hair. In addition to altering their appearance, Briskow required the imprisoned batée to perform manual labor such as digging ditches and planting trees.[9] After word spread of this incident, the principal leader at the time, Pretty Eagle, threatened Briskow at gunpoint, demanding that the batée

be released and allowed to live as they wished. Between 1914 and 1917, a new BIA agent, E. J. Estep, brought Ohchiish to the agency again and forced them to dress in settler men's clothes. Apsáalooke elder Lillian Bullshows Hogan explains that people were shocked to hear of this incident. Shortly after Ohchiish's imprisonment, principal leader Plenty Coups confronted Estep in his office and threatened to speak with the commissioner of Indian affairs, who headed the BIA, if Estep continued to disrespect Ohchiish. Plenty Coups told Estep that he could have him replaced in only two hours if he did not release Ohchiish immediately. In both instances, BIA agents immediately complied with the principal leaders' demands.[10]

Perhaps because of Pretty Eagle and Plenty Coups' defense of *batée*, the Apsáalooke became known as a community that resisted settler gender norms. Scholar Will Roscoe describes a Hidatsa individual fleeing to live with Apsáalooke after a BIA agent cut their braids and forced them to wear men's clothing. He writes, "The Crows continued to view these individuals as integral, even necessary members of their society. It was a chief's duty to protect them."[11] Over time, however, settler colonial control and surveillance of Apsáalooke weakened community support and space for multiple understandings of gender.

In the 1980s, anthropologist Walter Lee Williams interviewed Apsáalooke Sun Dance leader Thomas Yellowtail, who described Ohchiish as the last known person to identify as *batée* and attributed their disappearance to the public shaming of Ohchiish by Baptist missionary William A. Petzoldt. Yellowtail said, "When the Baptist missionary Petzoldt arrived in 1903, he condemned our traditions, including the bade. He told congregation members to stay away from Osh-Tisch and the other bades [and] continued to condemn Osh-Tisch until his death....That may be the reason why no others took up the bade role after Osh-Tisch died."[12]

Although Yellowtail identifies Ohchiish as the last *batée*, individuals continue to claim this identity despite the heterosexism and gender oppression that has become normalized in the community. Apsáalooke two-spirit and queer youth of today experience discrimination and often lack broader community support and understanding.

Knowing and sharing the stories of Ohchiish and other *batée* is one step toward recognizing and reclaiming Apsáalooke genders and their associated cultural roles. Equally important is sharing the stories of Apsáalooke resistance to settler gender norms. Such resistance demonstrates that heterosexism and gender oppression in the Apsáalooke community are colonial residues that can be addressed through collective action and healing.

Notes

1

In this essay, we use the nongendered pronoun "they" to refer to Ohchiish and to reflect their *batée* identity.

2

Hugh Lenox Scott, *Some Memories of a Soldier* (New York: The Century Company, 1928), 31–32, 57.

3

Will Roscoe, "'That Is My Road': The Life and Times of a Crow Berdache," *Montana: The Magazine of Western History* 40.1 (Winter 1990): 49.

4

Frank B. Linderman, *Pretty Shield* (Lincoln, NE: University of Nebraska Press, 2003), 117.

5

Ibid., 115–17.

6

At the time the Bureau of Indian Affairs was called the Office of Indian Affairs.

7

A. B. Holder, "The Bote: Description of a Peculiar Sexual Perversion Found Among North American Indians," *New York Medical Journal* 50, no. 23 (1889): 624.

8

Robert H. Lowie, *Primitive Religion* (New York: Boni and Liveright, 1924), 243–44.

9

Walter Williams, *The Spirit and the Flesh: Sexual Diversity and American Indian Culture* (Boston: Beacon Press, 1986), 179.

10

Lillian Bullshows Hogan, *The Woman Who Loved All Mankind: The Life of a Twentieth-Century Crow Elder* (Lincoln, NE: University of Nebraska Press, 2012), 124–27.

11

Roscoe, "'That Is My Road,'" 54.

12

Williams, *The Spirit and the Flesh*, 183.

del curfman

Del Curfman, *Baté Pride*, 2019

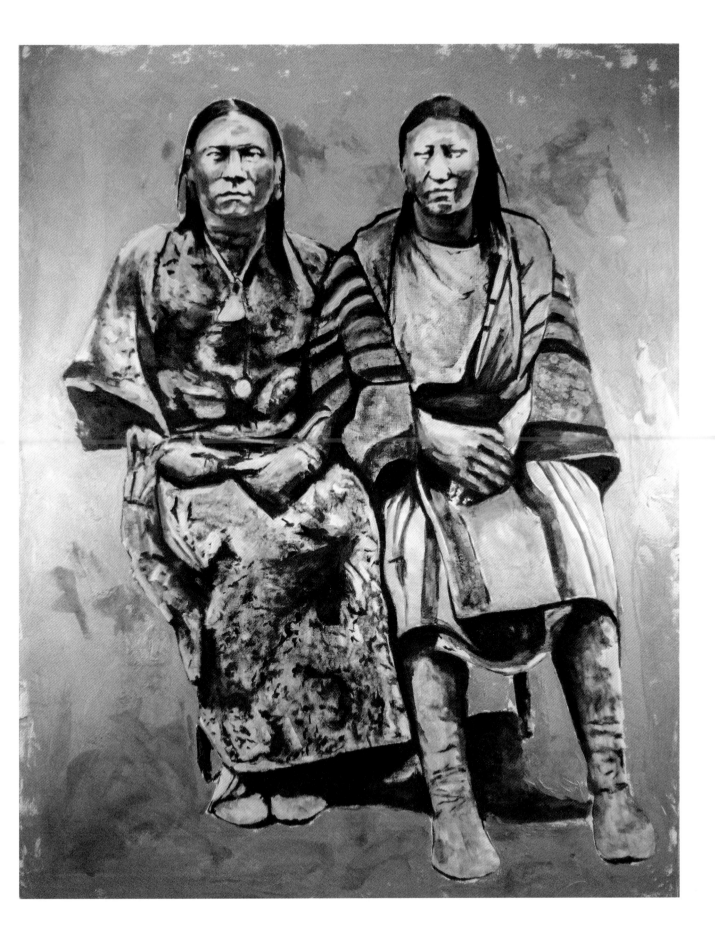

Del Curtman, *Mother's Knowledge*, 2019

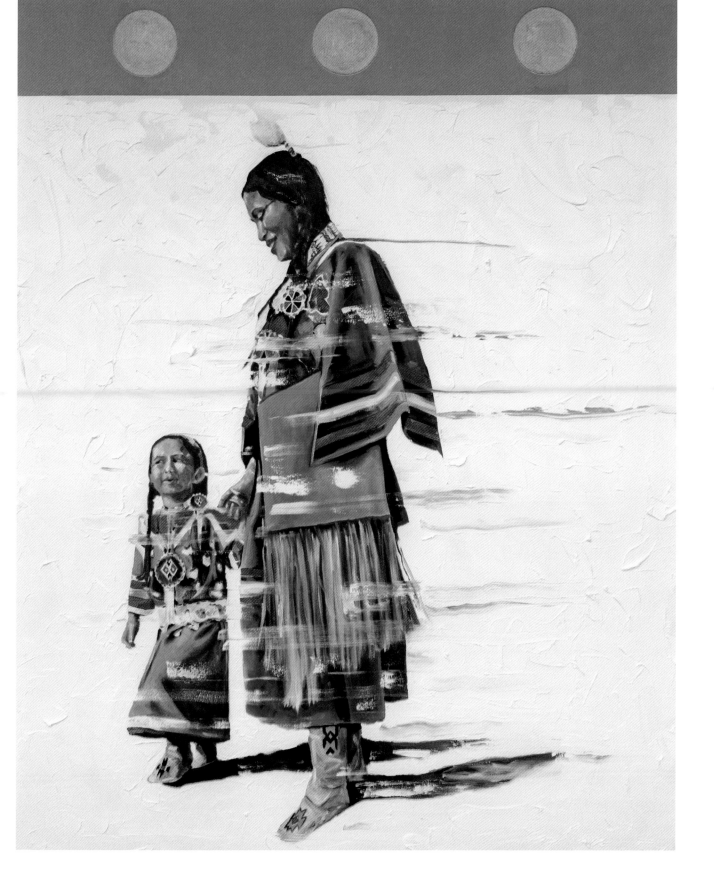

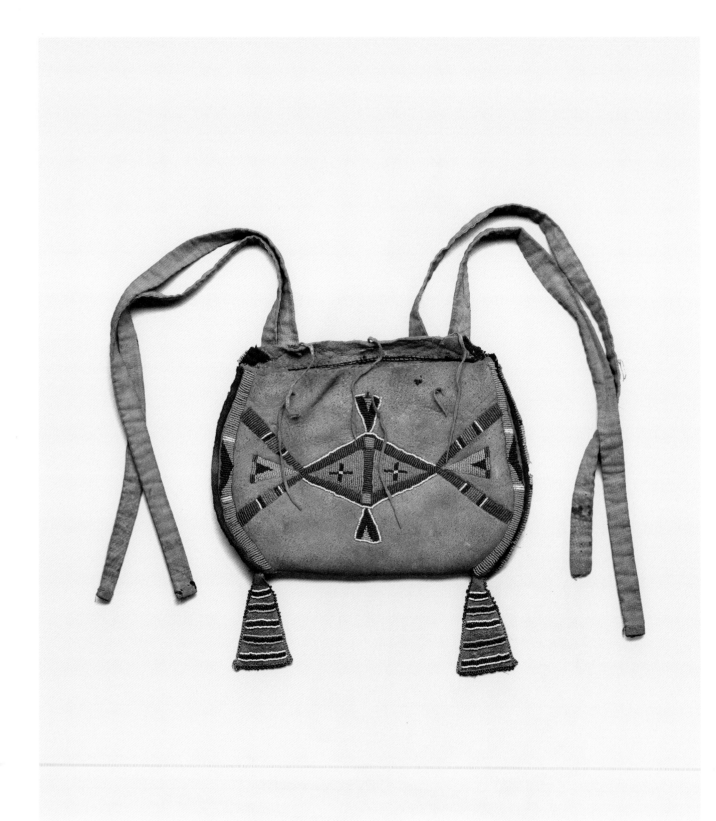

Baaisshe/Beaded work bag, 1880, buckskin, textile, glass, thread, pigment, Field Museum

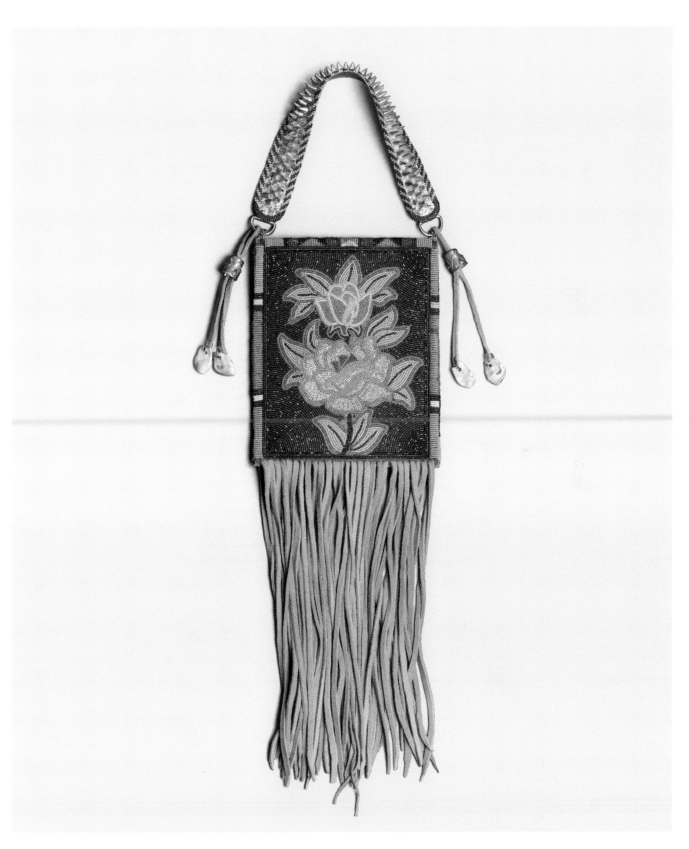

Elias Not Afraid, beaded bag, 2019, deer hide, elk ivory teeth, glass beads, Italian leather, Field Museum

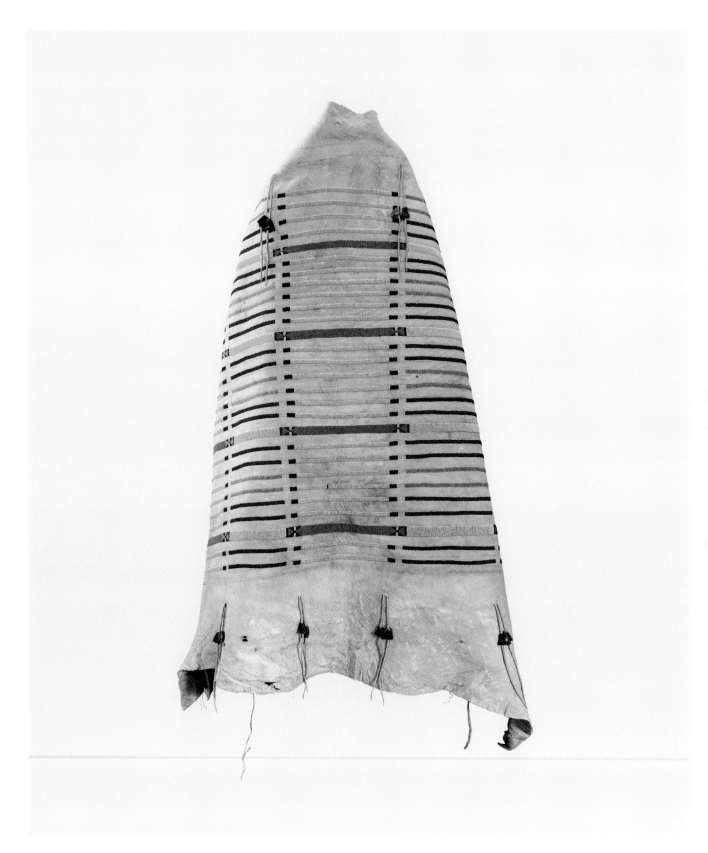

Bishbaalowishe/Courtship blanket, ca. 1880, buffalo hide, ribbon, trade cloth, beads,
Collection of Don and Liza Siegel

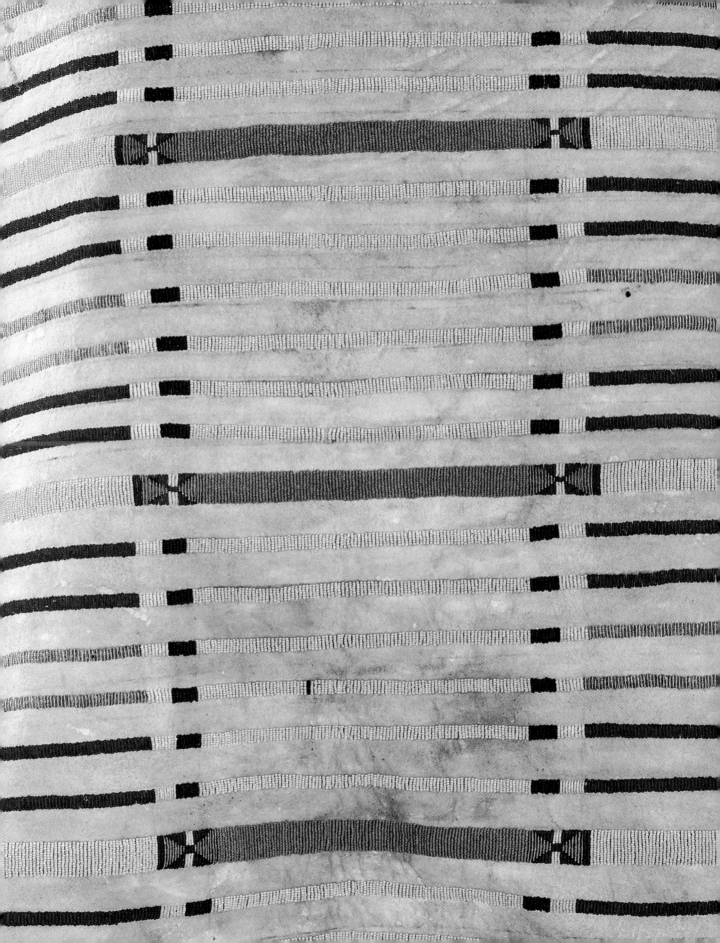

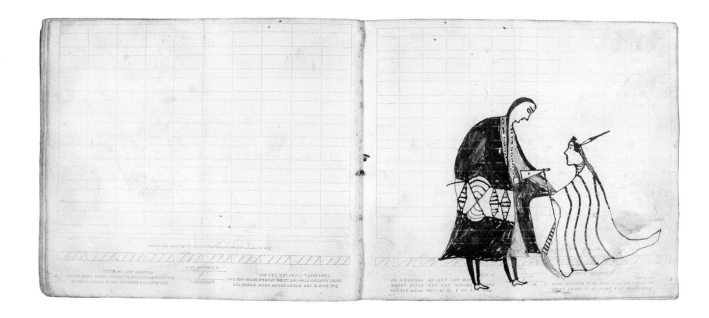

A warrior gifting a woman with a wedding blanket

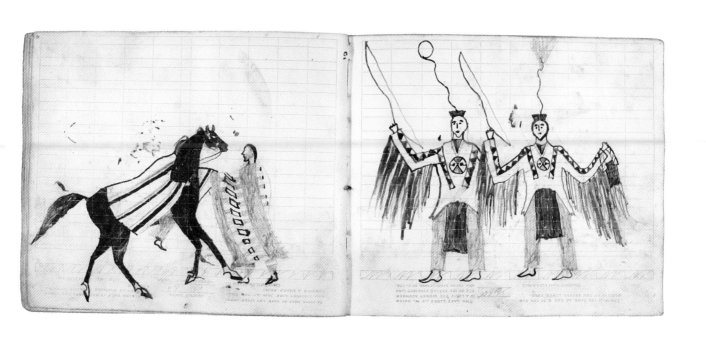

A woman seeing a warrior off to battle; two warriors, Hoop and Red Feather, performing a
Shoshone dance in their war shirts

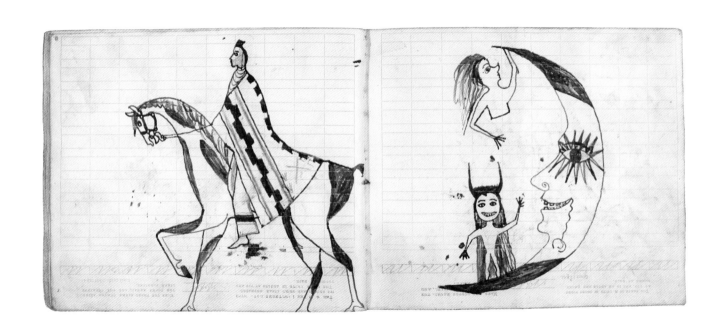

A warrior wearing a wool capote parading with his horse; supernatural beings from the warrior's vision

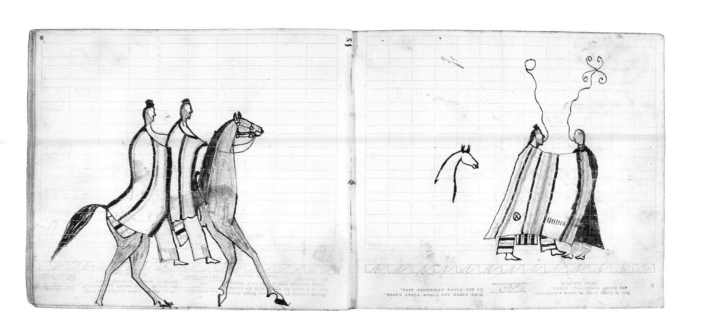

A warrior and the comrade he saved in battle; a man and woman sharing an intimate conversation while enveloped in a blanket

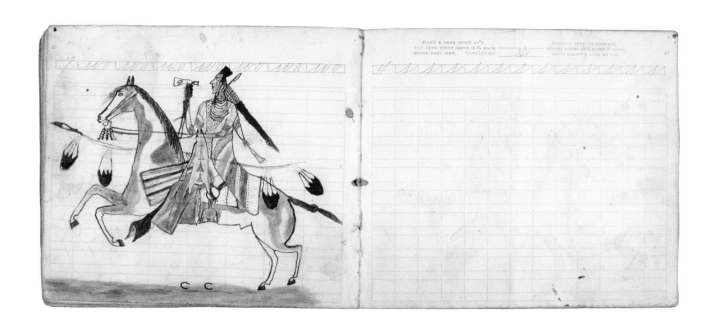

A warrior, dressed in his war shirt, capote, and breastplate, carrying a bow spear adorned with eagle feathers and a fox quirt

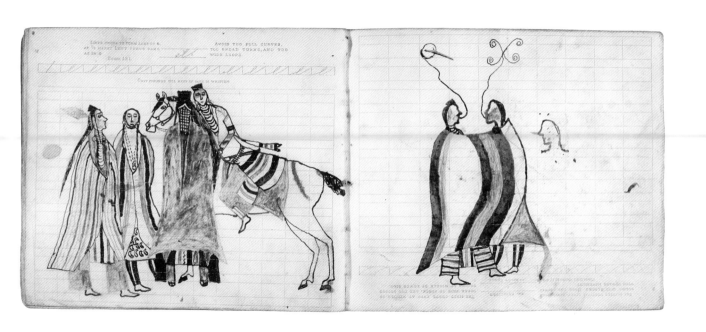

**Three young men and a young woman (second from left) wrapped in blankets and capotes;
a man and a woman in courtship**

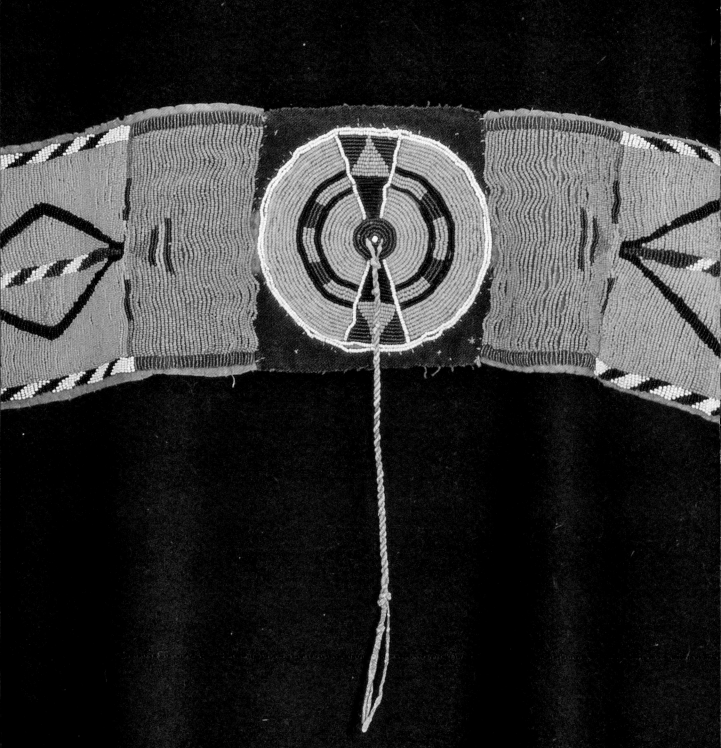

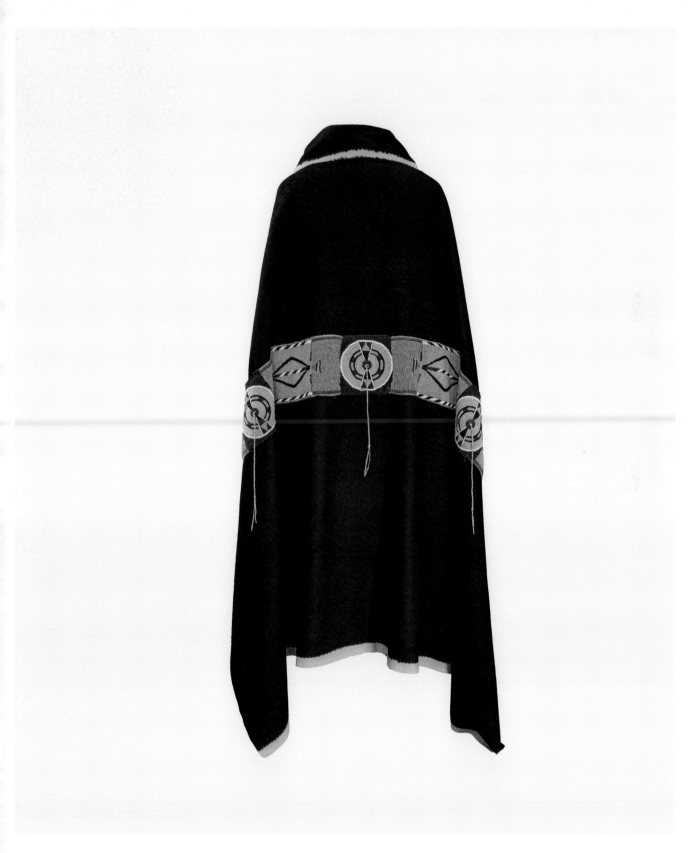

Bishbaalowishe/Wedding blanket and blanket strip, ca. 1880, buffalo hide, ribbon, beads, trade cloth, Collection of Don and Liza Siegel

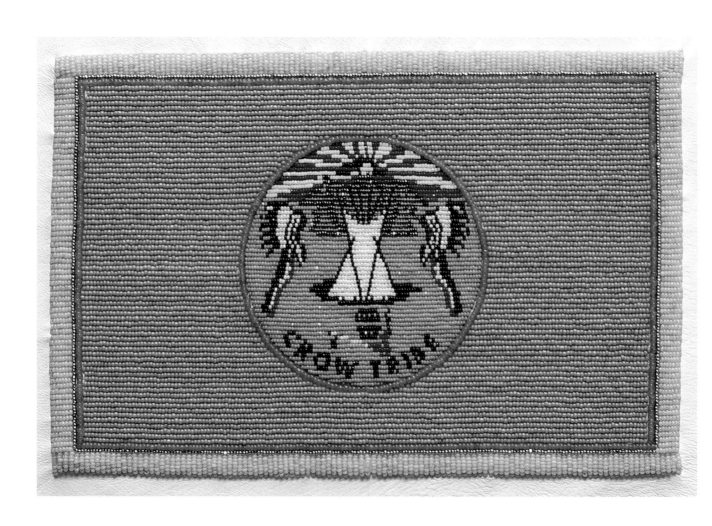

Karis Jackson, *Crow Tribal Flag*, 2019

a history of the apsáalooke

Timothy P. McCleary

The Apsáalooke, Children of the Large Beaked Bird, often called Crow Indians in English, have a rich and complex history. Archaeological findings, written documents, and, in particular, oral histories that reveal how Apsáalooke people themselves recall their past allow us to understand their origins, history, and culture.

The Apsáalooke are the westernmost members of the Siouan language family. Together with their close relatives the Hidatsa and the more distantly related Mandan, they comprise the Western Siouan subgroup.[1] From archaeological research it is clear that the Apsáalooke proper have resided in the Montana-Wyoming area for well over five hundred years, possibly longer. Archaeological evidence indicates Apsáalooke presence in Montana as early as AD 1150 and in the central Bighorn Mountains of Wyoming by AD 1500.[2] The earlier dates match nicely with estimates of when Apsáalooke became a distinct language from Hidatsa, roughly six hundred to eight hundred years ago.[3]

In addition, the ancestors of the Apsáalooke and Hidatsa have been linked through material culture to what archaeologists call the Northeastern Plains Village complex.[4] This complex first appears in northeastern Iowa and southwestern Minnesota about AD 900.[5]

The Northeastern Plains Village complex people lived a semi-sedentary lifestyle out of small residential villages made up of rectangular-shaped earth lodges built in rows. They hunted, gathered, and grew some crops, primarily maize, beans, and squash. Their horticulture was not as intense as their Middle Missouri neighbors. The Northeastern Plains Village people's move into the upper Missouri area was brought about by better growing conditions for maize and a rise in the availability of bison during a warming trend known as the altithermal.[6] By AD 1200 horticultural societies existed up to the mouth of the Knife River in central North Dakota, the furthest extent to which maize could be grown.[7]

Rock art found in the West also suggests a tie between the Northeastern Plains Village people and their midwestern relatives. The most common rock art images throughout the Midwest are various depictions of animal tracks, primarily game animal tracks, termed the "hoof-print tradition."[8] In the Great Plains this tradition is associated with the Western Siouan migrations and their concepts of birth and renewal.[9] During this same period numerous pecked, incised, and bas-relief "faces" appeared in the West that bear a striking resemblance to portable miniature shell masks, or gorgets, of the Midwest and Southeast.[10]

Apsáalooke and Hidatsa oral tradition corroborates the linguistic evidence and archaeological findings of a migration from the Midwest. The traditions specifically identify their ancestors as residents of earth-lodge villages in Minnesota.[11] Further, the narratives indicate that as the proto-Apsáalooke Hidatsa moved west they reached present-day Spirit (Devils) Lake in North Dakota. There the Apsáalooke and Hidatsa were formed when two brothers, No Intestines and Red Scout, who were leaders, divided their respective followers and sought different lifeways in fulfillment of supernatural visions. Red Scout's people went to the Missouri River and became the historic Hidatsa. Those who followed No Intestines migrated throughout the West in search of the Sacred Tobacco and god-given homeland.[12] Eventually, No Intestines located the Tobacco growing in the Bighorn Mountains of Montana and Wyoming, and his people became the historic Apsáalooke.[13]

Some of these early Apsáalooke apparently attempted to maintain the semi-horticultural lifeways of their Northeastern Plains Village ancestors. This is evident in the development of a small village site on the lower Yellowstone River, near present-day Glendive, Montana, known as the Hagen Site. The Apsáalooke place name for the site on the upper Yellowstone is Xooxaashe Alaatshiile

Awooshissee/Where the Corn Was Planted but Died.[14]

Oral tradition states that the early Apsáalooke also attempted to develop a village at the mouth of Rosebud Creek, on the Yellowstone River. The maize did not grow there either, but the Sacred Tobacco (*Nicotiana multivalvus*) that would serve as a spiritual standard to unify and define them as a nation did. It is believed that the plant and especially its seeds are tied to the well-being of the Apsáalooke people.[15]

The historic Apsáalooke consisted of three political divisions: the Mountain Crow, the River Crow, and the Kicked in the Bellies.[16] The Mountain Crow were the largest and first to enter the Montana-Wyoming area, being related to the Awatixa Hidatsa.[17] The River Crow left the Hidatsa proper, their origins being linked to the popular narrative about a dispute over a buffalo stomach, providing the Apsáalooke with their Hidatsa name Gixáa-iccá/Those Who Pout Over Tripe.[18] The Kicked in the Bellies developed out of the Mountain Crow during the historic era and derive their name from the first time the Apsáalooke encountered horses.[19]

The River Crow ranged from the Yellowstone River north to the Milk River. The Kicked in the Bellies traveled from the Bighorn Mountains to the Wind River Range in central Wyoming. The Mountain Crow straddled the present-day Montana-Wyoming border, with the Black Hills as the eastern edge of their territory, and the Kicked in the Bellies lived primarily in the Wind River and Bighorn Basins of present-day Wyoming.[20]

The Apsáalooke people had known of the existence of Europeans and had material items from them long before they first met one. One of the most important items of European origin acquired by Apsáalooke people was the horse. The acquisition of horses, probably around 1725, transformed the lives of the Apsáalooke. The horse provided a much more effective way of hunting buffalo, the main staple. Seasonal camp movements were made easier and faster. Tipi size increased from around twelve feet in diameter to as much as twenty feet in diameter. The horse also transformed warfare, from sporadic pedestrian encounters to the highly structured war honor, or coup-counting, system of the 1700s and 1800s.[21]

Other European items such as steel knives, axes, metal needles, copper pots, beads, and cloth had also reached Apsáalooke people before they had

encountered their makers. The gun, which also greatly changed Apsáalooke culture, arrived shortly after the Apsáalooke met Anglo traders and trappers.[22]

On June 25, 1805, the French Canadian trader Francois Laroque documented his observations of the Apsáalooke people and gave them the name that they would become known by in the Euro-American world, *gens de corbeaux* (People of the Crow, or simply Crows).[23]

The historic Apsáalooke culture represents a classic adaptation to the Northern Plains environment. Beginning with the initial separation from the Hidatsa in the 1500s, the Apsáalooke made the transition to a bison hunting culture.[24] Pottery was eventually replaced by wooden bowls and spoons made of horn and bone. Subsistence was primarily based on meat, such as bison, deer, elk, and bighorn sheep. Bison were hunted using group techniques, including surrounds and jumps. Numerous bison jump and kill sites in Montana and Wyoming are associated with the Apsáalooke.[25]

This diet of meat was supplemented with seasonally available roots and berries, the latter often mixed with fat to make pemmican. In addition, horticultural produce was procured by trade from the Hidatsa.[26] Apsáalooke knowledge of medicinal herbs was extensive. Dozens of plants were collected for their curative or spiritual powers.[27] Minerals and clays were collected for use in paints, to adorn clothing, the human body, horses, and a variety of objects.[28]

Lodging consisted of tipis made of bison hide cover and lodge-pole pine framework. Eight to sixteen people lived in one lodge. Tipis were oriented to the east, both for protection from the wind and for religious reasons. Tipis were usually left undecorated unless one of the occupants had received vision instructions concerning spiritual designs for the exterior. Windscreens made of bison skin were used to protect work areas.[29]

Clothing was made from the hides of elk, deer, antelope, and mountain sheep. Quillwork, and later beadwork, decorations were favored for certain items of clothing, horse gear, and other utilitarian objects.[30] The Apsáalooke were renowned for their quillwork, as well as for their painted designs. In general, female art took the form of geometric patterns, while male art was representational, with warfare and hunting motifs.[31]

The Apsáalooke engaged in trade with both eastern and western neighbors, for items such as catlinite pipes, bows, shells, foodstuffs, and, in the historic era, horses and Euro-American goods. Occupying the transitional zone between plains and plateau, the Apsáalooke became specialized traders as well as producers of trade-worthy products. With the advent of the horse, the Apsáalooke role in trade with friendly groups, as well as horse capturing from enemy groups, became more prominent. They played a central role in the fur trade, and acted as middlemen in bringing Euro-American goods into the northern Rocky Mountains from the outposts on the Missouri River.[32] The horse provided the Apsáalooke with a new avenue of material expression as witnessed through the various forms of practical and decorative horse gear.[33]

The role of the Apsáalooke as middlemen in trade evolved into a policy of diplomacy and cultural mediation that brought them into alliance with Euro-Americans. The Apsáalooke were involved early and extensively in the beaver trade, at first through participation in rendezvous and after 1832 by dealing with American Fur Company trading posts that had become established in the region. The beaver trade gave way by midcentury to the trade in buffalo robes.[34]

Extensive contact with Euro-Americans introduced the Apsáalooke to the sort of world that was coming to the Northern Plains. In addition to diplomacy and trade, Apsáalooke warriors fought alongside the US military on a number of occasions because Native enemies of the United States were also traditional enemies of the Apsáalooke.[35] According to Plenty Coups, the last principal chief of the Apsáalooke, the decision to side with the US military was taken consciously, with a view to avoiding the fate of tribes that had opposed the white man and been defeated.[36]

Direct diplomatic relations with the US government began in 1825 with what is today called the Friendship Treaty. This treaty established diplomatic ties between the federal government and the Apsáalooke people, but not much more.[37] The next treaty signed between the Apsáalooke and the United States was the Fort Laramie Treaty of 1851, which outlined tribal territories for those groups that attended.

The principal Apsáalooke leader of that time, Sits in the Middle of the Land, defined their territory as being within the four base poles of a tipi. Each pole rested in a mountain range: The one to the east rested in the Black Hills of South Dakota; the one to the south in the Wind River Mountains of Wyoming; to the west in the Beartooth Mountains of Montana; and to the north in the Bear Paw Mountains of Montana.[38]

In 1868 the next Fort Laramie Treaty was signed. This treaty can be seen as the beginning of reservation policy. It is the first treaty to remove land from Apsáalooke territory and to establish a full-time, resident Indian agent in Crow Country. All Apsáalooke holdings in Wyoming and most in eastern and northern Montana were ceded to the United States through this document. However, the treaty allowed use of these areas and other so-called government land for hunting.[39]

The mid-1800s were a difficult time for the Apsáalooke. European diseases, including smallpox, measles, and whooping cough, killed more than half the population. Traditional and allied enemies, including the Lakota, Cheyenne, and Arapaho, pushed the Apsáalooke from the east and south. Even food, which had been abundant previously, became scarce with the combined effects of game depletion and pressure from enemy tribes.[40] In much reduced state, where their very survival appeared at stake, the Apsáalooke fought valiantly against much larger foes.[41]

Also at this time, Euro-Americans moved into the peripheral areas of Apsáalooke land and set up homesteads. Despite the increase in tensions, the Apsáalooke maintained friendship with their new Anglo neighbors. After the Civil War and the transfer of military men and material to the West, the alliance between the Apsáalooke and the United States strengthened. The Lakota were viewed as the most significant obstacle to westward expansion, particularly along the Bozeman Trail.[42] During the Sioux Wars of the 1860s and '70s, Apsáalooke warriors in the capacity of scouts consistently aided the US military.[43]

At the conclusion of the Sioux Wars a greater influx of Euro-American settlers came to Crow Country. From 1880 to 1884 the Apsáalooke signed a number of agreements that greatly changed their relationship with the United States. These agreements restricted the Apsáalooke people to their reservation and allowed a right-of-way for the Union Pacific Railroad through the Yellowstone

Valley. The passage of the Dawes Act in 1887 officially began what is known as the Assimilation Period.[44]

The Assimilation Period called for Apsáalooke people to stop practicing any of their Native culture. Adults were encouraged to become yeoman farmers and tradesmen. A Catholic mission and government boarding schools were established on the reservation. In addition, many Apsáalooke were sent off-reservation for education at places such as Carlisle Indian School.[45] Indian police were tasked with enforcing assimilation policies. These included such actions as dispersing public gatherings, arresting and jailing leaders and participants in Native religious activities, and stopping people from leaving the reservation. This last policy put an end to intertribal warfare, its explicit goal. The only resistance came from a young Crow war leader named Wraps Up His Tail, who led a horse raid against the Blackfeet in the fall of 1887. The successful party returned with several Blackfeet horses. As they entered Crow Agency they rode through the streets shooting into the air and at various buildings, including the house of the Indian agent. The alarmed agent called for military troops from nearby Fort Custer. A cavalry and artillery unit arrived the next morning. After a brief fight, Wraps Up His Tail abandoned his plans and fled to the Little Bighorn River. He was killed there by Fire Bear, an Indian police officer. This effectively marked the close of what has been called the "buffalo days."[46]

Because of these fundamental changes in material life, other aspects of culture began to change. The Sun Dance was discontinued because the purpose of the ceremony was to obtain spiritual power against enemies. Indeed, the entire system of honors that formed the basis of the social structure was removed because the two main sources of virtue, warfare and bison hunting, were taken away.[47]

The early 1900s were a time of extreme change for the Apsáalooke. With the disappearance of the buffalo in the 1880s, the Apsáalooke became reliant on government rations. The loss of the buffalo caused the Apsáalooke to emphasize the horse as the primary source of wealth and medium of exchange. This process began well before the demise of the buffalo, except now the horse was the center of the Apsáalooke economy.[48]

The end of intertribal warfare, the shift to sedentary residence, and other factors led to a population explosion of Apsáalooke horses. By 1920 there were an estimated forty thousand head on the reservation. This meant wealth and increased membership in social and religious organizations, especially the Tobacco Society, whose members are responsible for cultivating and maintaining the seeds of the Sacred Tobacco, which was first located by No Intestines. (Tobacco Society members also ensure that the ceremonies are performed correctly so that the Apsáalooke may be prosperous.) Politically, the Apsáalooke were still relying on traditional leaders such as Plenty Coups, Pretty Eagle, and Medicine Crow.[49]

All this would change rather dramatically in December 1919 with the appointment of Charles H. Asbury as agent of the Crow Reservation. Asbury carried out a number of policies enacted by Congress or developed by the federal Office of Indian Affairs (commonly called the Indian Office, and later renamed the Bureau of Indian Affairs) that were intended to prohibit the Apsáalooke from practicing most of their traditional culture and assimilate them into Euro-American concepts of society and civilization. First among these was the passage of the Crow Act on June 4, 1920. The intent of the act was to make the Apsáalooke into yeoman farmers by breaking up communal land holdings into family-owned economic units. The effect was a dispersing of the concentrations of the Apsáalooke population that had dotted the reservation into family groups living on privately owned individual allotments. In addition, the 1920 Crow Act encouraged the leasing of land to white ranchers and farmers.[50]

Some allotting had been attempted previously, in 1897, 1899, and 1905. However, these attempts were generally unsuccessful because the Apsáalooke were reluctant to live on isolated allotments. Before the passage of the Crow Act only portions of the Bighorn and Little Bighorn Valleys and part of Pryor Creek had allotments. In most cases the few allotments that existed had absent owners, as these individuals preferred to stay in the communal camps of their bands. The Crow Act allotted the whole Crow Reservation and dispersed the camps once and for all.[51]

Once white ranchers began leasing Apsáalooke land, they began complaining about the Apsáalooke

horse herds that competed with their cattle and sheep for grass. Following a departmental circular Asbury ordered the rounding up and killing of "wild and worthless horses," each Apsáalooke family being allowed to keep a team of horses.[52]

This policy had a devastating effect on the Apsáalooke's revised economic system. Most Apsáalooke families soon found themselves without horses. Asbury also enforced policies banning social and religious gatherings. If he learned of a religious gathering, he had tribal police disperse it and arrest suspected leaders. Asbury focused primarily on the Tobacco Society. Acting on the slightest indication, he had Tobacco Society leaders rounded up, bound hand and foot, and displayed in the park in Crow Agency. The destruction of the horse herds and the anti-Native policies forced the Apsáalooke into accepting the reservation economy established by the government.[53]

The Crow Act also outlined the establishment of a tribal government. Initially called the Crow Tribal Business Committee, this government as such was made up of elected representatives from each of the six reservation districts and headed by an elected chairman. In August 1920 the committee elected its first chairman, Ralph Saco. Complaints of an educated minority controlling an uneducated majority were leveled against the committee by the majority of the Crow people. Nonetheless, the committee and its bylaws were approved by Asbury in May 1922.[54]

The early 1920s saw some improvements on the reservation. Crow Agency, Lodge Grass, and St. Xavier became centers for the developing farm and ranch activity. Crude roads connected these communities. Log or frame houses were constructed on allotments to move Apsáalooke people out of tipis and wall tents. Health conditions improved. Birth rates passed death rates for the first time during the Reservation Period, but not by a substantial margin.[55]

With the onset of the Depression Era, the Apsáalooke faced many of the same problems as other communities in the United States. Ubiquitous poverty only increased as white ranchers and farmers lost crops and profits and were therefore unable to make lease payments, which had become the main source of income for many Apsáalooke people. In the early 1930s Apsáalooke moved in increasing numbers to reservation towns seeking employment in federal relief programs such as the Civilian Conservation Corps, the Works Progress Administration, and the Indian Emergency Conservation Works. The living conditions were poor at best. The majority of the Apsáalooke lived in tents, and water was hauled from nearby rivers. Adequate housing could not be provided given the rapid growth of towns and poor economic conditions. For most Apsáalooke people the works projects were their first experience with wage labor and with the consumer economy of the wider United States. Many purchased goods they previously could not afford, especially automobiles.[56]

During this period of social and economic change the Assimilation Period abruptly ended with the passage of the Indian Reorganization Act (IRA) of 1934. This congressional act, intended to reverse the Dawes Act and the associated damaging social and economic effects, ushered in the Reform Period. The IRA also encouraged the development of tribal governments with the intention of substantial if not complete tribal sovereignty. When Robert Yellowtail, a Crow tribal member, was appointed superintendent, he became the first Native person to be the superintendent of his own reservation in the United States.[57]

The Apsáalooke people quickly responded to the new policies and began practicing long-forbidden Native activities, such as the dancing, sweat lodge, and Tobacco Society ceremonies. In addition, new forms of Native religion were brought to the reservation. In 1941 William Big Day sponsored the Shoshone Sun Dance, the first Sun Dance of the modern era, at Pryor, Montana.[58]

Under Superintendent Yellowtail, federal relief monies were directed toward infrastructure development on the Crow Reservation. This included the construction of roads; irrigation projects; and public buildings such as schools, a new hospital in Crow Agency, and a tribal council building known as the Round Hall. Yellowtail also worked with National Park Service personnel to reintroduce elk and buffalo to the reservation. And in an attempt to reconstruct the traditional economy he purchased studs and brood mares to rebuild tribal horse herds.[59]

Even with all the benefits of the Reform Period, the Apsáalooke chose to reject the IRA in hopes of developing their own governmental system. In the meantime the Crow Tribal Business Committee

remained the representative body and was largely impotent in providing any real leadership. In 1948 the Apsáalooke adopted a constitution that left political decisions in the hands of the Bureau of Indian Affairs.[60]

The Reform Period ended when the United States entered World War II. Around 250 Apsáalooke men and women joined the various branches of the military, and almost as many worked in war-related industries. World War II brought the first large-scale movement of Apsáalooke from the reservation to urban areas. For many soldiers the war exposed them to other cultures and gave them experiences they would not have had on their relatively isolated reservation.[61]

The end of World War II was marked by new federal Indian policies. The two most prominent polices were called "termination" and "relocation," which aimed to integrate the Native American population with the larger US population. Termination sought to dissolve reservations and end federal trust relationships. Relocation was designed to move Native people to urban areas. It was thought that once Native people left the reservation and discovered greater employment and educational opportunities elsewhere, they would not want to return.[62]

This shift in federal policy proved catastrophic for the Apsáalooke. Although they were not directly affected by the termination policy, approximately four hundred Apsáalooke people relocated to urban areas, finding employment primarily as laborers in factories or support staff in offices.[63]

The federal government brought a new threat to the reservation in the early 1950s, when the Apsáalooke were first made aware of the government's desire to build a dam on Crow land. In 1954 the issue was formally presented before the Crow Tribal Council, the governing body that had been founded through the implementation of the 1948 constitution. The debate centered on whether to sell the land outright or to lease it to the federal government. The two sides developed into political factions. Those supporting the outright sale of the land would become known as the River Crows, and those desiring to retain the land and lease it were called the Mountain Crows. These two newly formed political factions had no connection to the historic bands that shared the same names. Eventually the federal government grew weary of the internal bickering, and the US Bureau of Reclamation condemned the land, forcing a sale. So-called Yellowtail Dam was completed in 1968.[64]

In the 1960s the Kennedy and Johnson administrations instituted new ideas and policies more sympathetic to Native peoples. Termination policy was reversed, while relocation continued. Nonetheless, Democratic administrations recognized treaty rights and sought to allow Native groups to develop and implement their own policies. In 1962 the Apsáalooke received about $10 million (roughly $85.5 million in today's dollars) for lands ceded in the 1800s. Half of the settlement was used for the construction of a carpet mill, an electronics plant, and a hotel, all in Crow Agency. The other half of the settlement was placed in a "Family Fund." Tribal members could apply for up to $4,000 for home or land improvements. In 1968 Congress passed the Indian Civil Rights Act, which recognized Native tribes as sovereign nations.[65]

The most important legislation of this period was the Indian Self-Determination and Education Assistance Act of 1975, which allowed tribes to have more control over federally subsidized programs for Native people. Under Chairman Edison Real Bird the Apsáalooke saw the benefits of the federal policies. Two educational programs were developed: the Community Action Program, which would later form into Head Start, and the Tribal Work Experience Program, which provided on-the-job training and led to the founding of Little Big Horn College, the Apsáalooke tribal college.[66]

The 1970s also saw the Apsáalooke get involved in mineral development, as they negotiated the terms for mining their coal holdings. Profits from the mining of extensive coal reserves provided substantial per capita payments and allowed the Apsáalooke to develop a multifaceted government with various services for the reservation and its population.[67]

In 2001 the Apsáalooke passed a new constitution, which created a three-part government composed of executive, legislative, and judicial branches. The Apsáalooke hoped, in part, that by mirroring the structure of the federal government they would attract outside investors who would be more interested in supporting reservation projects and development. The new government is still experiencing growing pains, but overall it has provided the Apsáalooke people with more

representation on critical issues than in the past.[68]

The present-day Apsáalooke people, while far removed from the buffalo days, have adapted their culture to today's world. The annual celebration of Crow Fair, during the third week in August, provides a venue for Apsáalooke people to showcase their culture. Furthermore, involvement in the Northern Plains powwow circuit, the professional rodeo circuit, and other Native regional and national events has provided Apsáalooke people with outlets for traditional and Native activities. This persistence and revival of traditional practices has been aided by culture and language curricula provided in the public and parochial schools on the reservation and by the founding of Little Bighorn College, which introduced a Crow Studies program in 1980.[69]

From the moment Apsáalooke people became a distinct nation they have sought to form and develop a society that is uniquely theirs. Their journey began when they left the Hidatsa people and located the Sacred Tobacco in their god-given homeland. The trek continued through time, and Apsáalooke people responded to new challenges: the coming of the horse, the fur trade, increased conflict with US settlers, and reservation life. Throughout this journey Apsáalooke people not only survived, but sought innovative ways to utilize the unique nature of Crow culture to move forward. The history of Apsáalooke people shows that change provides opportunity even when it brings suffering. The Apsáalooke, a people with a strong culture, persist in proudly constructing their own identity.

Notes

1

James W. Springer and Stanley R. Witkowski, "Siouan Historical Linguistics and Oneota Archaeology," in *Oneota Studies*, ed. Guy E. Gibbon (Minneapolis: University of Minnesota, 1982), 71.

2

George C. Frison, "The Crow Indian Occupation of the High Plains: The Archeological Evidence," *Archaeology in Montana* Special Issue 1 (1980): 3–16. James Keyser, "Ceramics from the High-walker Site," *Plains Anthropologist* 27, no. 98 (1982): 287–303.

3

Springer and Witkowski, "Siouan Historical Linguistics." Robert C. Hollow and Douglas R. Parks, "Studies in Plains Indian Linguistics," in *Anthropology on the Great Plains*, eds. W. Raymond Wood and Margot Liberty (Lincoln, NE: University of Nebraska Press, 1980), 68–97.

4

Dale R. Henning, "Plains Village Tradition: Eastern Periphery and Oneota Tradition," *Handbook of North American Indian* 13, no. 1 (2001): 222–23. Dale R. Henning and Dennis L. Toom, "Cambria and the Initial Middle Missouri Variant Revisited," *The Wisconsin Archaeologist* 84, nos. 1 and 2 (2003): 197–217. Dennis L. Toom, "Northeastern Plains Village Complex: Timelines and Relations," *Plains Anthropologist* 49, no. 191 (2004): 281–97. W. Raymond Wood, "Plains Village Tradition: Middle Missouri," *Handbook of North American Indian* 13, no. 1 (2001): 186–95.

5

Henning, "Oneota Tradition," 222. Henning and Toom, "Cambria."

6

Henning, "Oneota Tradition," 222. Wood, "Middle Missouri," 190.

7

Wood, "Middle Missouri," 190.

8

Carol Diaz-Granados and James R. Duncan, *The Rock-Art of Eastern North America* (Tuscaloosa, AL: University of Alabama, 2004). James D. Keyser and Michael A. Klassen, *Plains Indian Rock Art* (Seattle: University of Washington Press, 2001), 177–90.

9

Linea Sundstrom, *Storied Stone: Indian Rock Art of the Black Hills Country* (Norman, OK: University of Oklahoma Press, 2004): 83–98.

10

Ibid., 160–73.

11

Medicine Crow, "The Crow Migration Story," *Archaeology in Montana* Special Issue 1 (1980): 66.

12

Following the lead of Robert Lowie (1956), when the Sacred Tobacco, *Nicotiana multivalvis*, of the Crow is referenced the term is capitalized.

13

Timothy P. McCleary, *The Stars We Know: Crow Indian Astronomy and Lifeways* (Prospect Heights, IL: Waveland Press, 1997), 16–17. Raymond W. Wood, *The Origins of the Hidatsa Indians: A Review of Ethnohistorical and Traditional Data* (Lincoln, NE: Midwest Archaeological Center, 1980).

14

Timothy P. McCleary, *Apsáalooke Cultural Landscape Project* (Crow Agency, MT: Little Big Horn College, 2000). William Mulloy, *The Hagen Site: A Prehistoric Village on the Lower Yellowstone* (Missoula, MT: The University of Montana Publications in the Social Sciences, 1942).

15

Frank B. Linderman, *Old Man Coyote* (Lincoln, NE: University of Nebraska Press, 1996), 10–11. Peter Nabokov, *Two Leggings: The Making of a Crow Warrior* (Lincoln, NE: University of Nebraska Press, 1962).

16

McCleary, *The Stars We Know*, 2–3.

17

Alfred W. Bowers, *Hidatsa Social and Ceremonial Organization* (Lincoln, NE: University of Nebraska Press, 1992), 21.

18

Bowers, *Hidatsa Social and Ceremonial Organization*, 23. Robert H. Lowie, *Myths and Traditions of the Crow Indians* (Lincoln, NE: University of Nebraska Press, 1993), 272–75.

19

Robert H. Lowie, "Social Life of the Crow Indians," *Anthropological Papers* 9, no. 2 (1912): 183–84.

20

McCleary, *The Stars We Know*, 2–3.

21

John C. Ewers, "The Horse in Blackfoot Indian Culture: With Comparative Material from other Western Tribes," *Bureau of American Ethnology Bulletin* 159 (1955): 1–374. Timothy P. McCleary, *Iichíile: The Horse in Crow Indian Culture and History* (Crow Agency, MT: Little Big Horn College, 2002).

22

Frederick W. Voget, *The Shoshoni-Crow Sun Dance* (Norman, OK: University of Oklahoma Press, 1984), 9–10.

23

Frederick E. Hoxie, *Indians in American History* (Arlington Heights, IL: Harlan Davidson, 1988), 31–32. Nabokov, *Two Leggings*, xvii.

24

Rodney Frey, *The World of the Crow Indians: As Driftwood Lodges* (Norman, OK: University of Oklahoma Press, 1987), 11–12. Frank B. Linderman, *Plenty Coups: Chief of the Crows* (Lincoln, NE: University of Nebraska Press, 2002), 10–11.

25

Frey, *The World of the Crow Indians*, 12. Frison, "The Crow Indian Occupation," 3–16.

26

Frey, *The World of the Crow Indians*, 12–13.

27

Joy Y. Toineeta, "Absarog-issawua: From the Land of the Crow Indians" (MA Thesis, Montana State University, 1970), 88–115.

28

Ibid.

29

Robert H. Lowie, "The Material Culture of the Crow Indians," *Anthropological Papers: American Museum of Natural History* 21, no. 3 (1922): 222–25. Dale D. Old Horn and Timothy P. McCleary, *Apsáalooke Social and Family Structure* (Crow Agency, MT: Little Big Horn College, 1995), 51–55. Frederick W. Voget, "Crow," in *Handbook of North American Indians* 13, no. 2 (Washington, DC: Smithsonian Institution, 2001), 700.

30

Lowie, "The Material Culture of the Crow Indians," 225–26. Voget, "Crow," 700.

31

Robert H. Lowie, *The Crow Indians* (New York: Holt, Rinehart and Winston, 1956), 77–81. William Wildschut, *Crow Indian Beadwork: A Descriptive and Historical Study*, vol. 16, ed. John C. Ewers (New York: Museum of the American Indian, Heye Foundation, 1959), 39–44.

32

Colin Taylor, *Crow Rendezvous: The Place of the Mountain Crow and River Crow in the Material Culture Patterns of the Plateau and Central Plains Circa 1800–1870* (London: English Westerners Society, 1981), 33–48. Voget, "Crow," 696–97.

33

Timothy P. McCleary, *Horse Parading Among the Crow Indians* (Crow Agency, MT: Little Big Horn College, 1993).

34

Voget, *The Shoshoni-Crow Sun Dance*, 10–11.

35

Frederick E. Hoxie, *Parading Through History: The Making of the Crow Nation in America, 1805–1935* (New York: Cambridge University Press, 1995), 96–111.

36

Linderman, *Plenty Coups*, 40–42.

37

Timothy A. Bernardis, *Crow Social Studies Teacher's Guide* (Crow Agency, MT: Bilingual Materials Development Center, 1986), 19–20. Hoxie, *Parading Through History*, 66.

38

Bernardis, *Crow Social Studies Teacher's Guide*, 20–21. Hoxie, *Parading Through History*, 86–87.

39

Bernardis, *Crow Social Studies Teacher's Guide*, 27. Hoxie, *Parading Through History*, 91.

40

Hoxie, *Parading Through History*, 96–111.

41

Ibid., 85–95.

42

Ibid., 91.

43

Ibid., 106–15.

44

Bernardis, *Crow Social Studies Teacher's Guide*, 30–31.

45

Frey, *The World of the Crow Indians*, 32. Timothy P. McCleary, Thomas Carter, and Edward Chappell, *Tipis and Square Houses: The Chief Plenty Coups Homestead and the Building of the Crow Indian Reservation in Central Montana 1884–1910* (Billings, MT: Montana Fish and Wildlife Parks, 2005), 11–12.

46

Frey, *The World of the Crow Indians*, 34–35.

47

Voget, *The Shoshoni-Crow Sun Dance*, 16–23.

48

Nabokov, *Two Leggings*, 193–97. Wendell Oswalt, *The Crow: Plains Warriors and Bison Hunters*, in *This Land Was Theirs: A Study of North American Indians*, 3rd Ed. (New York: John Wiley and Sons, 1978), 282.

49

Edwin Bearss, *Big Horn Canyon National Recreation Area: History Basic Data* (Washington, DC: United States Department of the Interior, Government Printing Office, 1970), 345. Robert H. Lowie, "The Tobacco Society of the Crow Indians," *Anthropological Papers: American Museum of Natural History* 21 no. 2 (1919): 135. Joseph Medicine Crow, *From the Heart of Crow Country* (New York: Orion Books, 1992), 106. William T. Roberts, *Socioeconomic Impact Assessment of Shell's Youngs Creek Mine* (Crow Agency, MT: Crow Tribe of Indians, Office of Natural Resources, 1983), 44.

50

Oswalt, *The Crow*, 284. Roberts, *Socioeconomic Impact Assessment*, 44.

51

Charles C. Bradley, "After the Buffalo Days: Documents on the Crow Indians from the 1880's to the 1920's" (MS Thesis, Montana State University, 1970), 127–42; 230–32.

52

National Archives (1919), Seattle, WA, Circular 1432, Crow Agency Records, RG 75.

53

Joseph Medicine Crow, "Economic, Social, and Religious Life of the Crow Indians" (MA Thesis, University of California, Berkeley, 1939), 19–21. National Archives (1919–30), Seattle, WA, C.H Asbury File, Crow Agency Records, RG 75.

54

National Archives (1922), Seattle, WA, Superintendent's Annual Narrative and Statistical Reports, Crow Agency Records, RG 75. Roberts, *Socioeconomic Impact Assessment*, 44.

55

National Archives (1928), Seattle, WA, Superintendent's Annual Narrative and Statistical Reports, Crow Agency Records, Health Supplement, RG 75. William Petzoldt, *From War-Path to the Jesus Trail*, in *The Moccasin Trail* (Philadelphia: Judson Press, 1932), 22–23.

56

Roberts, *Socioeconomic Impact Assessment*, 44. Robert Kiste, *Crow Peyotism* (Crow Agency, MT: Little Big Horn College Archives, 1962), 15.

57

Oliver La Farge, *As Long as the Grass Shall Grow* (New York: Alliance Book Corporation, 1940).

58

Frey, *The World of the Crow Indians*, 35, 69–71. Voget, *The Shoshoni-Crow Sun Dance*, 129.

59

Roberts, *Socioeconomic Impact Assessment*, 45–46.

60

Ibid., 45–46.

61

Eloise White Bear Pease, ed., *Crow Tribal Treaty Centennial Issue 1868–1968* (Crow Agency, MT: 1968), 41–44.

62

Hoxie, *Indians in American History*, 260–62.

63

Janine Pease, *The Story of the Crow Indians: The Past to the Present* (forthcoming).

64

Kiste, *Crow Peyotism*, 125. Mardell H. Plainfeather, *Factionalism Among Contemporary Crow Indians* (Crow Agency, MT: Little Big Horn College Archives), 4.

65

Hoxie, *Indians in American History*, 264. Dale K. McGiniss and Floyd W. Sharrock, *The Crow People* (Phoenix, AZ: Indian Tribal Series, 1972), 58–62.

66

McGiniss and Sharrock, *The Crow People*, 77–80.

67

Pease, *The Story of the Crow Indians*. Voget, *The Shoshoni-Crow Sun Dance*, 26–28.

68

Pease, *The Story of the Crow Indians*.

69

Voget, "Crow," 711–14.

kevin red star

Kevin Red Star, *Crow Indian Girl on Young Parade Pony*, 2019

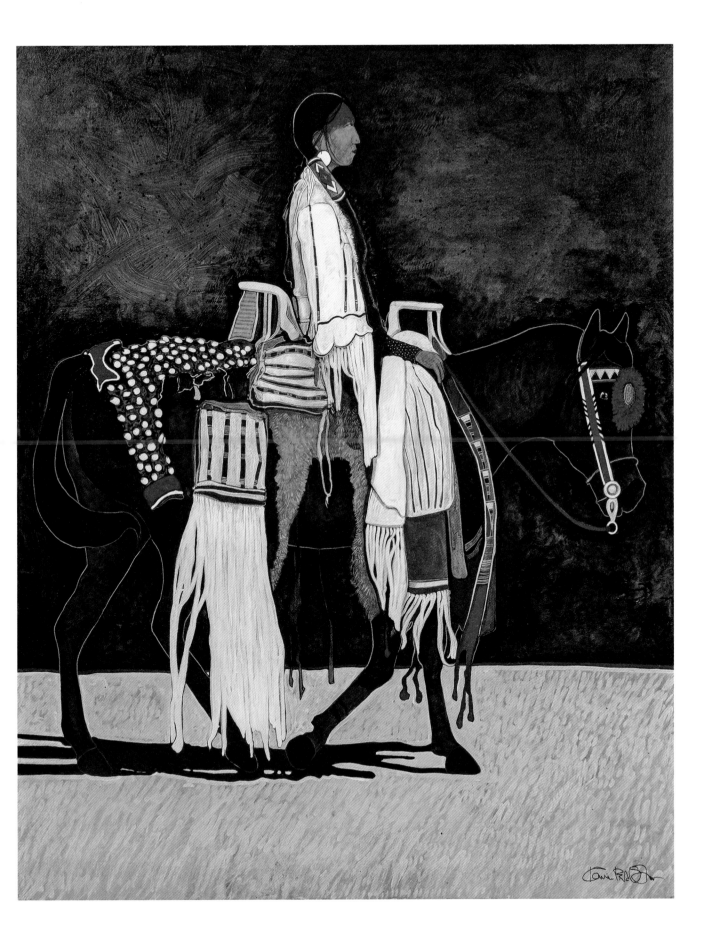

Kevin Red Star, *Evening Lodges,* 2017

Kevin Red Star, *Mountain Crow Flower Dress, 2019*

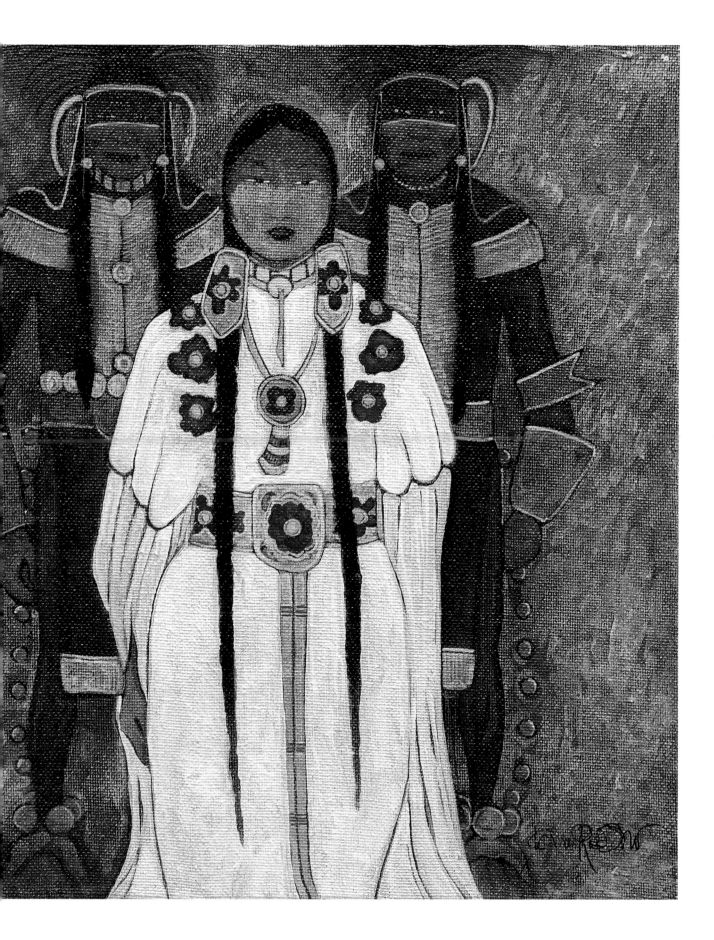

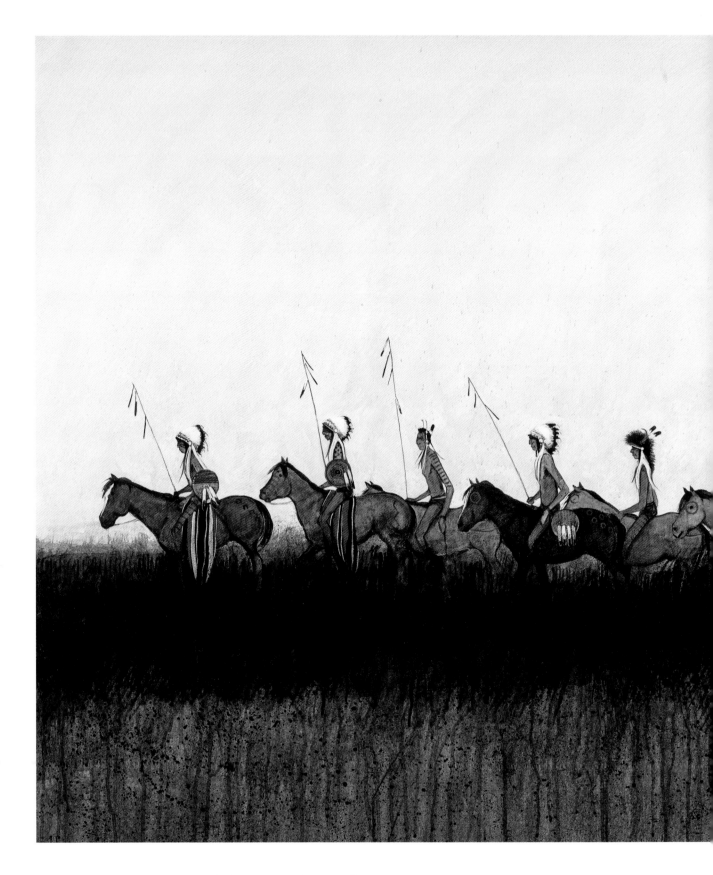

Kevin Red Star, *Crow Indians Returning to Camp,* **2018**

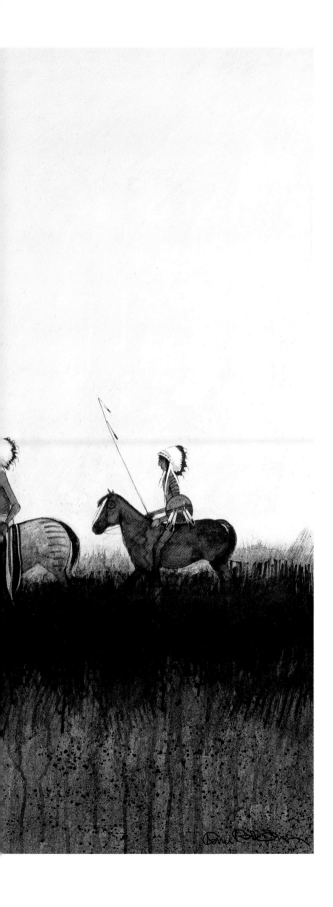

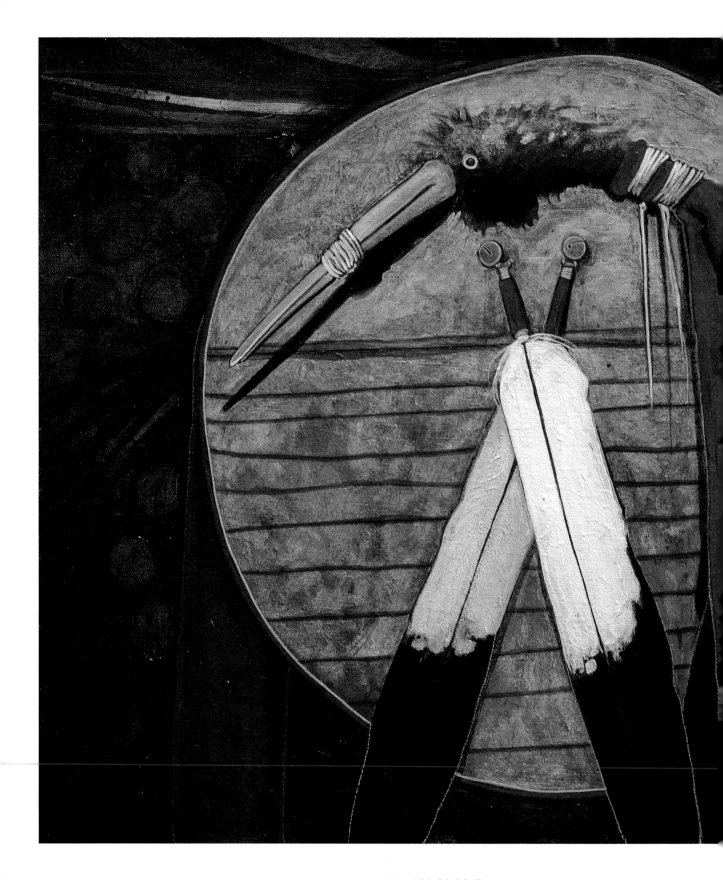

Kevin Red Star, *Cranes War Shield*, 2015

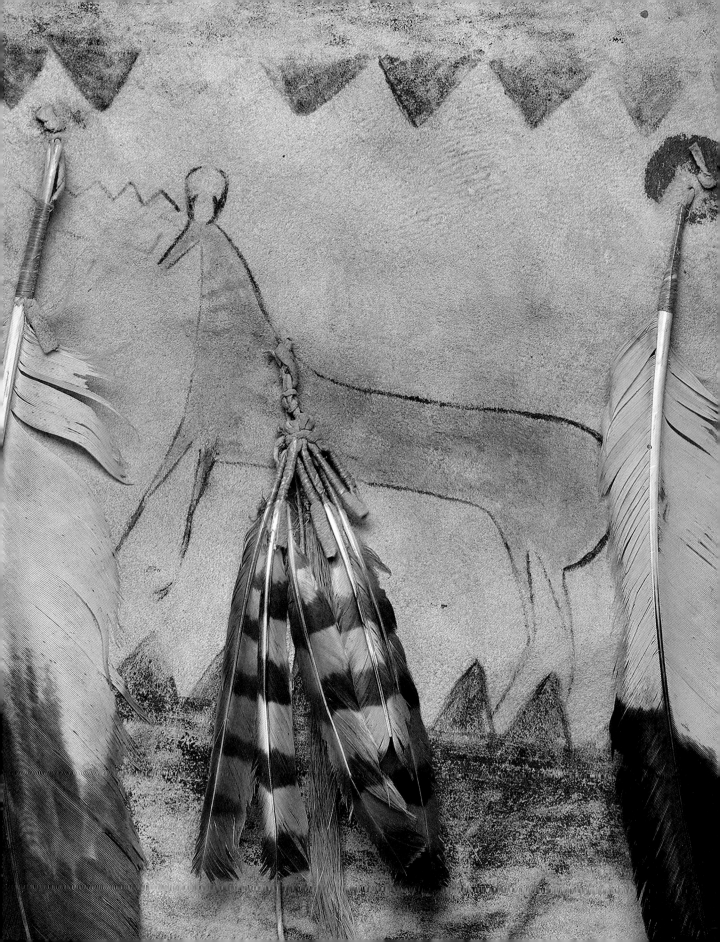

shield stories through biiluuke eyes

aaron b. brien

My father's father gave me my name Pretty Shield,
on the fourth day of life, according to our custom.
My Grandfather's shield was handsome: and it was
big medicine.
— Ishbinnaache Itchish/Pretty Shield

Not many people know about Apsáalooke shields.
But what would someone need to know about them
to understand their function within Apsáalooke
culture?

The word "Apsáalooke" literally means "Children
of the Large Beaked Bird." This is considered our
formal name as a tribe. Many of us refer to the tribe
by its informal name, Biiluuke, which literally means
"Our Side." All shields encompass the understandings
of Apsáalooke belief, so when looking at a shield it is
important to view it through the lens of the Biiluuke.
The word "Akbinnaachiikaash" means "The One Who
Looks at Shields." Everyone who reads this essay
is taking part in that activity. We are all brought
together in the effort to understand these sacred
objects.

There was a time when most men of the tribe
owned a shield. These shields represent the power
of the creator and the fortitude of the individuals
who owned them. They also represent the covenant
that the Apsáalooke will always be protected and
that we will always hold what is ours.

Each shield is made of three major parts.
The first is rawhide made from the thickest parts of
the buffalo hide: the thoracic area, or the buffalo
hump. To make a shield, the owner digs a hole in the
ground, sets a small fire in the hole, and then places
the clean rawhide over the hole. The heat from the
fire pulls the moisture out of the hide, causing it to
shrink. The hide gains thickness from that process.
The owner then makes a cover for the shield and
typically places his "medicine" on the cover. This
can be, but is not limited to, things the owner has
seen during a fasting experience or medicine that
has been given to the owner of the shield. It is also

common to place the medicine objects directly
on the rawhide and conceal the shield with a plain
buckskin cover when it is not in use. The third part
of a shield is the handle or shoulder strap. Most of
the shields in the Field Museum's collection include
a shoulder strap. These make the shield sit on the
owner in a bandolier style.

Shields are considered baaxpáa/sacred. I have
asked many elders to explain the meaning of this
term, and there are many views, but one that stands
out to me comes from one of the leaders of the
Sacred Tobacco Society, Grant Bulltail. He states,
"We [Apsáalooke] only have one word for holy and
those things, it's 'baaxpáa.' It means 'to be with God'
or 'powerful source of energy'....That's why they say,
If you harm anything in nature, it harms everything."

The Apsáalooke are blessed to have many
sacred objects and rituals that are associated with
ceremonial life: the Tobacco Society, the Pipe Dance,
the sweat lodge, rock medicine, shields, and many
others. The Apsáalooke have a designated place in
the home reserved for these sacred items, which,
in the past, was at the back of the lodge, above the
ground. In some cases during the day, the medicines
were placed outside and behind the lodge. Each
object had its own rules and taboos, which were to
be followed by the owner. These objects are revered,
but it is common for the Apsáalooke to be lively
around them: the sacred items are meant to enhance
life, not to hinder it.

Often I am asked, "How would someone come
to own sacred objects?" This is done through fasting,
often referred to by the Apsáalooke as bilisshíis-
saannee/No Water. Most people know this as a
"vision quest." The site where someone fasts is called
Bilisshíissaannuua Alaxpe/Where There Is a Bed.
Afterward, the name of the person who fasted be-
comes part of the name of the site. For example, the
site where the warrior Chiischiipaaliiash/Wraps Up
His Tail fasted is known as Chiischiipaaliiash Alaxpe/
Where Wraps Up His Tail Made a Bed (see p. 145).

Fasting is typically done over the course of four days. The faster does not eat or drink and goes without the convenience of shelter. The location is typically on a high mountain peak, but if the faster has seen a location in a dream, the dream can guide the faster to it. If the desired goal is not achieved during the fast, then the faster will typically take a break and return at a later date to seek success.

It is through fasting that the Apsáalooke people find direct "power," or "medicine," from Iichiikbaaliia/First Maker. The faster typically receives this medicine in a dream, and it is common for his clan fathers to interpret that dream. This is when the faster is told how to make and use his medicine, and how to decorate his war shield. The Apsáalooke warrior often placed representations of Medicine Power on his shield. In this way, the shield embodies the Medicine Power that serves the warrior who carries the shield. It is through the Medicine Power that success is achieved.

The shield of Buakwaalaaxeesh/Crazy Sister in Law is known to be particularly powerful (see p. 146). Buakwaalaaxeesh was the father of the respected Apsáalooke medicine woman Ishbinnaache Itchish/Pretty Shield, and much of what we know about him comes from her. He became one of the most respected war leaders of his time, achieving the military rank of Iipche Akee/Pipe Carrier. Only the bravest and most spiritually successful people could possess such a title. Buakwaalaaxeesh was present at the most important day in Apsáalooke history, known as Ashkootáawinnaxchihkuua/Where the Whole Camp Made a Fort. It is more than likely that his shield was present too. Had it not been for the Medicine Power that Iichiikbaaliia gave to Buakwaalaaxeesh, the outcome of this famous battle might have been different.

Although not many people know about Apsáalooke shields, the information is still there. These sacred objects have been out of our possession for over a century, but they have never left our memory. It is up to the Apsáalooke people to learn more about them. The first step is to create an environment where shields are the centerpiece, the source of the physical and spiritual protection of the home.

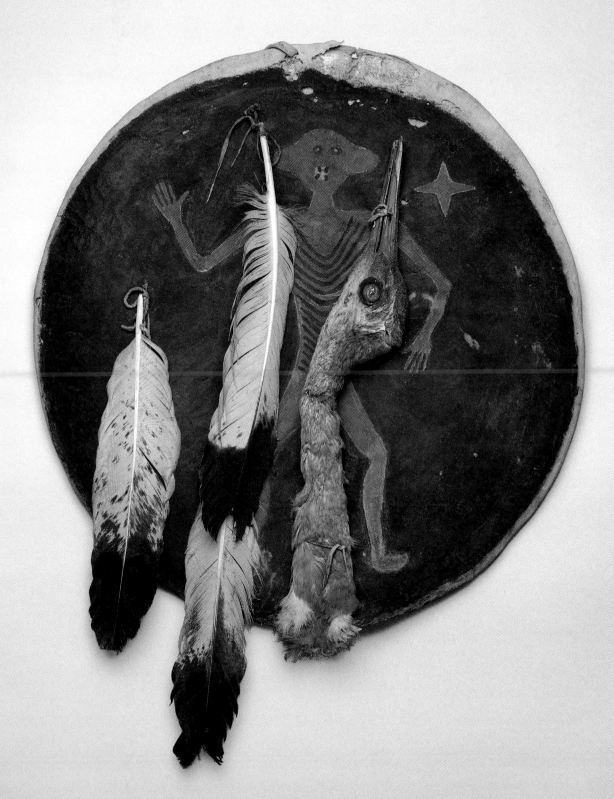

Wraps Up His Tail, Chiischiipaaliiash koo iishbinnaachik/The war shield owned by Wraps Up His Tail, ca. late 1800s, rawhide, pigment, eagle feathers, sandhill crane head, Field Museum

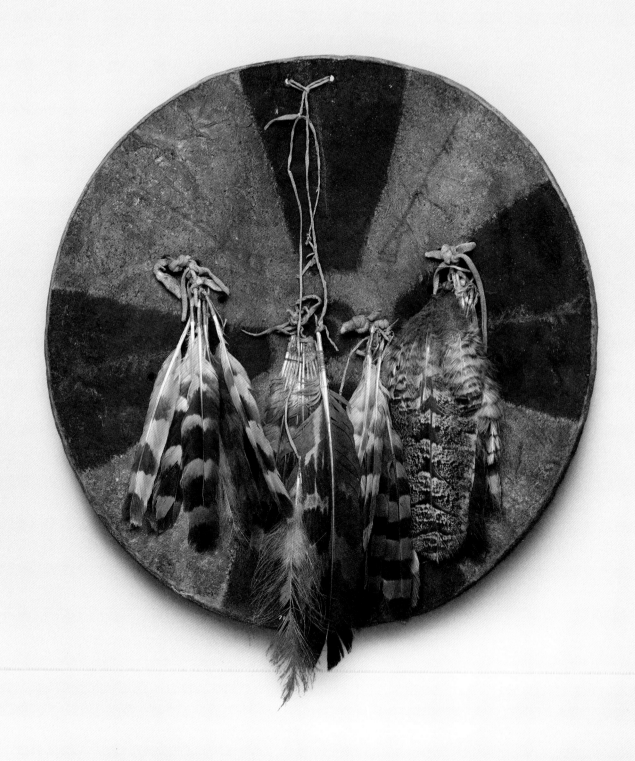

Crazy Sister in Law, Buakwaalaaxeesh koo iishbinnaachik/War shield belonging to Crazy Sister in Law, ca. late 1800s, rawhide, pigment, owl feathers, Field Museum

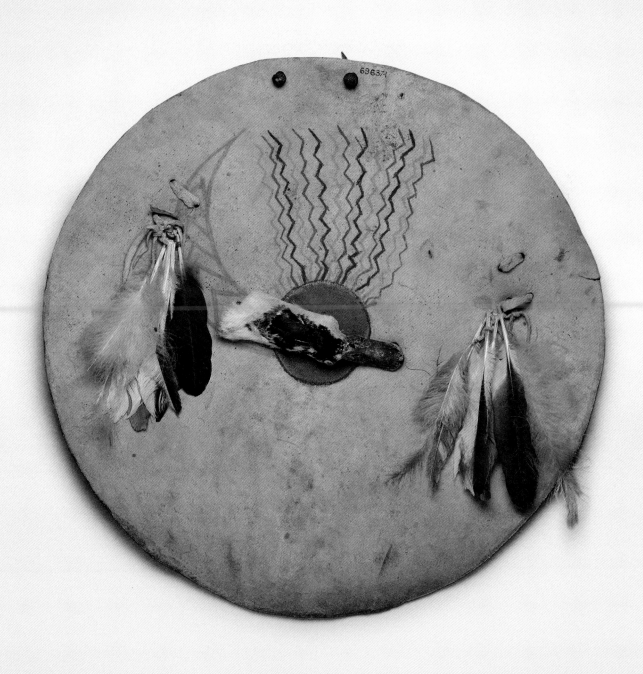

Ishbinnaache/War shield, ca. late 1800s, rawhide, pigment, domestic duck head, eagle feathers,
Field Museum

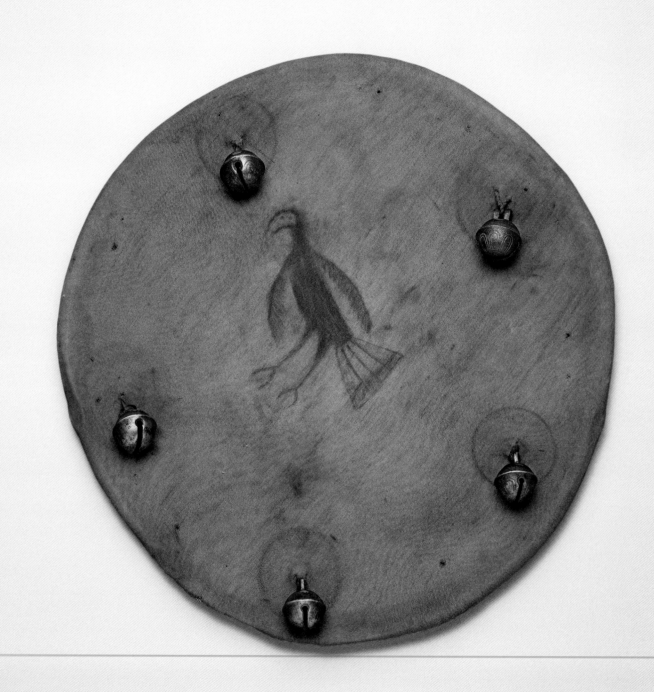

148 Ishbinnaache/War shield, ca. late 1800s, rawhide, pigment, brass bells, Field Museum

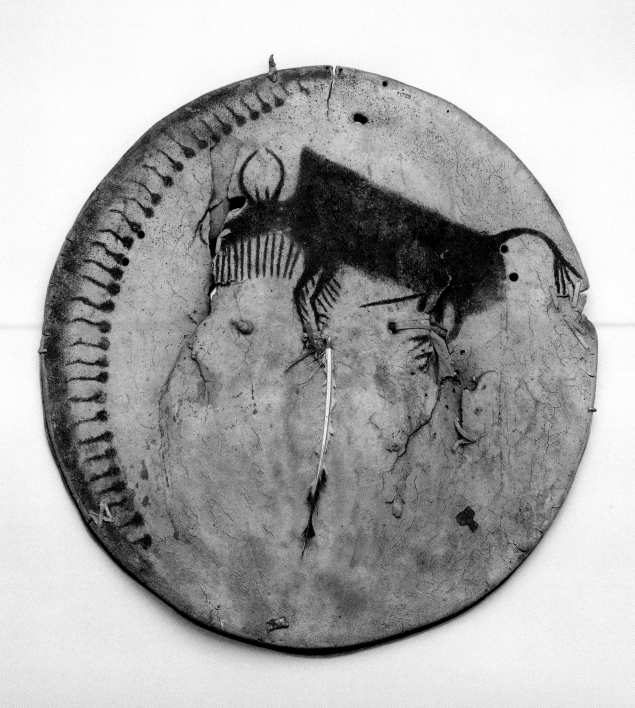

Sees the Living Bull, Ishbinnaache/War shield, ca. late 1800s, hide, buckskin, feather, textile, iron alloy, pigment, sinew, Field Museum

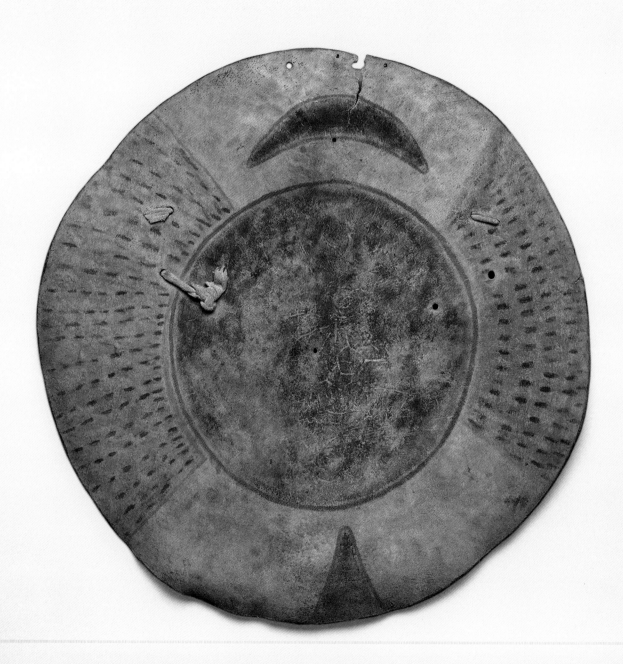

Ishbinnaache/War shield, ca. late 1800s, hide, buckskin, pigment, Field Museum

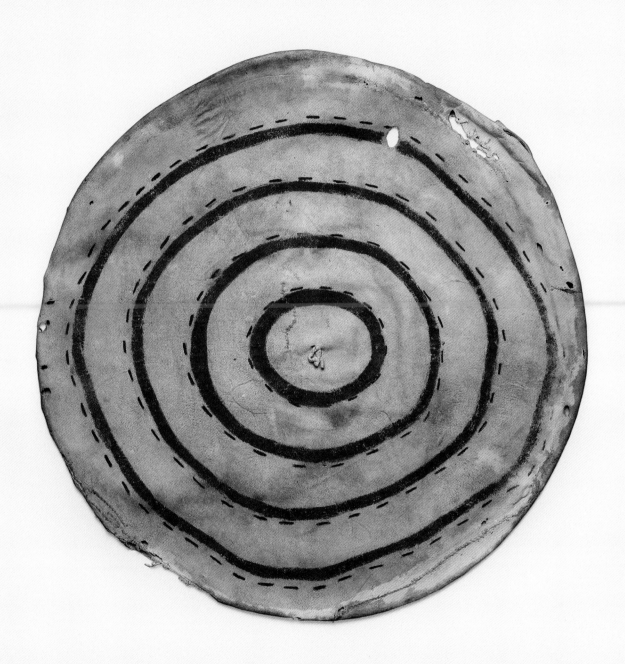

Crazy Pon de Ray, Ishbinnaache/War shield, ca. late 1800s, buckskin, pigment, Field Museum

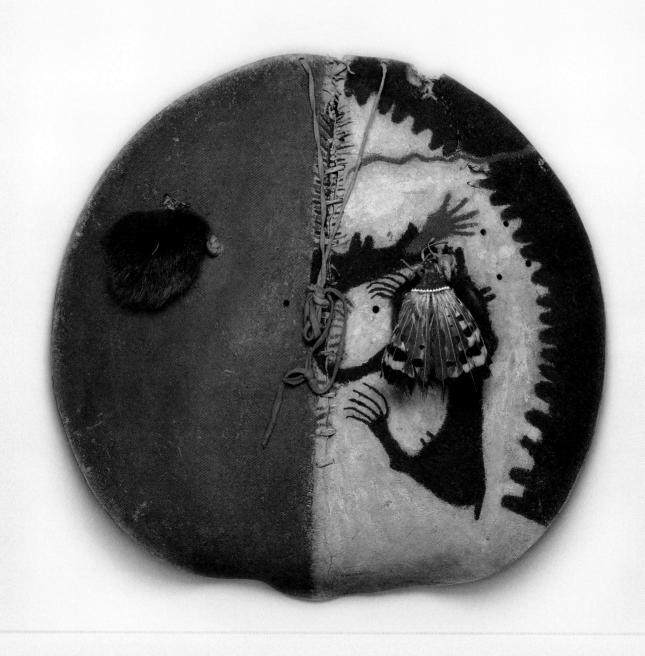

Ishbinnaache/War shield, ca. late 1800s, rawhide, pigment, kestrel feathers, bear's ear,
Field Museum

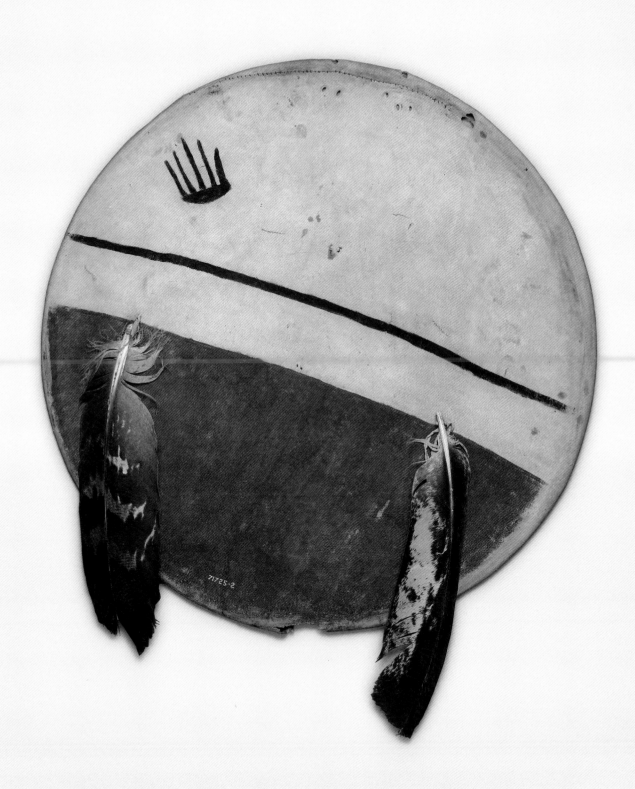

Two Leggings, Ishbinnaache/War shield, ca. late 1800s, rawhide, bald eagle feathers, thread, pigment, Field Museum

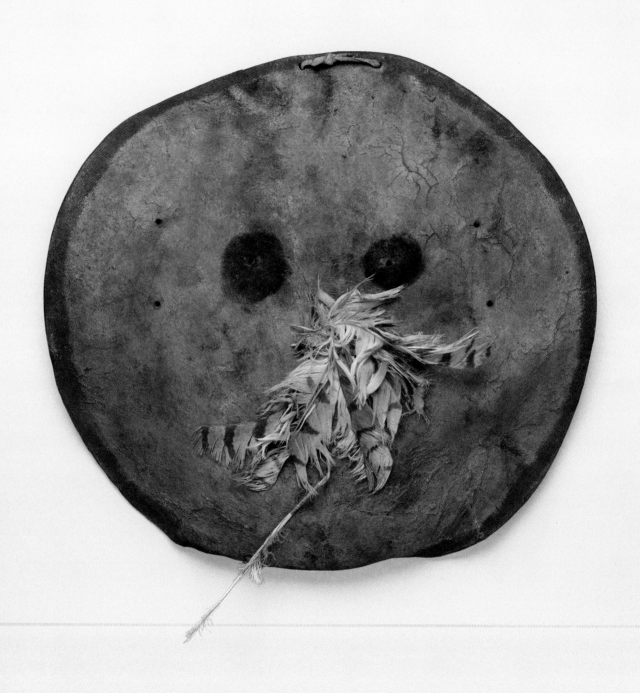

Ishbinnaache/War shield (attributed to Pend d'Orielle), ca. late 1800s, rawhide, pigment, feathers,

Field Museum

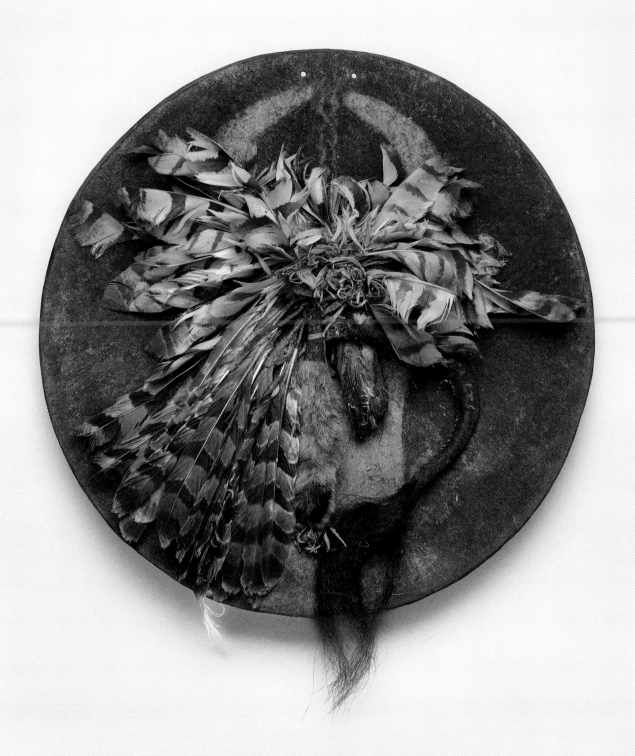

Ishbinnaache/War shield, ca. early 1800s, hide, buckskin, feathers (including eagle and hawk), buffalo and bobcat tails, claws, textile, pigment, sinew, Field Museum

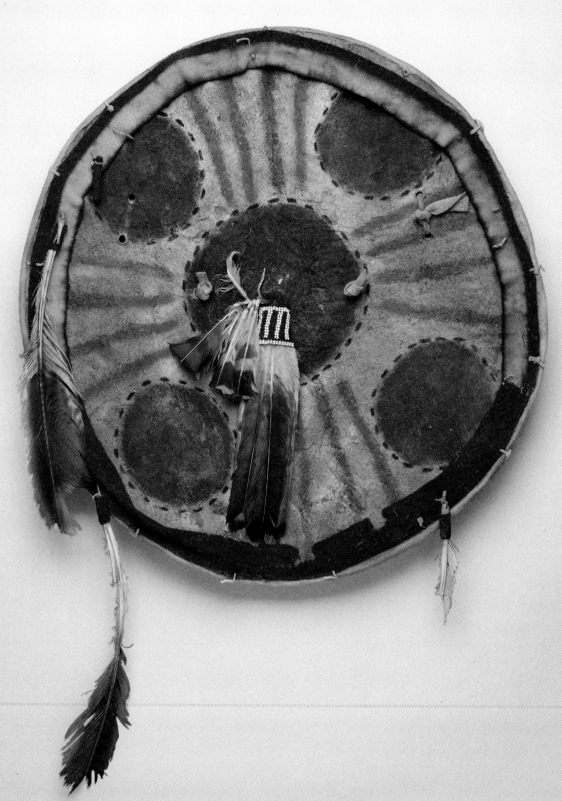

Ishbinnaache/War shield, ca. early 1800s, hide, buckskin, eagle and northern harrier feathers, textile, glass beads, pigment, sinew, Field Museum

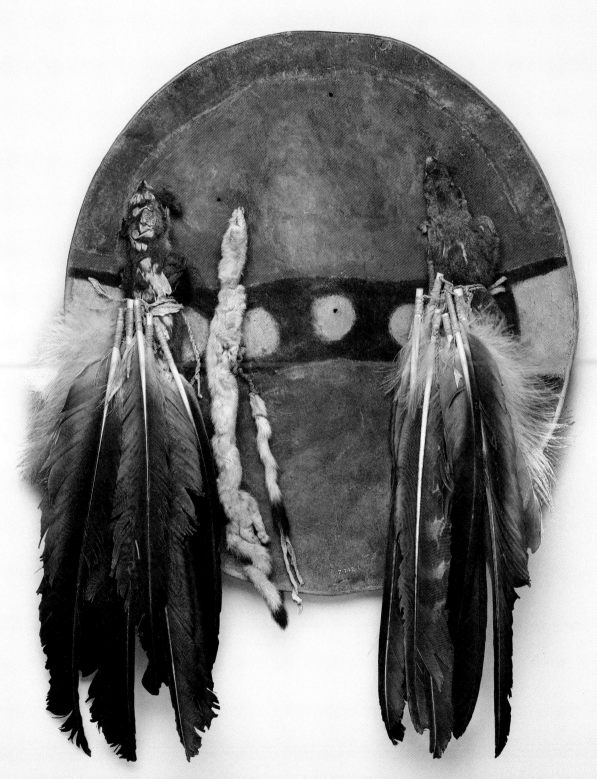

Ishbinnaache/War shield, ca. late 1800s, hide, buckskin, eagle feathers, textile, squirrel
and ermine skins, sweet grass material, horse and buffalo hair stuffing, pigment, sinew,
Field Museum

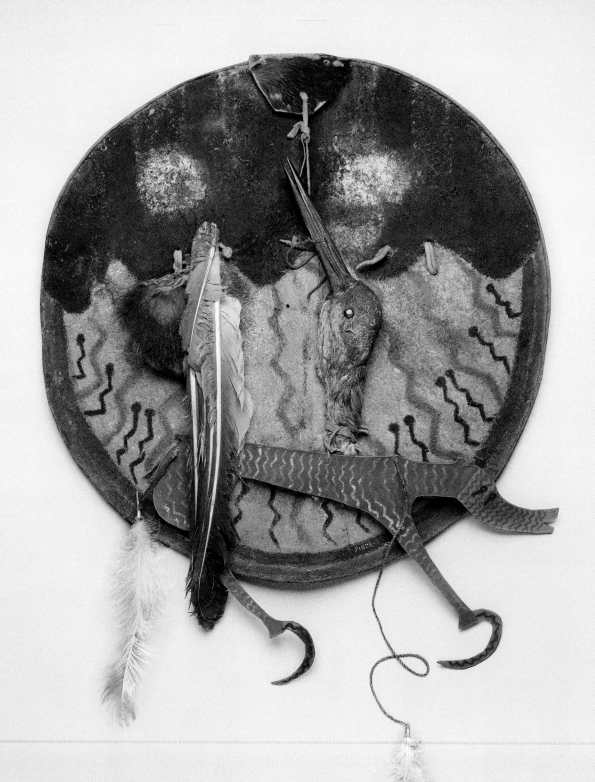

Ishbinnaache/War shield, ca. early 1800s, hide, buckskin, sandhill crane, eagle feathers,
158 bear's ear, copper alloy, pigment, Field Museum

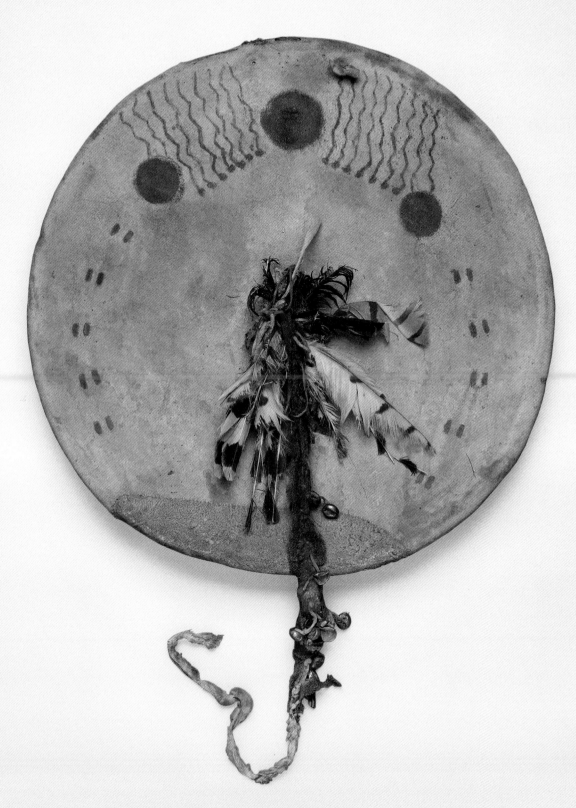

Charges Strong, Ishbinnaache/War shield, ca. 1800s, hide, buckskin, textile, animal fur, hawk feathers, copper alloy, pigment, sinew, Field Museum

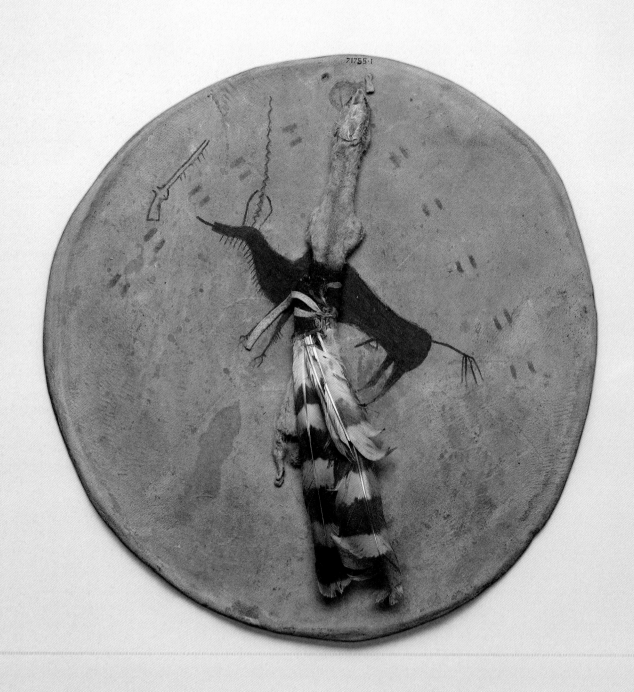

Shows as He Goes, Ishbinnaache/War shield, ca. late 1800s, buffalo hide, ocher pigment,
weasel skin stuffed with buffalo hair, Field Museum

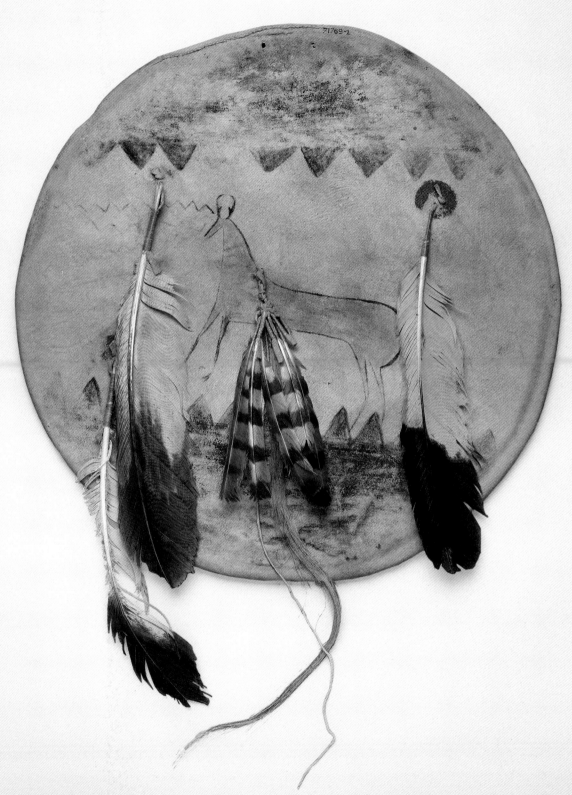

Ishbinnaache/War shield, ca. early 1800s, buckskin, eagle and hawk feathers, dyed horse hair, pigment, sinew, Field Museum

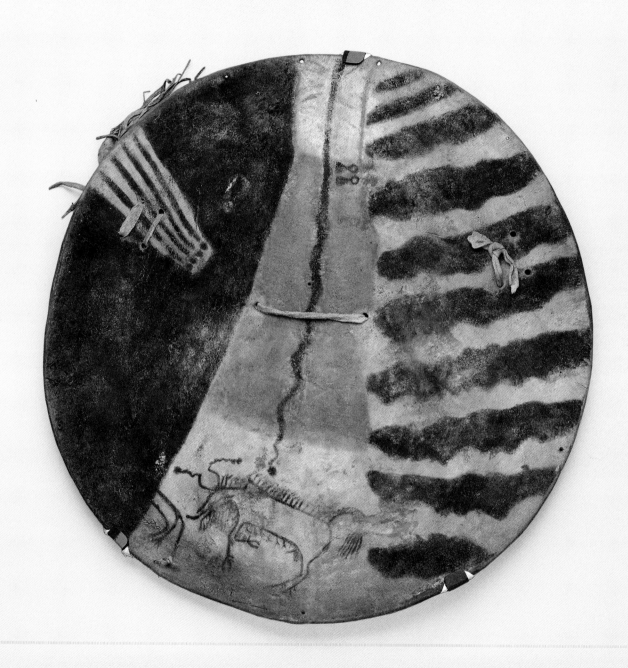

Spotted Tail, Ishbinnaache/War shield, ca. 1800, rawhide, pigment, Field Museum

chiishxaxxish

aaron b. brien

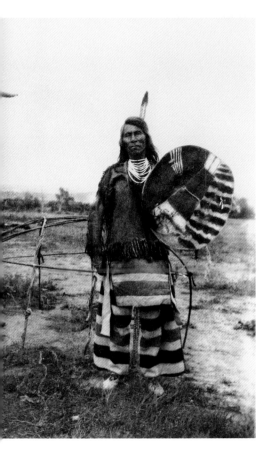

The shield belonging to Chiishxaxxish/Spotted Tail is the largest in the Field Museum's collection and one of several that depict the image of Báakkaawishee/Buffalo Above, a common Apsáalooke constellation that corresponds to the European constellation Taurus. The Buffalo Above is situated between the constellations known as the Hand Star and the Gatherer of Stars, and at one point the sun passes through it. The reason this is important is that young warriors would typically fast to seek war medicine in the early summer, when the Buffalo Above is at its most visible.

Spotted Tail was born in 1851. He was an accomplished warrior who obtained many war honors, including the military rank of Iipche Akee/Pipe Carrier. During the Reservation Era, he and his wife, Huleshiilish/Yellow All Over, made their home in the Center Lodge District.

The shield was handed down for several generations, and its power was used for many reasons on the war trail. But perhaps the most interesting thing about it is what happened immediately after collector Stephen Simms purchased it from Spotted Tail in the summer of 1902. This act tells us a lot about the thoughts of these warriors when the shields were collected, a time when poverty was high and death was common. When Spotted Tail sold the shield to Simms, he ritualistically gave up the shield, showing us that this was not an easy thing to do. As Simms wrote:

> He reached and took the shield, and reverently clasped the shield with both arms, putting it near his lips, and turned his face upwards and began a prayer, consuming several minutes in which earnest sincerity was displayed. His eyes became moisten[ed] and his voice faltered, then with dignity he passed the shield to his wife who also made a short silent prayerful farewell to the shield. She in turn passed it to the elder of the two girl children, who also offered a silent prayer, then she turned [and] passed it to the younger child, who with as much earnestness and reverence and sorrow prayed and bid it good-bye.

Spotted Tail, year unknown; Ishbinnee Iitaashte/War shirt, year unknown, buckskin, pigment, human hair, owned by Spotted Tail, Field Museum

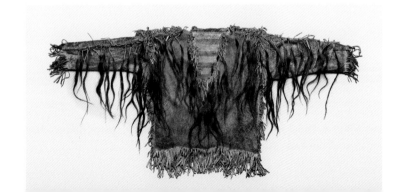

163

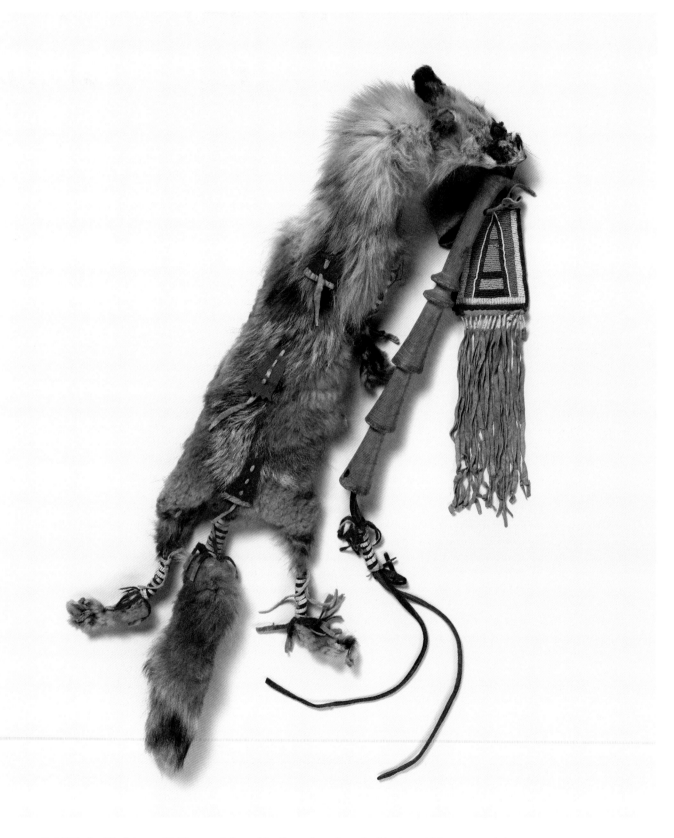

Iichiiliiche/Quirt, ca. 1910, wood, fox skin/fur, glass beads, National Museum of the
American Indian

with a good heart: learning from the apsáalooke war shields

meranda roberts

I first met the Apsáalooke war shields in the summer of 2018. At the time, my supervisor at the Field Museum was working on fulfilling a request orchestrated by scholars not affiliated with the *Apsáalooke Women and Warriors* exhibition to identify the original owners of the shields. Additionally, colleagues from the museum's bird department had been recruited to identify the varying species of birds that had been placed on a number of the shields. One day, my supervisor invited me to join in on the identification process. From the moment I entered the room where this work was being done, I began to feel apprehensive, doubtful, and a little fearful.

It goes without saying that each shield is beautiful in appearance. Each of their designs communicates a story and dream so powerful that their true message cannot ever be fully known to us. In fact, a shield's life force is so intense that it has the ability to encapsulate people's emotions and physical being. Having always been sensitive to these dynamics, I was uncomfortable watching the shields being categorized in such an impersonal way. Since I did not have a true understanding of what they meant to Apsáalooke culture, there was nothing I could do at the moment to try to rectify these thoughts or emotions. As such, I excused myself to pray to my ancestors for clarity in understanding the shields' vibrancy. I also asked for the shields to be given a sense of peace before being put back in the museum's collection. Little did I know that just a few short months later my questions would be answered by way of Nina Sanders.

Nina and I first met at the Field Museum as talks began to determine if the museum could host an exhibition on Apsáalooke culture that would complement the one being planned at the Neubauer Collegium. Knowing that one of the shields would have to go to the Collegium, Nina asked me to accompany her to the collection so that she could visit with the shields. Given my prior experience,

I was a little apprehensive about meeting them again. Nevertheless, I went with her, and from the moment we walked into the collection, it felt as though the shields were making the walls vibrate with excitement, anticipation, and relief. These emotions became even more intense as we walked over to them and lifted the lids off their containers. It felt as if the shields had been patiently waiting for Nina's arrival and were celebrating at having someone from their home be in their presence.

The shields also welcomed me, almost as if my last visit had never happened. In fact, I immediately felt a strong pull to the shield identified as "Sharp Horn." When I reached out to touch him, my hand felt like it had been electrified. His happiness and eagerness to be seen and felt was palpable. In a way, it felt as if Sharp Horn and I have always known each other. This kinship to Sharp Horn made me so relaxed that I no longer feared the intensity being transmitted by the other shields. Instead, I let their zeal fuel my desire to properly discuss Apsáalooke culture, people, and history.

The main message to take away from these anecdotes is that museum collections are not dormant spaces filled with inanimate items. The Native American cultural items that encompass these assemblages contain countless stories relating to a community's traditions, cultures, and belief systems. From parfleche, baskets, and baby cradles to drums, war shirts, pieces of clothing and jewelry, and other instruments, museums house pieces of culture that crave being reunited with their source communities so they can fulfill the dreams of their makers. Each item wants to be appreciated, talked to, laughed with, touched, loved, and prayed over. Like the shields, a lot of these pieces possess an energy and power that are not easily understood with human reasoning; which is okay because not everything is meant to be understood. Overall, a collection holds the answers to questions that can help Native people in healing their communities,

whether by providing insight to language or showing how ancestors manufactured items that are currently endangered. These items deserve to be out in the open, feel fresh air, and be admired. They are alive, and it is our responsibility to honor them.

apitisaash

Timothy P. McCleary

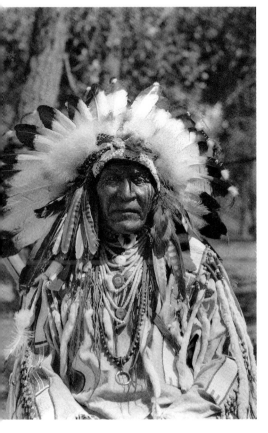

Two Leggings, a war leader and prominent River Crow chief, was born in the late 1840s. When he was four days old he was named Apitisaash/ Big Whooping Crane, by a prominent warrior from his father's clan. A few days later his father, Four, died of gunpowder burns. His mother, Strikes at Different Camps, also died when he was young. This orphan status affected him his entire life.

Big Crane sought the warrior life early on. At the age of fourteen he went on his first war party, and by the time he was eighteen he had earned three war honors. It was during this time that he attained the name Two Leggings. As a participant in a war party that got caught in a severe winter storm, Big Crane cut a pair of leggings from a blanket, put them on over his shredded leather leggings, and stuffed them with buffalo wool. His companions called him lisaatxaaluuash/Padded Leggings. Later on the same expedition, they stopped at a trading post, and the trader misunderstood the name as Two Leggings, which he was called in English from that point on.

Two Leggings also fasted successfully for the first time at eighteen. He received two sacred songs and saw the woman he would later marry. He continued to fast over the years, but was always dissatisfied with his dreams because he never gained a powerful medicine. The dreams told him that he would become known all over the world (these were later interpreted in reference to the biography that was written about him), that he would be successful in horse capturing, and that he would live to be old.

Nonetheless, older, experienced warriors told Two Leggings that his dreams were not powerful, and they instructed him to purchase a medicine bundle from a well-known warrior. He continued to organize small war parties but was warned that misfortune would occur. Eventually disaster struck. When the Crows chased after Lakota horse raiders, some of the Lakota were killed; but two Crows, one being Two Leggings' best friend, were also killed. Two Leggings was filled with grief and regret.

Two Leggings began to heed the warnings and advice and sought a powerful warrior to make him a medicine. He went to the well-known medicine man Sees the Living Bull and asked him to make a medicine. Sees the Living Bull initially refused, but eventually he succumbed to the pleading and gifts Two Leggings gave him. Sees the Living Bull made Two Leggings a medicine that allowed him to become a successful war leader and eventually band chief.

According to Two Leggings, after the end of intertribal war and the buffalo way of life, nothing happened, and the people just "lived."

Two Leggings, 1919–1922, **William Wildschut**

Two Leggings and his followers settled in the Two Leggings area of the Black Lodge District. At this point Two Leggings began a new role in tribal affairs, serving as a reservation chief. He was involved in council meetings with the US government over such issues as grazing leases and irrigation ditches for reservation agriculture.

It was during this time that Two Leggings revealed he still possessed spiritual power. When the town of Hardin, Montana, held its first rodeo, many Crow chiefs were invited to attend. But when Two Leggings arrived at the gate he was turned away. Although he protested, the gatekeeper refused to allow him in. Two Leggings then cursed the rodeo with rain, which occurred every time Hardin held a rodeo.

Possibly the most important action Two Leggings was involved in was as a member of the Crow delegation to Washington, DC, in 1917. The delegation was there to stop the opening of the reservation to general homesteading, which had been proposed by Montana Senator Thomas Walsh. The bill was defeated, and the reservation was saved from further land reduction.

Two Leggings died on April 20, 1923, on his allotment in the area named after him. Four days later he was placed in an unmarked grave near his house.

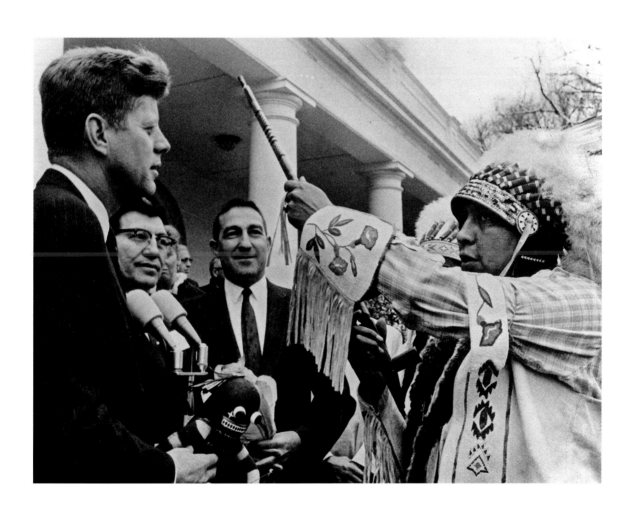

Crow Tribal Chairman Edison Real Bird blessing President John F. Kennedy with a tobacco pipe, March 5, 1963

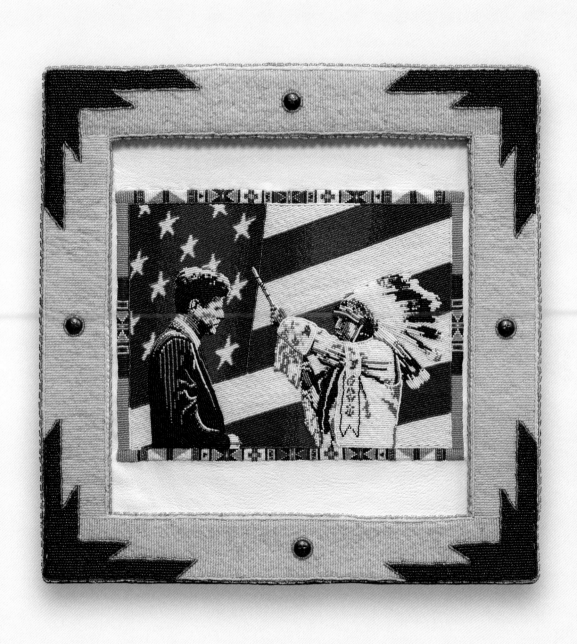

Karis Jackson, *Blessing of a Leader,* **2016**

biiawacheeiitchiish

janine pease

Biiawacheeiitchiish/Woman Chief was among the few Apsáalooke women whose feats took her to the level of chief. Generally, Crow women had their own sphere of actions that kept them in the home, raising children, preparing foods, clothing, and lodge skins, a world quite separate from the men's realm in warrior societies and warfare. Occasionally a Crow woman would accompany war parties to cook, sew, and dry meat along the way, but not to take part in battle. Woman Chief is an exception.

Edwin Denig was a fur trader of the American Fur Company and early ethnographer who was active at Fort Union in Dakota Territory (present-day North Dakota) and became a bourgeois, or superintendent, of the post. He began writing on the Plains Indians in 1851. Denig's account of Woman Chief is here in summary.

The Crow captured a ten-year-old Gros Ventre girl around 1830. She was adopted into a Crow family, and the adoptive father encouraged her to tend and guard the horses. While carrying out that duty, she shot arrows at birds and later carried a gun that she learned to shoot on foot and horseback. The girl was taller and stronger than most women. She was perceived as masculine in habits, and even outshot her male contemporaries. She hunted successfully, joined a buffalo surround, and continuously supplied her family with meat. Upon the death of her foster father, she became the protector and provider for her family.

It happened that her Crow band was camped outside Fort Union when the Blackfeet attacked. Most everyone escaped into the safety of the fort walls, but she decided to speak directly with the Blackfeet and ask them to halt their attack. The Blackfeet responded by firing on her; she rode to the fort but could not get out of the way, riding back and forth to avoid the enemy shots. Eventually she rode into the fort unharmed. This daring act brought her notoriety, and praise songs were sung in her honor.

A year later Woman Chief led a number of young men on a foray into Blackfeet country. She and her war party approached the camp at night and stole seventy horses, then drove them off at top speed to her encampment. The Blackfeet pursued them and overtook them, and a skirmish ensued. Woman Chief and her party fought the enemy and kept the horses. She took one scalp, struck an enemy, and stole his gun. This marked the beginning of many such excursions. She earned more war honors and was elevated to a level of highest respect. The Crow were proud of her, sang her praise songs, and recounted her deeds. She was named Woman Chief for her deeds, and rose to the third chief in the 180 lodges of their band.

Woman Chief owned many horses, and provided for her family, friends, and all the children in her lodges. She led a single life; no man asked for her hand in marriage. She took to herself a wife for hide dressing and cooking, as she did not perform woman's work. She took three more wives who added to her honored standing among the Crow. For twenty years, Woman Chief held forth as war chief, with successful forays and raids.

The Treaty of 1851 aimed to bring a new era of peaceful relations between Plains tribes. Woman Chief set out to visit and confer with the Blackfeet and Gros Ventre tribes. Her interest was to make acquaintance with the Gros Ventre, the tribe of her origin. She proceeded to their camps in her customary woman's regalia, and met with them, spoke to them boldly, and engaged them in talks. Suddenly, their warriors recognized her as the fierce woman warrior Woman Chief, and shot her down along with the four Crow warriors who accompanied her to their camps. This incident brought her career as war chief to a close, and ended the hopes of intertribal peace based on the 1851 treaty.

peelaatchiiwaaxpaash

Nina Sanders

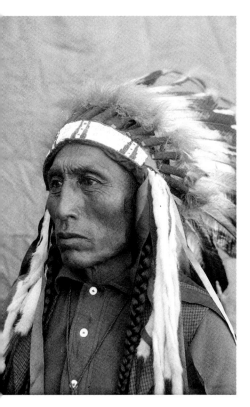

Peelaatchiiwaaxpaash/Medicine Crow, or more accurately Sacred Raven, was born along the Mussel Shell River around 1848. This was a time of unconscionable change: Native people were being forcibly removed from ancestral territories, indigenous children were taken from their communities, and multiple life-threatening diseases decimated the populations of many Native tribes. Nevertheless, young Medicine Crow lived in accordance with the traditional warrior's path; he fasted to receive visions and sought out medicine spirit Helpers that would protect his endeavors in war. At fifteen Medicine Crow went on his first war party. By the time he was twenty-two he had successfully completed all of the feats required to become a bacheeiitche/chief. He was said to have counted coup twenty-two times, with his war exploits recorded by his beloved friend Bird Far Away. Medicine Crow led many war parties, stole numerous horses, captured countless weapons, and took down many men. In 1876 he fought in the Battle of the Rosebud alongside other Apsáalooke warriors like Plenty Coups.

Medicine Crow was known for his prophetic medicine visions. In his visions he foretold the coming of the white man from the land of the rising sun, and was instructed to deal with them wisely to protect the land and the people. Thirty years before the arrival of the train Peelaatchiiwaaxpaash had a vision of a black-box-like object with circular legs and smoke spewing out. Medicine Crow also foresaw the obliteration of the buffalo and the arrival of cattle.

Medicine Crow had two wives. One was Takes Many Prisoners, the mother of Annie Medicine Crow-Real Bird. The other, Mountain Sheep, gave birth to four sons: Cassie, Leo, Hugh, and Chester. It has been said among his grandchildren and great-grandchildren that Medicine Crow was a very kind and loving father and husband who enjoyed spending time with his family. In July 1920 our beloved Peelaatchiiwaaxpaash crossed over to Other-Side-Camp. He was laid to rest on a hill overlooking the Valley of the Chiefs.

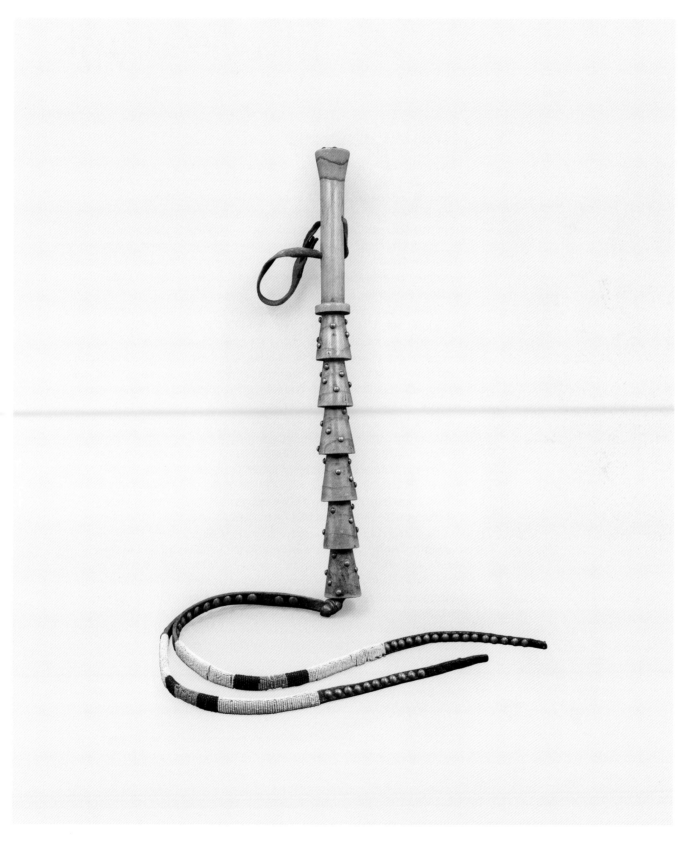

Iichiiliiche/Quirt, ca. 1870, wood, brass tacks, paint, leather, beads, Collection of Don and Liza Siegel

alaxcheeahuush

Timothy P. McCleary

Alaxcheeahuush/Many War Achievements, or Plenty Coups, known also as Chiilaphuuchissaaleesh/Bull that Faces the Wind, was born in 1848 and became the last principal chief of the Crow people. Throughout his life he fasted and had dreams and visions that helped him become a war leader and eventually leader of the whole Crow Tribe. His most important visions instructed him that white people would take over Crow Country and replace the buffalo with their cattle. He was also instructed to follow the peaceful ways of the chickadee in his dealings with white people.

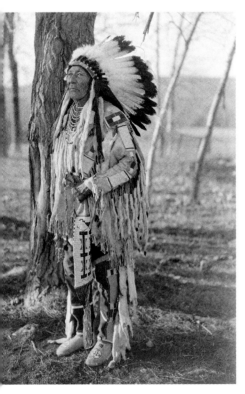

Throughout his teen years Plenty Coups honed his skills as a warrior, and by the age of twenty-one he was a chief. It is believed he had earned one hundred war honors and the chiefly war honors at least four times over. At first he was a war leader; then he became a camp and band chief. As the US military fought the allied Lakota, Cheyenne, and Arapaho in the Plains Indian Wars, Plenty Coups and his fellow chiefs decided to maintain peace and even assist the US military against common enemies. Crows served as scouts throughout the Plains Indian Wars. Plenty Coups himself fought with General Crook at the Battle of the Rosebud in June 1876.

Although Plenty Coups established his position through his military prowess, it was his diplomatic skills that gave him the most influence among his people and with the US government. After the passing of the principal leader, Sits in the Middle of the Land, in 1879, Plenty Coups was recognized by the US government as one of a dozen band leaders.

Pretty Eagle was subsequently chosen to succeed Sits in the Middle of the Land, but when he died in 1904, Plenty Coups became the principal leader of the Crow. He soon became the most influential Crow leader of his time. From 1907 until 1917, Plenty Coups led the most significant political battle of his career as chief. A series of bills had been proposed in Congress to open the reservation to non-Indian settlement. Debates over the issue solidified Plenty Coups' position as principal leader.

Seven Crow delegations traveled to Washington, DC, over the ten-year period. The delegations were composed of the elder chiefs and younger, educated leaders. These groups successfully defeated the various bills. Pressure to open Crow lands continued, but the Crow leaders proved able to negotiate the process on their own terms. The battle against the effort to open the reservation became Plenty Coups' last large-scale involvement in tribal affairs. He remained involved in tribal politics until the end of his life, but when the Business Committee was established he chose a less active role.

The aging chief assumed the role of elder statesman, and in 1921 he was chosen by the US War Department to represent all American Indian tribes at the dedication ceremony for the Tomb of the Unknown Soldier in Arlington National Cemetery. Plenty Coups' participation in this ceremony brought him international recognition. A few weeks later, Marshal Ferdinand Foch, commander of the Allied Forces during World War I, made an unplanned stop on the Crow Reservation to meet with the chief. Plenty Coups also received other national and international dignitaries at his home in Pryor.

In the spring of 1928, Plenty Coups bequeathed his home and 190 acres of land as a park for all people. At the dedication ceremony on August 8, 1928, he stated that his gift should be "a reminder to Indians and white people alike that the two races should live and work together harmoniously."

In the last years of his life Plenty Coups was still concerned about the affairs of his people. On November 7, 1931, he asked attorneys working for the Crow Tribe to petition the government to reserve the Pryor and Bighorn Mountains from allotment into private land. This wish was approved by the government, and the portion of these mountains on the present reservation remains tribal communal land.

Plenty Coups died a few months after this meeting, on March 3, 1932. Two days after he passed the Business Committee unanimously passed a referendum recognizing Plenty Coups as the last chief of the Crow Tribe.

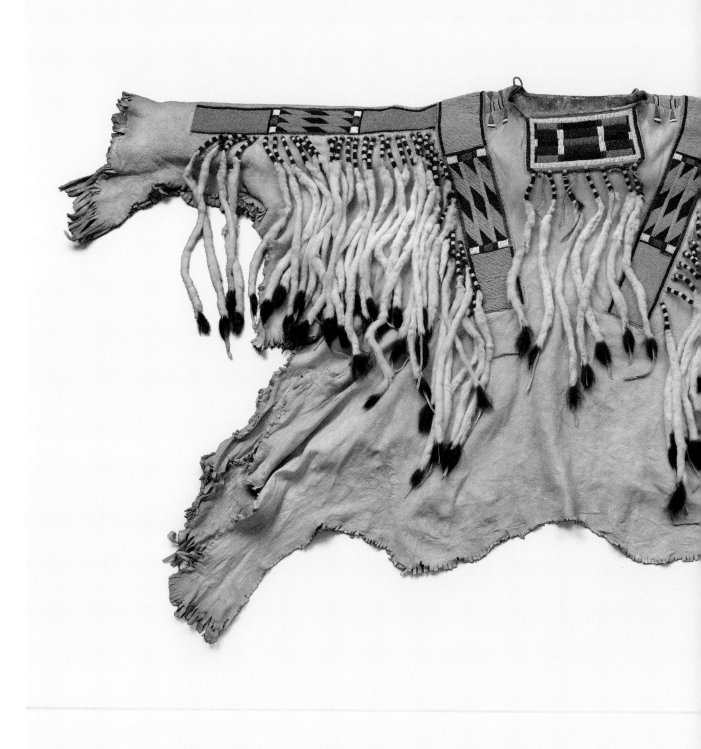

Baleiittaashtee/War shirt, year unknown (possibly mid-nineteenth century), hide (buckskin, leather), textile, fur (est. ermine), glass, hair, quill, sinew, thread, pigment, Field Museum

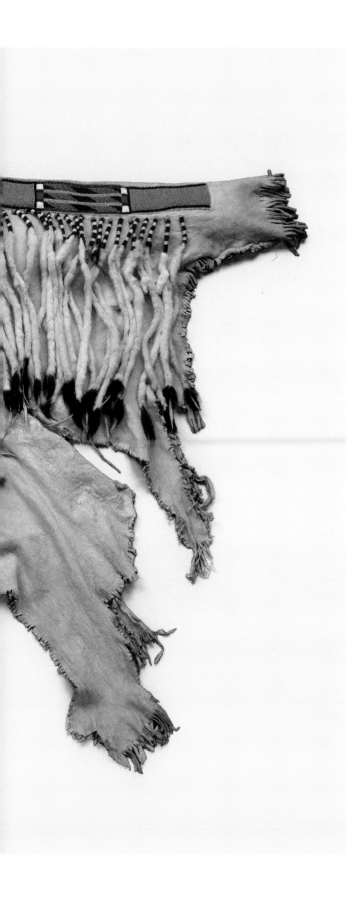

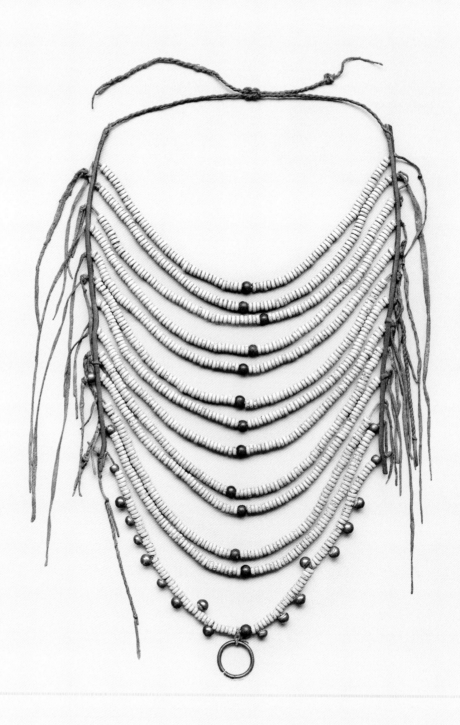

Duushluuataache/Breast piece, year unknown (possibly late nineteenth century), leather, copper alloy, glass, Field Museum

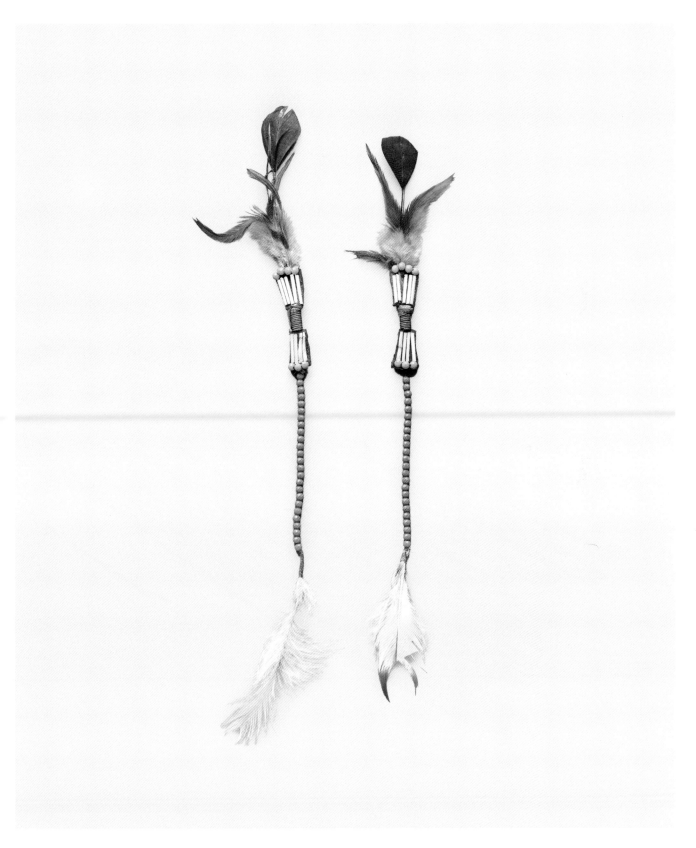

Baleiitchuunmaakoole/Hair bows, year unknown (possibly late nineteenth century), hide, sinew, beads, bone, feathers, copper alloy, Field Museum

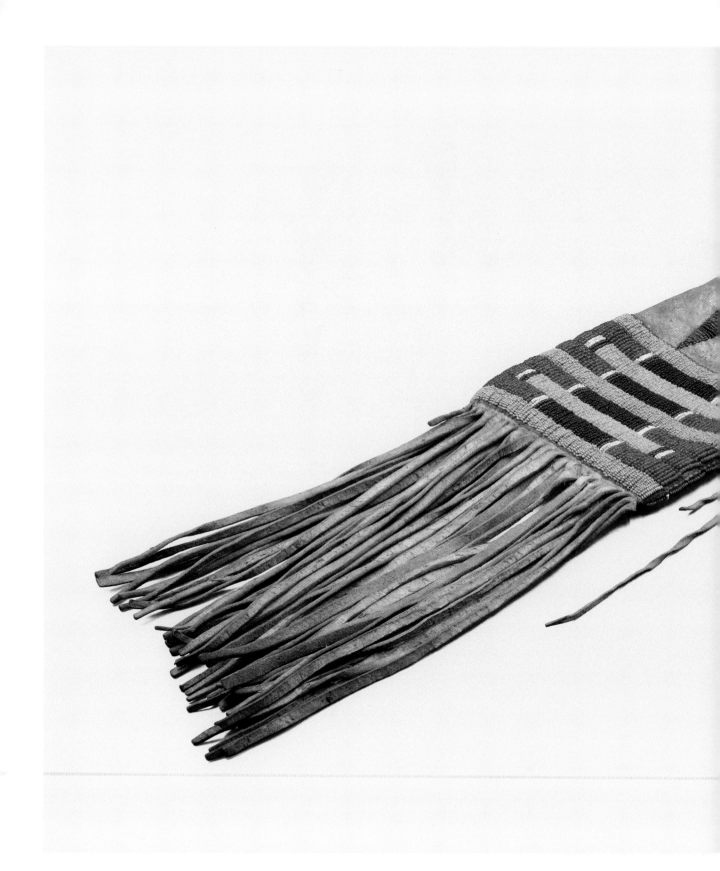

Iipchisshe/Pipe bag, ca. 1885, hide, beads, sinew, Collection of Don and Liza Siegel

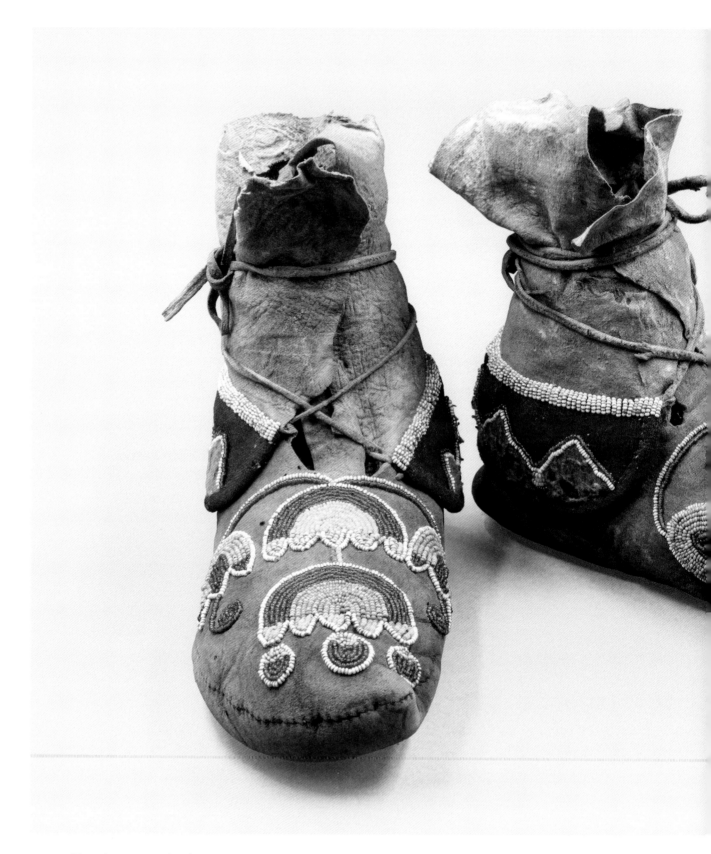

Huupkootaawaaluu/Moccasins, Tobacco Society, ca. 1870, hide, wool, beads, sinew, thread,
Collection of Don and Liza Siegel

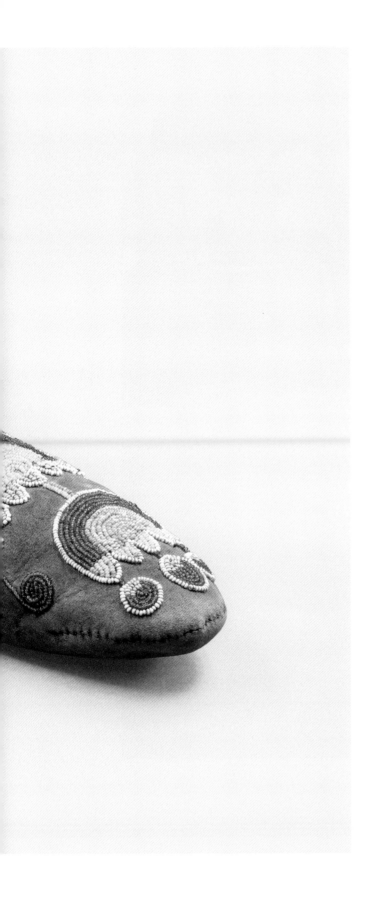

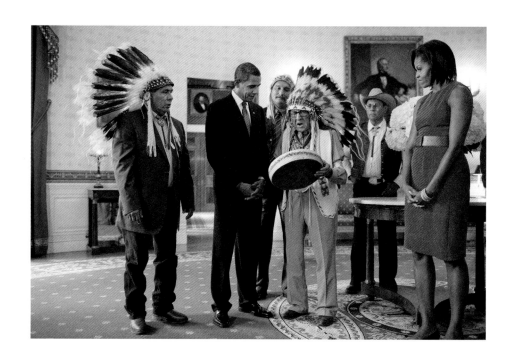

Joe Medicine Crow (center) with Barack and Michelle Obama and others at the White House, August 12, 2009; the Presidential Medal of Freedom awarded to Joe Medicine Crow

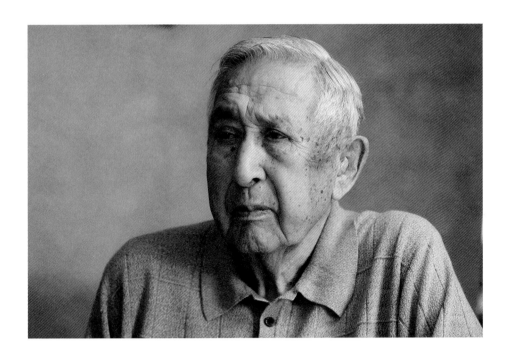

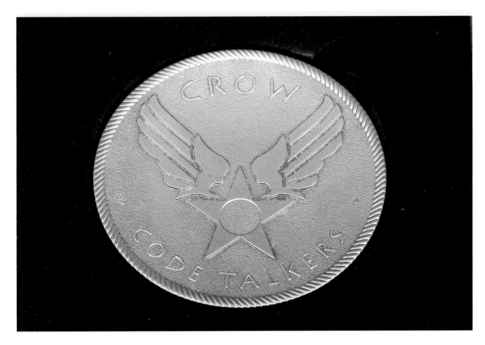

Barney Old Coyote at his home in Belgrade, Montana, 2011; the Congressional Medal awarded to Barney Old Coyote for his service in World War II

Upon voluntary enlistment at age seventeen, Barney Old Coyote Jr. said, "When there is gunfire at the edge of the camp, warriors answer." When referred to as a Code Talker, he replied, "We are not Code Talkers. We simply spoke Crow." It was an unbreakable code. Humility, courage, sacrifice, survival, family—Apsáalooke beliefs are embedded and affirmed in this recognition from the United States.

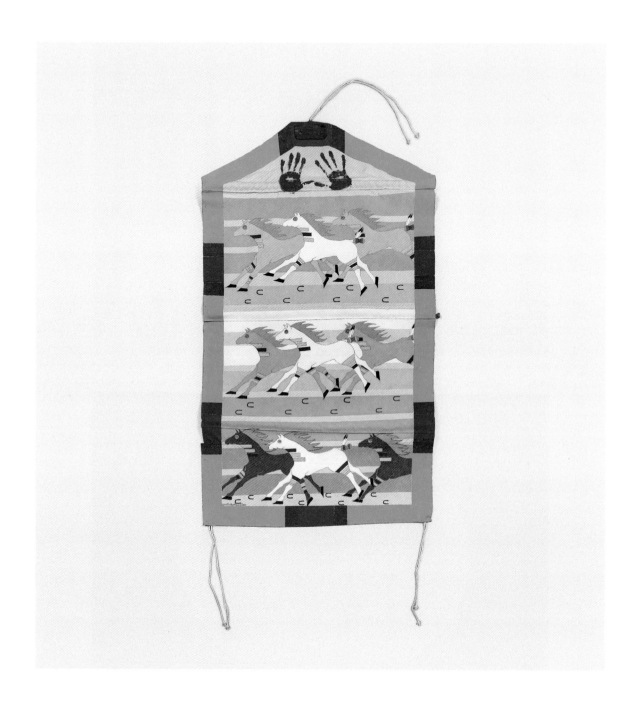

Mona Medicine Crow, *Warriors,* 2019

I stand here today a proud two-spirit Apsáalooke artist. I love my culture and the amazing creative expressions in all its forms. The one constant throughout all the generations is the timeless Apsáalooke's artistic aesthetic—derived from both nature and imaginative interpretations. Regardless of historical struggle and challenges, a proliferation of traditional artistry carried into the twenty-first century. I have deep admiration for my ancestors and my people's tenacity and strength. I love that the younger generation is continuing this.

— Mona Medicine Crow

jonathan lear

In 1988 I went to a lunchtime lecture at the humanities center at Yale University. The historian William Cronon was giving a talk about how to write a history of the Northwest Plains. In passing, he quoted Chief Plenty Coups speaking about his tribe's move onto the reservation: "After this, nothing happened." When I heard those words I felt I was kicked in the stomach. The talk ended, and I walked out a bit sick. Then I felt better, and I forgot all about it. More than a decade passed. I had moved to Chicago. One day I was walking along Lake Michigan letting my mind wander and Plenty Coups' words came back, as if from nowhere. This was a surprise. I had no idea that Plenty Coups' words had taken up residence in me. (An Apsáalooke friend has since told me I should not assume the words were "in me.") I felt I needed to do something, but I had no idea what. I walked back to the Seminary Coop Bookstore and found a copy of Frank Linderman's biography *Plenty-Coups: Chief of the Crows*. That began a years-long immersion in everything I could find about the Crow (or Apsáalooke), about peoples of the Plains and the histories of Native Americans. I started making trips to the Crow Reservation. I did not want to impose on anyone, but I did want to talk and above all *listen* to whoever might want to talk to me. One summer an acquaintance lent us a cabin about twelve miles up into the Wolf Mountains. She would not accept rent. The road up to the cabin was mostly unpaved—and my wife and then six-month-old son and I went up there to live. The cabin was located just over a hill beyond a Sun Dance ground. It was a good spot for picking chokecherries. People would stop by. We went on trips through Crow Country. My son, Sam, was put on a Crow horse before he could walk.

I am not a historian and I am not an anthropologist. And I had no interest in "studying the Crows." But I thought that Plenty Coups had spoken to whoever would listen and, however it came about, I was confronted: either I needed to say something

back or I had to decide not to do so. There was no evading *that* choice. The more I thought about it the more wondrous I found it that Plenty Coups—with all he and his people went through—was willing to speak at all. Why did he not refuse to have anything to do with us ever again? My book *Radical Hope: Ethics in the Face of Cultural Devastation* begins: "Shortly before he died, Plenty Coups, the last great chief of the Crow nation, reached out across the 'clash of civilizations' and told his story to a white man." Others can tell us about Plenty Coups' personality. As a philosopher, I am interested in a background commitment that shines forth from Plenty Coups' willingness to have a conversation. I came to think of that commitment as *radical hope*: a hope that the conversation would lead to something good, even if one has no idea or even lacks the concepts to think what that good could be. *Apsáalooke Women and Warriors* is another gift of the Apsáalooke people to keep a conversation going.

Soon after *Radical Hope* was published I was invited to speak at Little Big Horn College, at Crow Agency. I had no idea how the conversation would go. What was a "white man" doing writing about the Crow? I have no "expertise" and the book fits in no established genre. It is not an investigation of facts but an essay in philosophical imagination. It is a thought experiment into what Plenty Coups *might have meant* if he was standing witness to happenings coming to an end. I wanted to take seriously the idea that things might stop happening. And I wanted to bring Plenty Coups into open-ended conversation with thinkers who have sustained me: Aristotle and Plato, Kierkegaard and Heidegger, Freud. Where would that conversation lead? I assumed the book would be flawed, but that I would only come to understand the flaws over time, if I did my part to keep a conversation going. So I went up to the reservation, this time to give a talk.

The room was packed; not only with students and faculty, but with tribal elders and officials and

a wide range of adult members of the community. I was about thirty seconds into my presentation when a tribal elder, sitting in the front, raised his hand. "Who are your people?" No one had ever asked me that question before. And I had never thought of myself in those terms. (Only later did I learn that I should have done more to introduce myself; and one does this by letting the audience know who one's people are.) I said what came into my mind: "I think an answer to your question is that I am Jewish." It crossed my mind for the first time that when the Apsáalooke were moving onto the reservation my family was escaping from pogroms in Europe and the Ukraine. Another hand went up. "Why is it that you Jews never fight amongst each other, while we Crows are always fighting with each other?" Obviously, that is not how it seemed to me. I came to learn how fascinated some indigenous peoples are by the fact that thousands of years after the destruction of their traditional way of life, the Jewish people still exist and have developed new traditional ways of life. How is it that this tribe was not destroyed? The conversation went on and, at least that day, we never got to *Radical Hope*. The friends I made that afternoon and evening are still my friends. They have introduced me to others who have become my friends. By now I have been up to Crow Country many times and my friends have taught me to understand that their land is sacred to them, a promised land. They have taught me to see and smell and walk and sleep on the land differently. And when they have come to visit with me in Chicago they have taught me that when it comes to artifacts in the collection at the Field Museum there is important unfinished spiritual business. (They have also asked me to take them to synagogue.)

In *Radical Hope* I spoke of the possibility of a new generation of Crow poets who would take up the Crow past and—rather than use it for nostalgia or ersatz mimesis—project it into vibrant ways for the Crow to live and to be. Here by "poet" I mean the broadest sense of creative maker of meaningful space. The possibility for such a poet is precisely the possibility for the creation of a new field of possibilities.

Of course, I did not know what I was talking about. How could I? I needed a contemporary generation of Apsáalooke poets to share their art with me. Without their poetry, without their teaching, I could only gesture in a direction. To the Apsáalooke

artists and writers in this volume I want to say thank you, *Aho!*

With *Apsáalooke Women and Warriors*, the Apsáalooke artists exhibit and speak for themselves. I would like briefly to comment on the environment in which this exhibition takes place. The Field Museum is one of the great cultural institutions in Chicago and one of the great *natural history* museums of the world. As such, it has a troubled past. From its inception the Field Museum depended on contributions from indigenous peoples as well as from members of dominant cultures. But the manner of these contributions was unjust and exploitative. And the whole structure rested on motivated misconceptions of the relations between peoples. To take one painful example: the original aim of collecting these artifacts was to assign them to natural history. They were intended to be understood not only as *from* the past, but soon to be *of* the past. The interest in "preserving" this history carried with it an assumption of a fading future. And the idea that there was some kind of "natural" unity to be had in housing these artifacts in the same institution that held collections of butterflies and insects pinned on display boards, snakes, iguanas, bats, not to mention stuffed gorillas, wolves, tigers, and buffalo... *that* cultural outlook is no longer viable, thank goodness. But how to be instead?

Here we are! Readers of this volume, visitors to the Field Museum, Apsáalooke artists, museum staff, members of the culture at large, some indigenous, many not: *here we all are, landed* with the problem of a troubled history. This is not a problem any of us chose; none of us was there back then to bring it about. But this is our condition: to be creatures whose present and future is shadowed or nurtured or haunted by pasts—pasts of which we may or may not be aware, but are nevertheless issues for us.

Among the artifacts we live with is the Field Museum itself. The museum is not just an institution that puts on a variety of exhibitions; in its exhibitions, as well as in the collecting and the research it supports, the museum *exhibits itself. Apsáalooke Women and Warriors* is historic not only because the museum invited an Apsáalooke woman to curate the presentation of its historic collection of artifacts, but also because it supported her determination to reimagine what such an exhibition might be like. This exhibition celebrates the museum's collection by locating it in the context of contemporary work by

Apsáalooke painters and photographers and writers and fashion designers, beaders, dancers, and rap artists. This exhibition is not just "about" Apsáalooke life—it is an expression of Apsáalooke life by the Apsáalooke people themselves. Until recently, this was not even a possibility. At the same time, this exhibition is also a resculpting of the museum.

It is not an exaggeration to say that the very idea of a natural history museum is in play. This is an ethical and social challenge, and it is also a philosophical problem. So, what are we any longer to mean by *conservation*? We can understand the traditional meaning by looking at the meticulous practices the Field Museum has worked out over the past century. It is thanks to this care that the historical artifacts in this exhibition are still in existence for us to appreciate. Yet what if peoples from whom these artifacts derive believe that these things *need to be used*—by appropriate people in appropriate circumstances? It is too limiting to conceive of this challenge simply as a conflict of *values*—between those who put primacy on conservation and those who privilege use. That framing of the issue assumes that we already know the terms of the debate, and that the only question is how to rank our preferences. It assumes that the concept of *conservation* is itself fixed—fixed as dominant cultures have understood it over the past century or two. But what if we were to go down a different path: one in which *conservation* implied *proper care* and proper care required appropriate use? This would in turn require that parts of the Field Museum be transformed into sacred spaces or into spaces appropriate for ceremonies: places where it would be appropriate to carry out the rituals in whose context these objects (and spirits) would be, if not *at home*, at least *comfortable for the time being*. Do the shields need a parade?

I have no idea where this conversation will lead nor do I have firm thoughts about where it ought to go. But that it should continue seems to me both marvelous and of untold significance for the future of our civilizations.

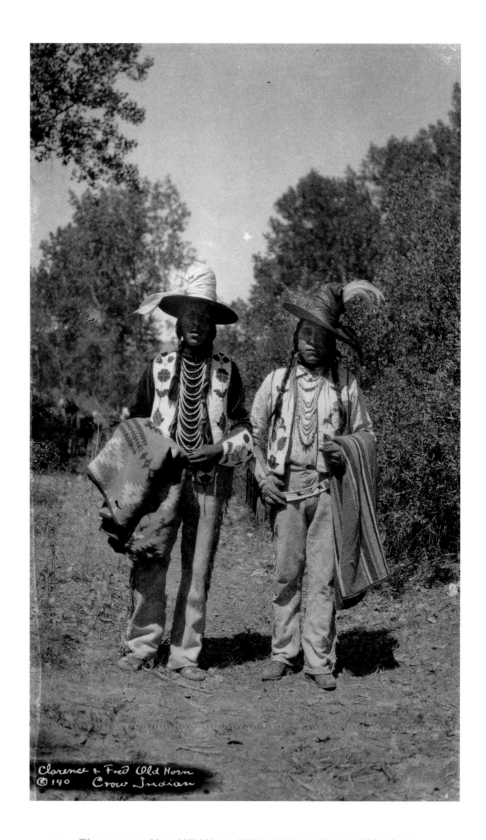

Clarence and Fred Old Horn, 1917–1928, William Wildschut

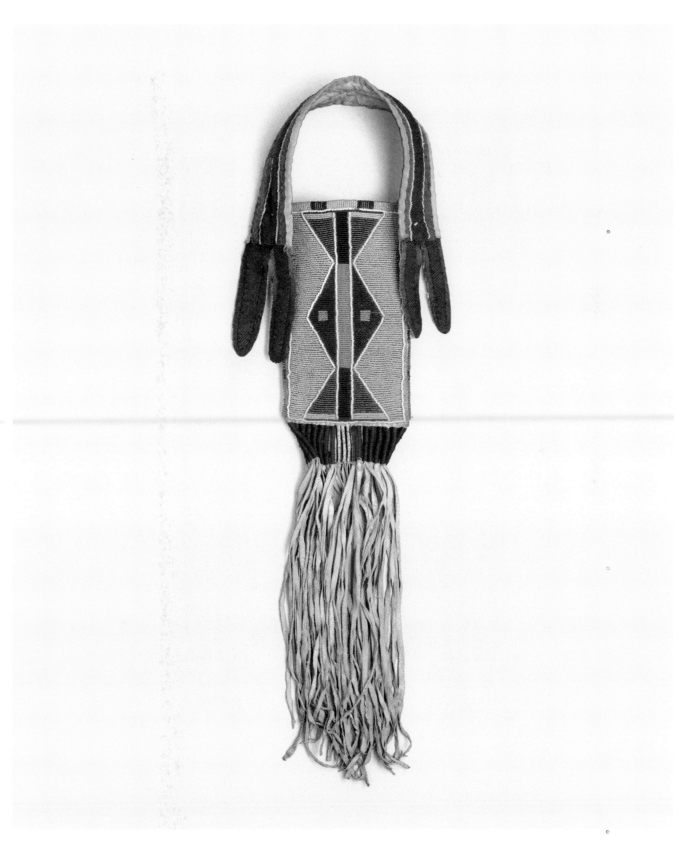

Iiwaleihchichikkaaisshe/Mirror bag, year unknown, leather, textile, hair, glass, iron alloy, pigment/
paint, dye, plant fiber cord, sinew, thread, Field Museum

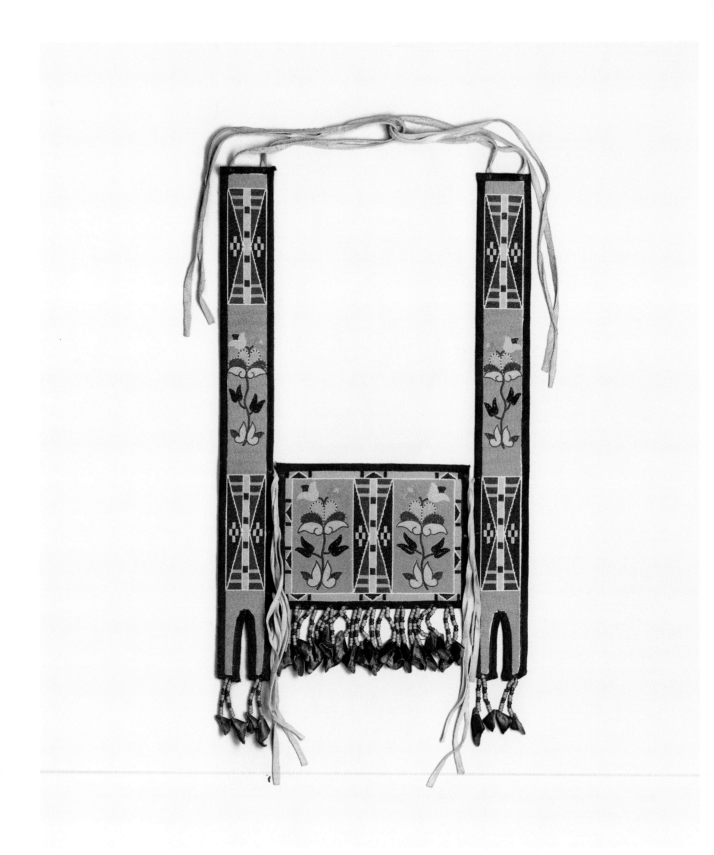

194 Lydia Falls Down, *Martingale*, 2012, Field Museum

good horses to lead: a crow fair memory

hunter old elk

It is six a.m. Friday morning of Crow Fair. I have just awakened from my slumber by camp crier Mr. Tilton Old Bull.[1] He has just driven through the Center Lodge District camp area for the first time this morning. He's exclaimed, "Wake up, all you Center Lodge! Wash your face and put the coffee on. The parade starts at 10 a.m. sharp." I breathe in the cool fresh air, peel out of my bedroll, and think, Crow Fair is here. It marks the end of summer and the beginning of a new year. My heart is whole.

The past week has been consumed by hours of setting up our camp and repairing tipis. My Kaale Carlene, aunts, and sisters have spent all of August repairing and organizing parade gear, and dressmaking. Kaale has also directed her descendants on how she wants her camp set up.[2] My aunts sit back and observe; it will be their camp one day. My Basaaksahke Daniel and uncles attend to horses, cutting shade, and tipi poles.[3] My grandparents have done this since the 1970s, when they established their camp west of the powwow arbor.

Cowboy coffee is brewing in the vintage enamel kettle. I walk over to the wash pan, splash water on my face, and look up at Gas Cap Hill. In hours a cannon will boom, and the most spectacular horse parade will begin. Last night, while sitting around visiting, it was decided which family members will parade today. My sisters Sarah and Samantha, as well as my brother Evan, have volunteered. Sarah's father bought a gray gelding just for the occasion.[4] We eat breakfast and then it is time to dress the horses. Thousands of hours of beadwork, rawhide work, and horsehair hitching are laid out as my grandmother directs which beaded sets she wants where. My grandfather does the same. The sight is like nothing you have seen before. After about an hour and a half of dressing horses, the girls are ready. Each will parade in the Old-Time Saddle category in their respective age groups. Evan enters the Men's War Bonnet category. My grandfather sings praise songs as his grandchildren ride up the hill. We'll do it all again the next day.

Notes

1

The camp crier is an important member of Crow society, as he holds special rights to speak to large groups of Crow members. The camp crier is trained and must own the right to be the crier. He purchases or is given the right from someone who possesses that skill set.

2

"Kaale" is the Apsáalooke word for grandmother. Carlene Old Elk, my paternal grandmother, married my grandfather Daniel Old Elk in 1967. She was born in South Carolina and was stationed on the Crow Indian Reservation when she was an AmeriCorps Vista worker in the 1960s. She is adopted into the Tobacco Society and she is a fluent Crow speaker, although she is non-Native.

3

"Basaaksahke" is a female's term for addressing her grandfather. My grandfather Dan had a long career in tribal governance as a district senator representing the Center Lodge. He earned spiritual rights as a Sun Dance leader and in several other societies including the Tobacco Dance.

4

Celebration and honor of the horse are among the highest regarded teachings of Crow people. Traditionally, Crow men desired rare and outstanding Medicine Hat horses. This breed of horse is completely white with a patch of black covering the ears and top of the head. Crow women traditionally rode mares with young colts following close behind. It was believed that a good mare brought prosperity and life with the birth of her colt. With advanced techniques, the Apsáalooke admire finely bred horses of all colors, especially the American Paint Horse.

chiichiaxxawassuua

hunter old elk

Chiichiaxxawassuua/Where They Race in a Circle is a reclamation of government policy and programming aimed at showcasing twentieth-century efforts to Americanize Apsáalooke people. Like several other paternalistic and ethnocentric programs across Indian Country that reinforced efforts to integrate Native peoples' agrarian lifestyles, Crow Fair failed to benefit its recipients. But in the century since its inception Crow Fair has adapted to represent more than just a failed government program. It represents more than one hundred years of Apsáalooke ownership of its contemporary narrative.

By 1900, the Bureau of Indian Affairs (BIA) commissioner had forbidden traditional ceremony, song, and celebration. Crows felt isolated from the outside world, and government policies reinforced this attitude across the reservation. Ranchers in all districts were eager to showcase their cattle in farming competitions, and the government sought to measure its acculturation successes. Bearing all this in mind, BIA agent Samuel G. Reynolds, who was stationed in Crow Agency from 1903 to 1910, imagined a festival like the local county fairs of the Midwest that would support self-sufficiency and food sovereignty. In October 1905, the first Crow Indian Industrial Fair was held.

Subsequently, district leaders agreed to participate in the weeklong festivities, but with many stipulations. Members were able to dress in "old-time regalia"; decorate, parade, and race horses among clans; and participate in traditional forms of celebration such as honor songs and the Hot Dance. Apsáalooke men competed for prizes in carpentry, produce, and livestock management. Women's participation, although menial in the eyes of the organizer, celebrated skills such as penmanship, canning, baking, and sewing. Reynolds recognized the social gathering and celebration as an integral part of Apsáalooke health. This relationship estab-lished a compromise between district leaders and BIA agents: if Crows participated in "American and Christian holidays," then they could celebrate in traditional dress. The BIA immediately recognized the benefit of a yearly celebration, and by 1909, forty acres had been set aside as a permanent camping space. Several families have since occupied those spots or moved closer to their district.

In the early years the BIA chose certain members to hold leadership roles such as Crow Fair president and secretary. The event was halted during World War I, World War II, and for some years during the Great Depression. It was difficult for the BIA to manage the event after the Great Depression. Crow Fair was relinquished to the tribe in the mid-1930s, likely a response to the Indian Reorganization Act. After that, the focus of the event shifted from its original intention of celebrating agrarian achievements to celebrating kinship and district competition. Organizers, now governed within the tribe, wanted to emphasize skills such as dancing, singing, and horsemanship, and they permanently moved the event to August. In 1962, Crow Fair earned the title "Teepee Capital of the World" and became an All Indian Rodeo with the leadership of Pius Real Bird.

These values continue to guide Crow Fair to this day. All participants, including Apsáalooke, extended families, friends, visitors, even adversaries, aid in the narrative that the celebration of life is an integral part of the human experience. For Apsáalooke people, it is not just how but also why we celebrate at Crow Fair that makes the event such an important part of our contemporary story. Crow Fair is so much more than just six days of camping, parades, rodeos, powwow, and Indian Relay. It is the physical manifestation of the fact that Crow people own our resilience, our right to sovereignty, and control of our next century.

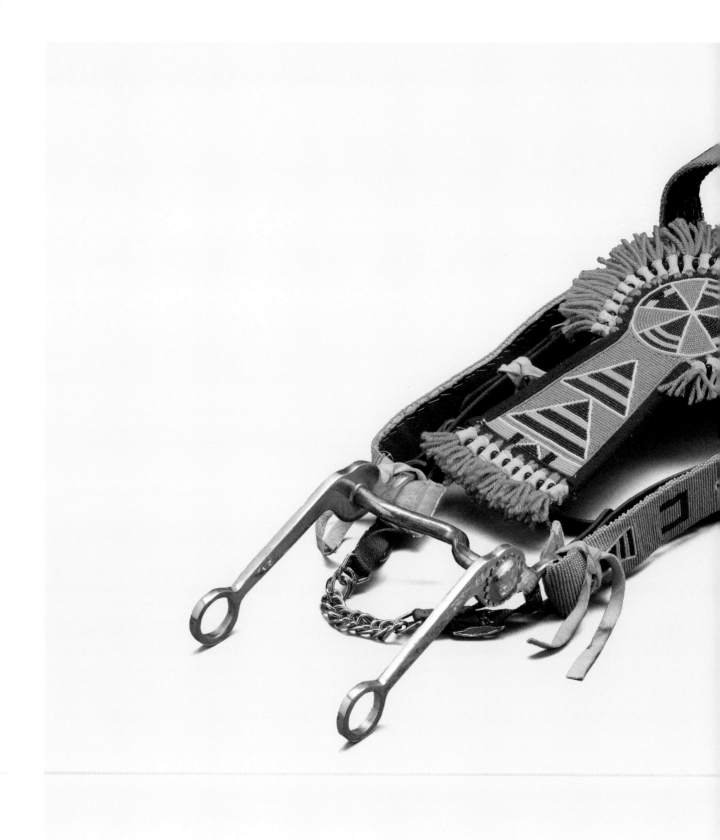

Lydia Falls Down, *Head Ornament*, 2012, Field Museum

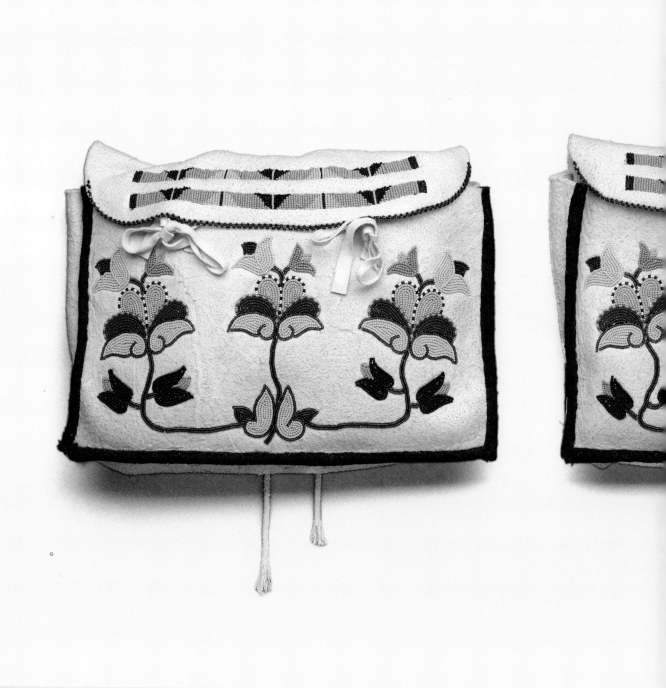

200 Lydia Falls Down, *Bags*, 2012, Field Museum

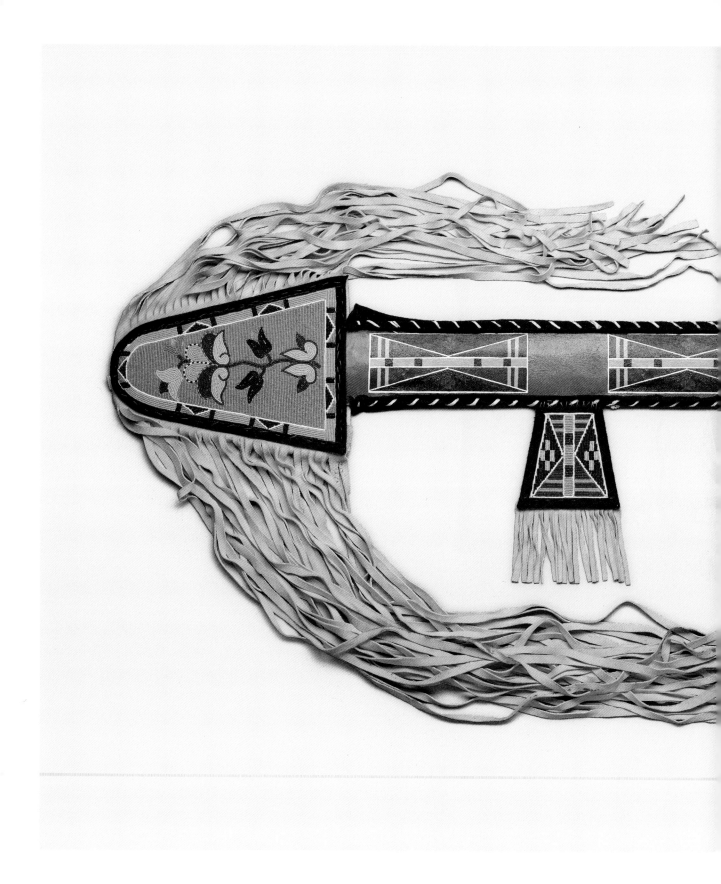

Lydia Falls Down, *Lance Case*, 2012, Field Museum

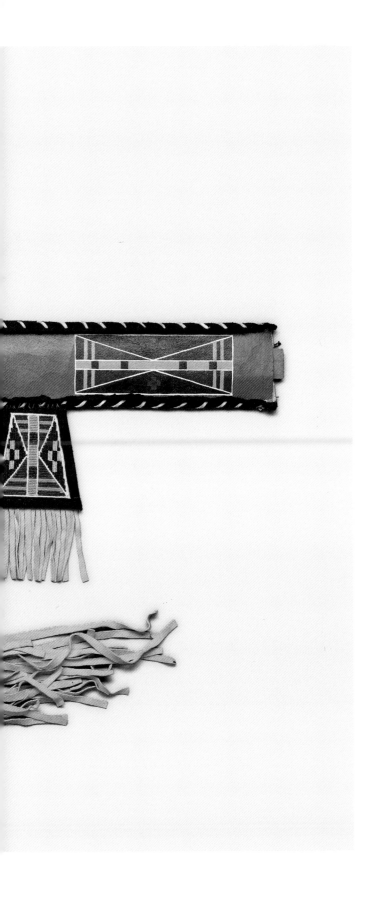

bethany yellowtail

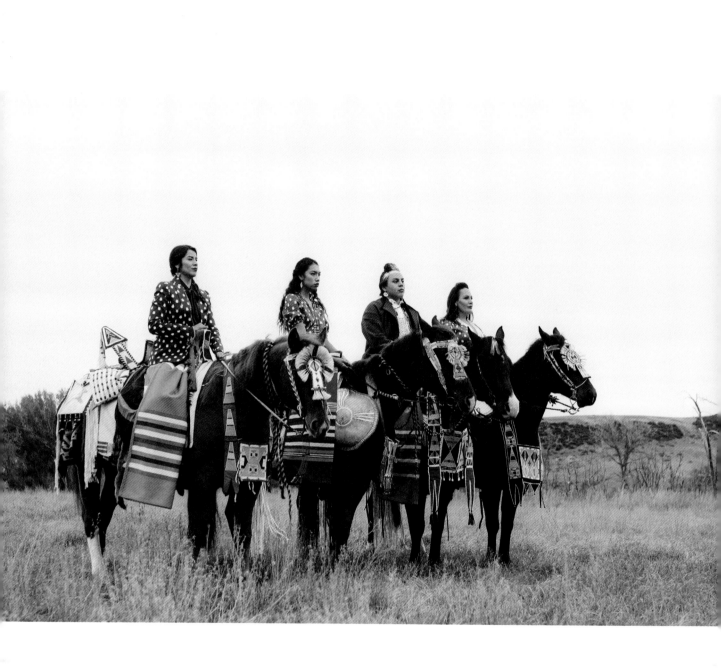

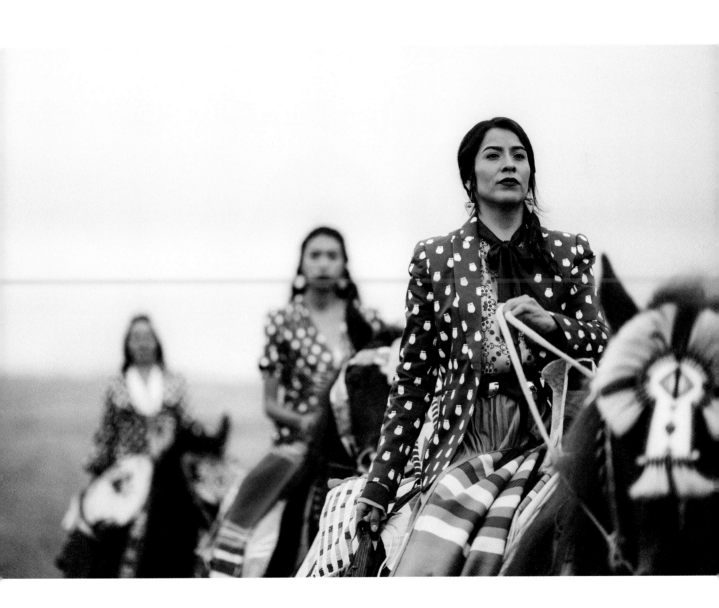

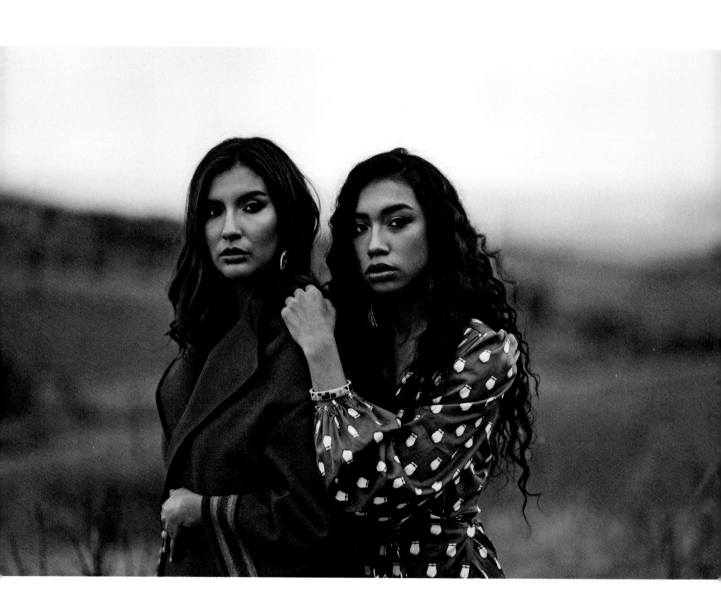

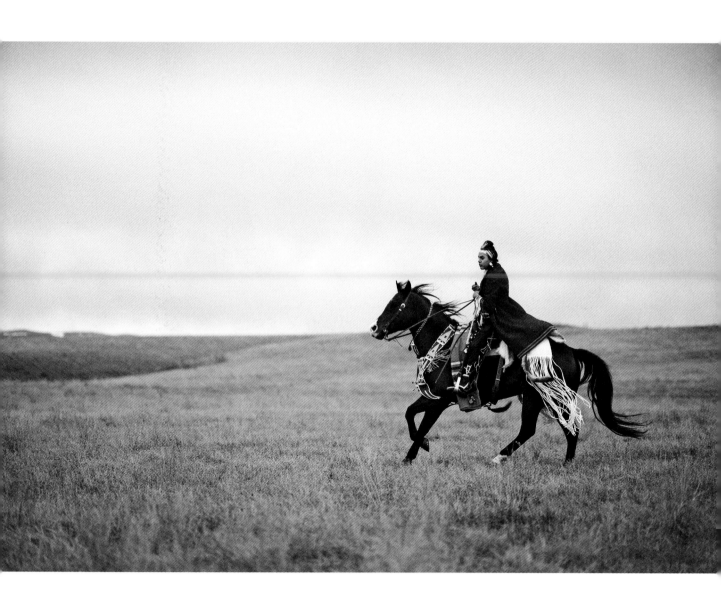

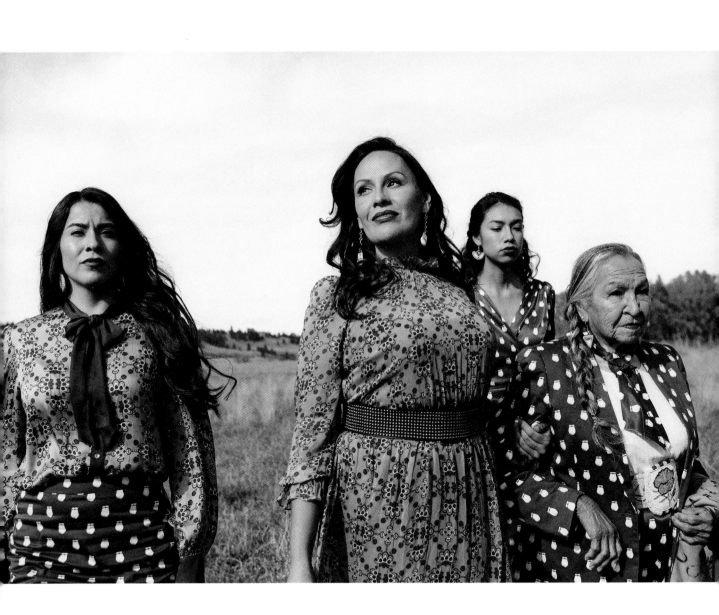

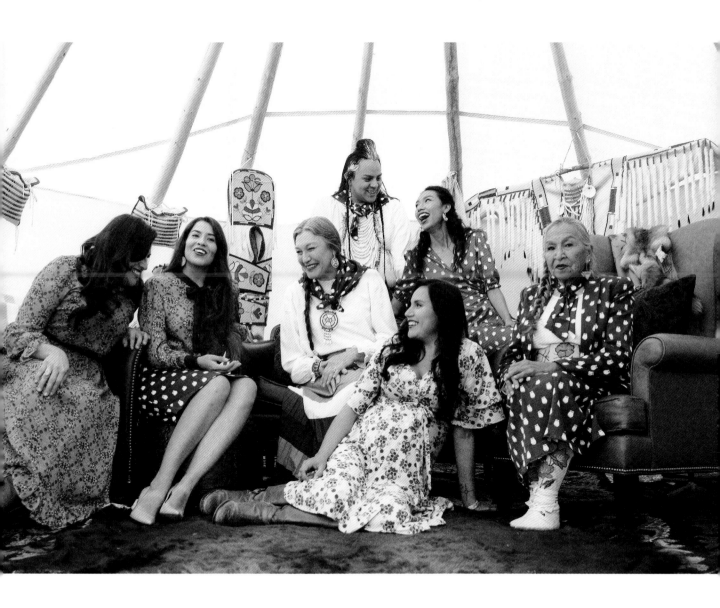

Models

p. 206 (from left): JoRee LaFrance, Kami Jo White Clay, Rusty LaFrance, Nina Sanders;
p. 207: Joree LaFrance; p. 208: Shania Russel, Kami Jo White Clay; p. 209: Rusty LaFrance;
p. 210: JoRee LaFrance, Nina Sanders, Kami Jo White Clay, Margo Real Bird;
p. 211: Nina Sanders, JoRee LaFrance, Janine Pease, Rusty LaFrance, Kami Jo White Clay,
Tana Stewart, Margo Real Bird

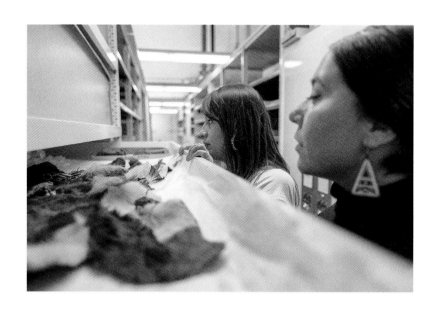

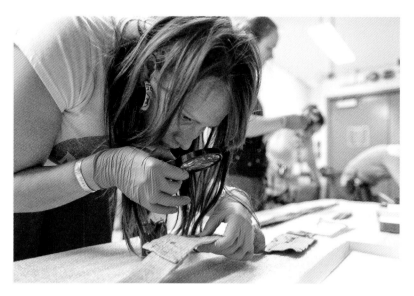

Apsáalooke scholars in the Field Museum collections, 2019

antecedents and consequences

alaka wali

Museum practice in the twenty-first century is rapidly changing. Artists, curators, and scholars are confronting these institutions' paradigms, which are rooted in European or Western philosophical and ideological perspectives. Some have called their efforts the "decolonizing" of museums, squarely framing it as a political act designed to overturn centuries of power dominance by an exclusionary elite.[1] This movement has its roots in the struggles of Native Americans (as well as other colonized societies) for civil, human, and land rights. In the mid-1970s activists began to petition and demand return of ancestors' remains and sacred objects, culminating in the concerted effort to pass federal legislation to protect Native American burial sites and to prompt the return from museums and federal agencies of remains, grave goods, and objects of patrimony. They also protested the representation of Native Americans and their cultures in museums and in the wider national imaginary. Working on multiple fronts, Native American tribes achieved a number of gains, including the historic passage of the Native American Graves Protection and Repatriation Act (NAGPRA) of 1990.

Since the passage of NAGPRA, museums have begun to establish relationships with federally recognized tribes in order to comply with the law. Over time, Native American communities asserted their desire and their right to reclaim their heritage, established tribal offices dedicated to repatriation, and worked with museums to bring back their belongings. Collections stewardship also changed significantly at many museums in response to NAGPRA and community activism.[2] At the Field Museum, for example, as tribal representatives came to view their belongings during NAGPRA-related visits, they requested changes in the care and access protocols. Some objects, whether under consideration for repatriation or not, were deemed to be sacred or ceremonial and were placed in secure cabinets or behind cloth curtains. Other objects were provided with labels instructing who could or could not handle them. Tobacco and other offerings were placed on shelves to afford protection and spiritual redress. The museum staff began to request that scholars consult with or inform tribal representatives before undertaking research.

The acquisition of new objects for the museum collections also changed in this time period. In 2007, after much deliberation, Field Museum curators established new procedures for collecting that relied less on the individual curator and instead required collective strategic decision-making that reflected broad research and public programming objectives for the anthropology collections.

These new directions in establishing relationships with descendant communities, caring for the collections, and acquiring new collections have posed challenges to museum practice as the "decolonization" process has been operationalized. Questions arise about what is appropriate for a museum of natural history or anthropology to collect and represent in the public galleries. Should we continue to collect only material culture of non-Western peoples, which is the historical scope of these museums? The Field Museum's anthropology collections largely reflect the lifeways of the "Global South" in the late nineteenth and early twentieth centuries, a time when these societies were facing the massive consequences of global colonialism. How should the museum "update" its collection, reflecting on the ways in which most postcolonial subjects' materiality is completely intertwined with Western mass-produced commodities?[3] These questions seem particularly acute in the case of the North American collections, in part because of their special status under NAGPRA, and in part because of the geographic intimacy of Native Americans: the museum resides on Native land. It is also the case that the Native North American anthropology collections (including Canadian territories) are the largest of the regional collections.

When I assumed responsibility for curating the North American ethnographic collection at the Field Museum in 2010, I was asking myself these questions and struggling to craft a way forward with this material. Debates had long been underway about how museums would navigate these terrain shifts, and there was much experimentation in curation, representation, and meaning-making occurring at museums across the world. Collaborations with descendant communities to both curate collections and change exhibition strategies were also underway in a variety of formats.[4]

Seizing the opportunity of the moment and thinking about possibilities at the Field Museum, I started to invite artists to curate small exhibitions that presented collections in a way that disrupted their historical narrative and allowed them to speak to contemporary concerns through the distinct aesthetic perspective of the artist curator. I chose art as a pathway for several reasons. First, art has long been a field of inquiry for anthropology, whether through the investigation of comparative aesthetics or through the analysis of its role in the social fabric. Second, material culture is the foundation for understanding art as an expression of human creativity. As I became familiar with the collection, I was overwhelmed with the aesthetics and creativity imbued in objects of everyday life. Third, I was influenced by a new direction in the anthropology of art, which theorized that objects had agency and should be considered as actors in human relations.[5] This theoretical perspective echoes what some Native American scholars and activists have long stated: that collections items should not be treated as "objects" but as living beings with powers of their own.

The choice of artists to curate these exhibitions was more serendipity than deliberation. The first such exhibition was in collaboration with Chicago-based fashion designer and artist Maria Pinto, whom I met by chance at a Field Museum event. Pinto created an installation (*Fashion and the Field Museum Collection: Maria Pinto*) that illuminated the modern sensibility and material ingenuity of the makers of clothing and adornment. She selected pieces from across the world's regions represented in the collection and wove in pieces from her own work to explore thematic concepts such as the durability of fashion, the changing nature of what

women use to create an image of self, and the versatility of materials used to craft clothing and adornment.

The next three such exhibitions were all collaborations with diverse Native American contemporary artists, whom I also encountered by chance: Bunky Echo-Hawk (Pawnee and Yakima), Rhonda Holy Bear (Lakota), and Chris Pappan (Kanza and Osage). Each had a distinctive style and all were deeply connected to their heritage. Echo-Hawk painted on canvas, but also did graphic design for commercial work (he did work for Nike, for example). Holy Bear had come to Chicago as a young girl and spent many hours in the Field Museum. She created exquisitely detailed sculptural figures wearing clothing of the late nineteenth century. She used wood, beadwork, and quillwork. Her works had been featured in exhibitions at the Chicago Art Institute, the Musee du Quai Branly in Paris, and the Metropolitan Museum in New York. Pappan considers himself an urbanite and a twenty-first-century ledger artist. He works on paper using graphite, acrylic, and collage, drawing out themes about the situation of contemporary Native peoples in colonial landscapes.

Pappan's exhibition was perhaps the most ambitious one, because he used his art to "intervene" in the gallery, which is devoted to Native North America of the late nineteenth and early twentieth centuries. This gallery (about six thousand square feet) was originally installed in the early 1950s and has essentially remained unchanged since then. While other galleries devoted to cultural material were renovated, this gallery continued to act as an anachronism, a painful reminder of an anthropological perspective that was complicit in perpetuating a harmful representation of Native Americans. Pappan placed his artwork throughout the gallery, including "layering" it directly on cases with a translucent material. As Jami Powell writes in her review of Pappan's exhibition (titled *Drawing on Tradition*):

Pappan raises interesting questions about the ways Native Americans perform and distort themselves to meet mainstream expectations about what it means to be an American Indian in the past, present, and future. Pappan urges the audience to reevaluate preconceived notions, and works

to shift expectations. Drawing on Tradition challenges visitors' expectations about American Indian experiences and opens up space for continued dialogue...[6]

These four exhibitions opened a pathway at the Field Museum to allow display of living artists' works, not just the historical cultural resources in the collections. As Justin Richland (who co-curated Rhonda Holy Bear's and Chris Pappan's exhibitions) is documenting in his forthcoming work on the Open Fields project (a two-year initiative to examine the intersections between law, art, anthropology, and Native American representation, hosted by the Neubauer Collegium for Culture and Society), the processes of creating these exhibitions had significant impacts on the Field Museum curatorial and exhibition teams. Working with artists as collaborators accelerated the changes under-way by which the staff approaches care of the collections, the aesthetic of exhibition design, the writing of label copy, and many other aspects of museum practice. It has emboldened us to take on even more ambitious projects in the same collaborative manner.

This is the origin story of the *Apsáalooke Women and Warriors* exhibition, the subject of this volume. While the four exhibitions that preceded this one were small (in footprint and scope), this exhibition represents a major expansion of collaborative processes. For the first time in its history, the Field Museum has invited a Native American curator and artist, Nina Sanders (Apsáalooke), to lead the development of an exhibition that will be a featured attraction (with an additional ticket purchase required) and is expected to travel to other museums in the United States. The space allocated to the exhibition is nearly as large as the current Native American Hall. Contemporary art by Apsáalooke artists is incorporated with objects from the museum's collection selected by Sanders and her colleagues. The Field Museum exhibition exists simultaneously with an installation in the art gallery of the Neubauer Collegium (discussed elsewhere in this volume). The two exhibitions speak to each other across the space of a few miles about the possibilities of disrupting time and category. The two exhibitions, taken together, point to a new direction that museums can follow as long-marginalized voices are placed in the center of the process.

The *Apsáalooke Women and Warriors* exhibition has been installed as the Field Museum undertakes the major renovation of the above-mentioned Native North American gallery. The renovation is guided by an advisory committee of Native American scholars and museum professionals and Chicago community leaders. The committee has been engaged since the beginning of the process and advises not just on the content but also the aesthetic look and feel of the new gallery. The new gallery, opening in 2021, will reflect the shifts in museum practice that the collaborative efforts discussed here have inspired. The process of institutional transformation, the operationalizing of "decolonization" that these exhibitions represent, is just beginning.

Notes

1

Philip J. Deloria, "The New World of the Indigenous Museum," *Daedalus: Journal of the American Academy of Arts and Sciences* 147, no. 2 (2018): 106–15; Amy Lonetree, *Decolonizing Museums: Representing Native America in National and Tribal Museums* (Chapel Hill, NC: University of North Carolina Press, 2012).

2

Chip Colwell, *Plundered Skulls and Stolen Spirits: Inside the Fight to Reclaim Native America's Culture* (Chicago: University of Chicago Press, 2017).

3

Alaka Wali, "Collecting Contemporary Urban Culture: An Emerging Framework for the Field Museum," *Museum Anthropology: Journal of the Council on Museum Anthropology* 37, no. 1 (2014): 66–74.

4

Rodney Harrison, "Reassembling Ethnographic Museum Collections," in Rodney Harrison, Sarah Byrne, and Anne Clarke, eds., *Reassembling the Collection: Ethnographic Museums and Indigenous Agency* (Sante Fe, NM: School for Advanced Research Press, 2013); Ivan Karp et al., eds., *Museums and Communities: The Politics of Public Culture* (Washington, DC: Smithsonian Institution Press, 1992); Christina Kreps, *Liberating Culture: Cross-Cultural Perspectives on Museums, Curation, and Heritage Preservation* (London: Routledge Press, 2003); Christina Kreps, *Museums and Anthropology in the Age of Engagement* (London: Routledge Press, 2019).

5

Alfred Gell, *Art and Agency: Towards a New Anthropological Theory* (Oxford: Oxford University Press, 1998).

6

Jami Powell, "Review of Drawing on Tradition: Kanza Artist Chris Pappan," *First American Art Magazine*, no. 17 (Winter 2017–18): 74–75.

present: visible women and warriors

dieter roelstraete

Three curatorial experiences from very different phases of my twenty-year-long career in the art world have helped me prepare for thinking of *Apsáalooke Women and Warriors* as a quintessentially contemporary art project—indeed, it may well rank among the most contemporary art projects that I have ever had the pleasure and privilege of working on.

The first, and oldest, such experience was a formative early encounter with the (now controversy-laden) work of Jimmie Durham back in my native Belgium in the mid-1990s. (This was followed by a series of personal exchanges with the artist about a decade later, around which time I translated some of his poems into Dutch for publication in an exhibition catalogue.) In retrospect, Durham may well have been the first major American artist I ever worked with, and I never gave much thought to the fact that he was (that is to say, he was *known* to be) of Native American descent—indeed, fêted as the face, so to speak, of contemporary Native American art in his succession of adopted European homes. (Durham has not lived—and has hardly set foot—in the United States since 1987, and has resided in a handful of European cities since 1994.) Durham's work was—and continues to be—strongly representational in tenor and tone, proudly incorporating a wide range of "traditional" modes of imaging and manufacture at a time when the very notions of both representation and tradition had come under unrelenting attack from an equally wide range of art-critical angles. Yet here was an artist who, to a certain degree, wisely and doggedly clung to *picturing* people through it all, giving faces, names, and stories to the countless invisible men and women peopling Native American history. I am obliged to add that Durham's reputation as a darling of the critical art establishment has suffered considerably since a series of challenges formulated by a growing number of younger indigenous artists and art professionals has sought to unmask him as a "trickster" and "professional poser," claiming Cherokee ancestry while "neither enrolled nor eligible for citizenship in any of the three federally recognized and historical Cherokee Tribes," according to an open letter signed by ten Cherokee artists and scholars in 2017. It is painful to note that these challenges really only captured the attention of the contemporary art world in 2017, on the occasion of Durham's defining and long-overdue retrospective organized at the Hammer Museum in Los Angeles, the Walker Art Center in Minneapolis, and the Whitney Museum of American Art. I am in no position to comment upon this contentious matter—though the historical facts of his decade-long political involvement in the American Indian Movement in the 1970s are beyond contesting. In any case, I am invoking the example and inspiration of Jimmie Durham here because of his unwavering commitment to depiction and *representational* art: aesthetic strategies that are typically quick to be called into question and problematized by those who have long been used to representing themselves, or seeing themselves represented—such as the male white subject whose long history as the privileged object of representation more or less coincides with the history of art as such.

The second experience has been that of a five-year working relationship with Kerry James Marshall—the celebrated, hugely influential African American painter of black modern life whose work first drew me to Chicago in the early 2010s. I was exposed to Marshall's *oeuvre* in the context of the tenth edition of Documenta in 1997, in which his large-scale, crypto-realistic paintings, populated exclusively by jet-black figures engaged for the most part in humdrum, quotidian activities, proved the lone exception to the rule of a fiercely anti-pictorial exhibition project—the artist's deep dedication to representing blackness curiously at odds with the exhibition's overall hostility toward the very idea of representation (the 1990s were a terrible time for

painting as a whole). I have been a fervent admirer of Marshall's work ever since that transformative encounter. Our relationship culminated when I was given the privilege of co-curating Kerry James Marshall's epochal survey show *Mastry* at the Museum of Contemporary Art Chicago in 2016. One of the principal curatorial thrusts of this aptly named master class in the art of figuration was the notion that to properly challenge and rewrite the art-historical canon—to write oneself into this canon, to see oneself *represented* in it—one must begin by conquering that history's most canonical form, namely history painting, so as to end up in that canon's tried and trusted home, namely the *museum*. (The point of challenging the canon is not to destroy the museum, but merely to enter it on one's own terms, as both subject and object, artist and "sitter": to finally be, and feel, *at home in it*.) Marshall has often spoken of the experience of *belatedness* that has haunted his work ever since the moment he decided to abandon the allegedly universal language of abstraction in favor of a more directly legible pictorial style—like Durham's, a choice made against the current of a critical consensus converging, at the time, on the *deconstruction* of the representational paradigm rather than its expansion or reinvention. And even more than Durham, Marshall's commitment to representational art— to *picturing people who looked like him*—was rooted in a particularly American history of blindness and erasure. It was the youthful experience of reading Ralph Ellison's *Invisible Man*, after all, that illuminated the way ahead in what would become a forty-year career in the pictorial arts: to render Ellison's titular dark-skinned Everyman a "visible man" at long last.

The third and most recent experience relates to my work as a member of the curatorial team of documenta 14, the most recent edition of the gargantuan contemporary art exhibition that takes place in the provincial German town of Kassel every five years. Thanks in part to the work of my colleague Candice Hopkins—who, prior to joining the Documenta team, had been one of the architects of the acclaimed exhibition *Sakahàn: International Indigenous Art* at the National Gallery of Canada in Ottawa ("*sakahàn*" means "to light a fire" in the language of the Algonquin peoples)—the question of indigeneity became one of the primary forces animating documenta 14. The sprawling curatorial construct featured the work of some of Canada's best-known First Nations artists alongside a number of Australian Aboriginal artists, a little-known indigenous artist from Colombia, and a grouping of Sami artists from Europe's northernmost reaches (the more established of whom worked, once again, in a defiantly "traditional" iconographic and material register). In fact, it was the prominent inclusion of these Sami artists in particular—truly Europe's oldest "others"—that helped recast the question of indigenousness in the light of some of the most vexing questions of our present moment: What, precisely, does "native" mean in a globalized culture that prizes agility, flexibility, and mobility above all else, and how does the romance of nomadism in particular (for the entanglement of indigeneity and nomadism appears to be a quasi-timeless one) resonate in our age of migrant-fueled anxieties and nativist instincts? How do questions of authenticity and autochthony square with the current xenophobic obsessions with origins and belonging? (*Where are we ever really from?*) And how does all of this alter the debate around the millennial minefield of cultural appropriation? All these questions help lend weight to my sense that *Apsáalooke Women and Warriors* ranks among the most contemporary art projects that I have ever had the privilege of working on. This ambitious multi-layered exhibition project is exactly what "culture" is about in the year 2020—and will be for a long time to come.

It is through the prism forged by these three distinct experiences that, as a contemporary art curator with a longstanding interest in issues of presence and representation, and an abiding love of the idea of the museum, I have been able to make sense of *Apsáalooke Women and Warriors* as a project revolving, in essence, around issues of representation, presence, and visibility as they play out in the idealized world of the museum. (Whether this be a "natural history" museum or an art museum may matter less, in the end, than initially presumed: why not think of contemporary art as the "natural history" of the future?) The challenge posed by this project to a museum of natural history is a clear-cut, almost simple one: how does this fabulously wealthy repository of indigenous cultures' historical artifacts reimagine itself as a home for these cultures' living, breathing—hybridized, irreverent, recalcitrant— present? The challenge posed by this undertaking— which, in its occasionally blasphemous spin on the gospel of "tradition," leans so heavily on "traditional"

representational modes of image-making (figurative painting) and "traditional" crafts (beadwork)— to the narrowing imagination of mainstream contemporary art is only superficially more complex: can projects like this help the contemporary art world shed its imperious (indeed, properly *colonial*) reflexes with regard to the representational imperative? Simply put, when standing in front of, and thinking about, a painting like *Evening Lodges* by eminent Apsáalooke artist Kevin Red Star: *can we start from scratch*?

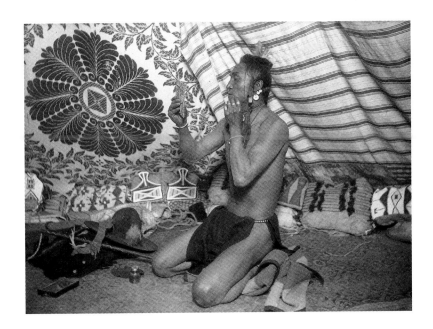

Has No Foretop (Also Known as Smart Iron) Sitting Inside a Tipi and Grooming with Tweezers, **ca. 1898–1910, Fred E. Miller**

CONTRIBUTORS

Phenocia Bauerle is the director of Native American student development at the University of California, Berkeley. She is the editor of *The Way of the Warrior: Stories of the Crow People*, a collection of Apsáalooke oral history accounts.

Aaron B. Brien is an anthropologist serving on the faculty of the Native American Studies department at Salish Kootenai College.

Luella N. Brien (Akbaaiitcheesh/One Who Keeps Things Good) is the editor of the *Big Horn County News*, a weekly newspaper based in Hardin, Montana.

Del Curfman (Baaatchiialish/His Life Will Be Fortunate) is an artist based in Santa Fe, New Mexico.

Mary Hudetz (Biilaahsaalakuuahisseesh/ Well-Known Winner) is an investigative reporter for the *Seattle Times* and past president of the Native American Journalists Association. She is a Whistling Water woman, a granddaughter of Ellsworth and Martha Little Light, and the great-great-great granddaughter of Chief Medicine Crow.

Karis Jackson is a bead artist based in Browning, Montana.

Allen Knows His Gun is an artist based in Billings, Montana.

JoRee LaFrance (Iichiinmaatchiilaash/ Fortunate with Horses) is an Apsáalooke scholar who was born and raised on the Crow Reservation. She is Greasy Mouth and a child of the Ties in the Bundle clan.

Rusty LaFrance (Iichiiniiwaatchiileesh/ One Who Is Fortunate with Horses) graduated from Little Big Horn College in 2018 with an associate of science degree in livestock management. He was selected by the Native American Rangeland Advisory Committee as the student representative for agriculture in Indian Country.

Jonathan Lear is the Roman Family Director of the Neubauer Collegium for Culture and Society and the John U. Nef Distinguished Service Professor at the Committee on Social Thought and in the Department of Philosophy at the University of Chicago. His books include *Radical Hope: Ethics in the Face of Cultural Devastation* (2006).

Marty Lopez (Apsáalooke) is pursuing a PhD in visual anthropology at the University of Montana, where he teaches in the Native American Studies department.

Katherine Nova McCleary (Little Shell Chippewa-Cree) grew up on the Crow Reservation. She graduated from Yale University in 2018 with a bachelor's degree in history and currently serves as Montana Senator Jon Tester's policy advisor on Indian affairs in Washington, DC.

Timothy P. McCleary, known in the Apsáalooke community as Baaxpáash, is an anthropologist and academic who has taught at Little Big Horn College for more than twenty-five years.

Mona Medicine Crow is an artist based in Lodge Grass, Montana.

Elias Not Afraid is a bead artist based in Whitecone, Arizona.

Hunter Old Elk (Bía Basaane/Woman in the Front), an Apsáalooke and Yakama from Montana, is a museum curator currently working at the Plains Indian Museum in Cody, Wyoming.

Ben Pease (Aashduuptako Ishtaxxiial- uutchish/Steals the Guns from Two Enemy Camps) is an artist based in Billings, Montana.

Janine Pease (Akchiwaliideeiishiitchaash/ One Who Loves to Pray) is the founding president of Little Big Horn College. She has served as the director of the American Indian College Fund and as president of the American Indian Higher Education Consortium.

Birdie Real Bird (Bassaanneeahoosh/ First Many Times) is a Big Lodge woman who resides on the Crow Reservation. She is a member of the board of advisors at the Buffalo Bill Center of the West and an endorsed member of the Montana Circle of American Masters.

Kevin Red Star is an artist based in Roberts, Montana.

Meranda Roberts (Northern Paiute/ Xicanx) is a postdoctoral fellow at the Field Museum working on the renovation of the Native American Hall. She earned a PhD in Native American Studies at the University of California, Riverside.

Dieter Roelstraete is the curator at the Neubauer Collegium for Culture and Society. He previously served as a curator for documenta 14 and the Museum of Contemporary Art Chicago.

Nina Sanders (Akbileoosh/Brings the Water) is a curator of historic and contemporary Native American art who has worked with the Field Museum, the Smithsonian National Museum of the American Indian, and the National Museum of Natural History, among other institutions.

Adam Sings in the Timber is a documentary photographer and filmmaker from Billings, Montana.

Alaka Wali is the curator of North American Anthropology at the Field Museum.

Bethany Yellowtail (Ammaakeealaache- libaachiilakaacheesh/Overcomes through Faith) is a fashion designer from the Apsáalooke and Northern Cheyenne Nations. She is the designer and founder of the Los Angeles-based clothing brand B. Yellowtail, which also promotes hand-made goods, jewelry, and accessories created by Native American and First Nations artisans.

ACKNOWLEDGMENTS

The Neubauer Collegium for Culture and Society at the University of Chicago is grateful to its many partners in creating this publication. We thankfully acknowledge that the University of Chicago is situated upon the ancestral lands of the Illiniwek, Myaamia, and Potawatomi peoples, among others, in addition to the city of Chicago being home to the third-largest urban Native population in the United States.

We thank the Apsáalooke people, who so generously shared their intellectual and artistic abundance with us as well as with the Field Museum. For all their wisdom and support and stewardship we say, Aho/Thank you. All proceeds from the sale of this volume will be given to Little Big Horn College, at Crow Agency, for students and faculty to continue their studies. For their many contributions to this publication and to the exhibition we would like to thank the following individuals in particular: Margo Real Bird, Ahookashiile Grant Bulltail, Marvin Steward, Dan Old Elk, Mardell Plainfeather, Harold and Indy Hill, and Levi Yellow Mule. It is only with your guidance and encouragement that we are able to share the sensitive and sometimes sacred parts of Apsáalooke culture. We thank Mimi Real Bird, Wailes and Lena Yellowtail, Dr. David Yarlott, Karl Little Owl, and Chairman Not Afraid for sustaining and invigorating our endeavors. We are further indebted to the Medicine Crow, Two Leggings, Plenty Coups, and Yellowtail families, as well as the Real Birds, Old Coyotes, Old Elks, Not Afraids, and McClearys. We thank the descendants of Pretty Shield, Pretty Eagle, and Medicine Tail.

We would like to give special thanks to the Apsáalooke artists and writers who contributed to this project and gave it shape, both in large-scale conception and down to the details: Phenocia Bauerle, Della Big Hair, Aaron B. Brien, Luella N. Brien, Del Curfman, Lydia Falls Down, Mary Hudetz, Karis Jackson, Allen Knows His Gun, JoRee LaFrance, Rusty LaFrance, Marty Lopez, Katherine Nova McCleary, Timothy P. McCleary, Mona Medicine Crow, Elias Not Afraid, Hunter Old Elk, Ben Pease, Janine Pease, Birdie Real Bird, Kevin Red Star, Adam Sings in the Timber, Supa Man, and Bethany Yellowtail. We give special acknowledgments to the Crow Nation, the Antique Tribal Art Dealers Association, the Stapleton Gallery, the Sorrell Sky Gallery, the Wheelwright Museum, the Smithsonian National Museum of the American Indian, and the School for Advanced Research for their support. We thank Don and Liza Siegel, and Putt Thompson and family, as well as Jason Garcia and Christopher Lunn, for their support and contributions to the exhibition. This volume is a collaboration, through and through.

There are many interweaving strands that have led to the production of *Apsáalooke Women and Warriors*. At the Neubauer Collegium it began with a research project, Open Fields, originally conceived in 2015 as "a collaboration between anthropologists, visual artists, curators, scholars of historic preservation, lawyers specializing in indigenous rights, and tribal elders from across North America." The project's original aim was to rethink the very idea of "natural history," with the Field Museum serving as both the site and subject of inquiry. The Field was in the midst of its own process of thinking about how to make itself more sensitive to and expressive of the outlooks of Native peoples. We thank Alaka Wali, curator of North American Anthropology at the Field Museum, who was a member of the original Open Fields research team and became a Visiting Fellow at the Neubauer Collegium. We are grateful to Field Museum President Richard Lariviere, who gave enthusiastic support, first for this project and then for the exhibition. We give thanks to the Field Museum staff who have played many crucial roles in bringing this exhibition and volume to fruition: Monisa Ahmed, Álvaro Amat, Amy Bornkamp, Daniel Breems, Latoya Flowers, Jason Gagovski, Lauren Hancock, Janet Hong, Jaap Hoogstraten, Stephanie Hornbeck, Paul Horst, Daniel Kaping, Jamie Kelly, Jamie Lewis, Taylor Marcel, Matt Matcuk, Christopher McGarrity, David Mendez, Susan Neill, Jacqueline Pozza, Ann Prazer, Meranda Roberts, Tom Skwerski, Kate Swisher, Katherine Ulschmid, Bridget van Breemen, Greg Walter, Simon Watson, John Weinstein, Meredith Whitfield, Debra Yepa-Pappan, and all the Field Museum staff who made the exhibition possible.

At the Neubauer Collegium we are especially grateful to the donors who made this research, this exhibition, and this volume possible. Joseph Neubauer and Jeanette Lerman-Neubauer created an institution to foster collaborative and interdisciplinary research. Brenda Shapiro donated funds for this publication so that all proceeds will go to the Apsáalooke people, and her support for the gallery enables us to integrate the arts into larger research inquiry. Emmanuel Roman provided funds to enable us to bring Native artists, tribal elders, and writers from all over North America, over a five-year period, to join in many conversations with curators and conservationists, museum directors, and scholars. Through the generosity of donors, the Neubauer Collegium became a place where conversations that need to happen can happen.

Our work at the Neubauer Collegium is part of the privilege of working at a university that values unbounded research. We wish to thank Robert Rush and Stephanie Oberhausen and their respective teams, and we thank our close colleagues Carolyn Ownbey, Jessica Musselwhite, and Jennifer Helmin for their support, critical to bringing this publication to life.

As editors, we thank our book designer, David Khan-Giordano, who listened so carefully to our Apsáalooke partners as well as to us, and who designed such a beautiful book.

Thank you all.

The Neubauer Collegium
Editorial Collaborative

Elspeth Carruthers
Jonathan Lear
Dieter Roelstraete
Nina Sanders
Mark Sorkin

COLOPHON

This book is published on the occasion of the exhibition *Apsáalooke Women and Warriors*, jointly organized by the Field Museum and the Neubauer Collegium for Culture and Society at the University of Chicago.

Apsáalooke Women and Warriors

Field Museum
March 13, 2020 – April 4, 2021

Curated by Nina Sanders

Neubauer Collegium for
Culture and Society
March 12, 2020 – August 21, 2020

Curated by Nina Sanders
in collaboration with Dieter Roelstraete

Editors
Elspeth Carruthers
Jonathan Lear
Dieter Roelstraete
Nina Sanders
Mark Sorkin

Design
David Khan-Giordano

Color management
Professional Graphics

Printed in Lithuania by BALTO

The Neubauer Collegium for Culture and Society gratefully acknowledges the following for their generous support: the Neubauer Family Foundation, the Earl and Brenda Shapiro Family Foundation, and Emmanuel Roman.

Support for the *Apsáalooke Women and Warriors* exhibition and publication comes from the Brenda Mulmed Shapiro Fund and the Rosetta Froug Mulmed Fund at the Neubauer Collegium for Culture and Society.

Distributed by the University of Chicago Press

ISBN 9780578549552

Cover: Ben Pease, *Keeper of Medicine from Above-Thunderbird Protector*, 2019
Inside cover (front and back): Adam Sings in the Timber, *Little Bighorn Mountains*, 2019

IMAGE CREDITS

© American Heritage Center, University of Wyoming, Throssel Collection: 56, 57, 58, 59, 60, 176. For more details, please contact collegium@uchicago.edu.

© Cultivate Consulting: 206, 207, 208, 209, 210, 211

© Del Curfman: 103, 105

© Lydia Falls Down, photographs by John Weinstein: 194, 198–99, 200–01, 202–03

© Field Museum, photographs by John Weinstein: 10, 24, 25, 26–27, 62, 106, 145–163, 178–79, 180, 181, 193. For more details, please contact collegium@uchicago.edu.

Photograph by John H. Fouch, courtesy of Dr. James Brust: 96

© Karis Jackson: 71 (photograph by Robert Heishman), 118, 171 (photographs by John Weinstein)

© Allen Knows His Gun: 19, 20–21

© Mona Medicine Crow, photograph by Robert Heishman: 188

© National Museum of the American Indian: 23, 54, 55, 82, 86–87, 95, 110, 111, 112, 113, 114, 115, 164, 167, 174, 192, 221. For more details, please contact collegium@uchicago.edu.

© Newberry Library: Map by W. W. (Walter Washington) De Lacy, 1819–1892, Everett D. Graff Collection of Western Americana: 12.

© Elias Not Afraid, photograph by John Weinstein: 107

© Ben Pease: Cover (photograph by Miranda Murdock), 73 (photograph by Robert Heishman), 77 (photograph by Miranda Murdock), 78–79, 80–81 (photograph by Garret Vreeland)

© Birdie Real Bird, photographs by John Weinstein: 88, 89, 90–91

© Kevin Red Star: 133, 135, 136–37, 138–39, 140–41. All photographs by Robert Heishman except 138–39 (courtesy of the artist and Sorrel Sky Gallery).

© Rue des Archives/GRANGER: 169

© Don and Liza Siegel Collection, photographs by Garret Vreeland: 28, 65, 66, 67, 68, 69, 70, 108, 117, 175, 182–83, 184–85

© Adam Sings in the Timber: Inside cover (front and back), 36–53, 214

© Pete Souza via Wikimedia Commons; medal photograph by Robert Heishman: 186

© Sean Sperry/*Bozeman Daily Chronicle*; medal photograph by Robert Heishman: 187

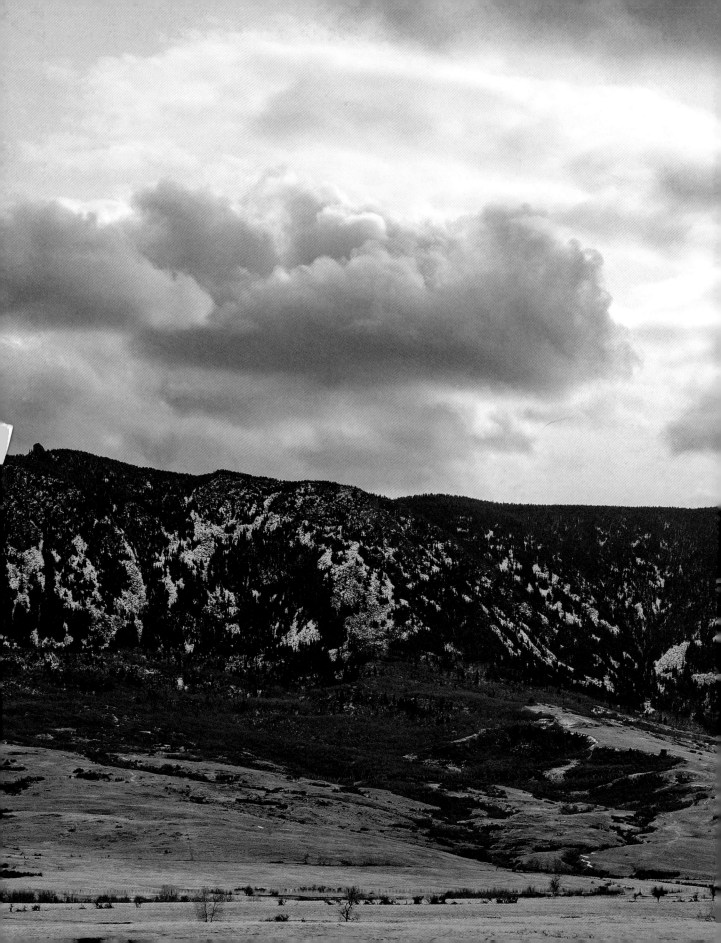